# ABE AJAY

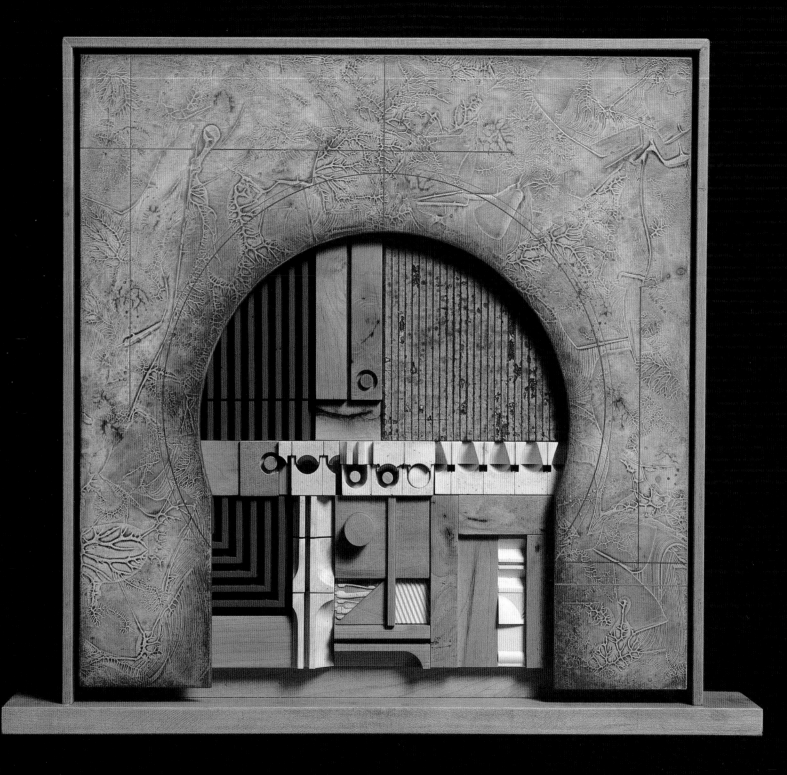

# ABE AJAY

by *Lee Hall*

1. Construction 689, 1989
Mixed media, 19″ × 21½″ × 4″;
collection of the artist.

Published for the Academy for Educational Development
by the University of Washington Press   *Seattle & London*

Copyright © 1990 by the University of Washington Press
Composition by the Department of Printing, University of Washington
Printing and binding by Toppan Printing Company, Tokyo, Japan
Designed by Audrey Meyer

Library of Congress Cataloging-in-Publication Data

Hall, Lee.
    Abe, Ajay / Lee Hall.
       p. cm.
    Includes bibliographical references.
    ISBN 0-295-96841-9 (alk. paper)
    1. Ajay, Abe—Criticism and interpretation.    I. Ajay, Abe.
II. Title.
N6537.A43H35        1990
709.2—dc20                                         89–16596
                                                        CIP

The paper used in this publication meets the minimum requirements
of American National Standard for Information Sciences—Permanence
of Paper for Printed Library Materials, ANSI Z39.48-1984.

The artist in his studio, 1968. *Photograph
by Frazer Dougherty.*

This book is dedicated to
BETTY RAYMOND AJAY
who encouraged its realization through
faith, hope, and love.

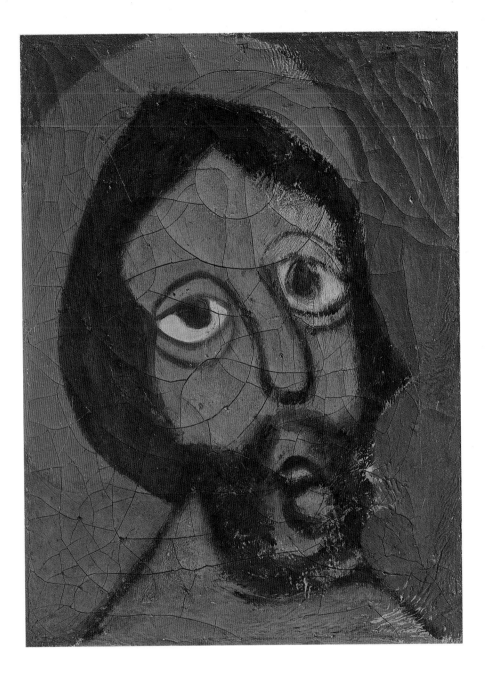

2. Head of Christ, 1938
Oil on canvas, 12″ × 9″; collection of
the artist. One of Ajay's earliest works
shows the influence of Rouault and the
Romanesque fresco tradition on the
young artist.

3. Untitled, 1959
Oil on canvas, 12″ × 18″;
collection of the artist.

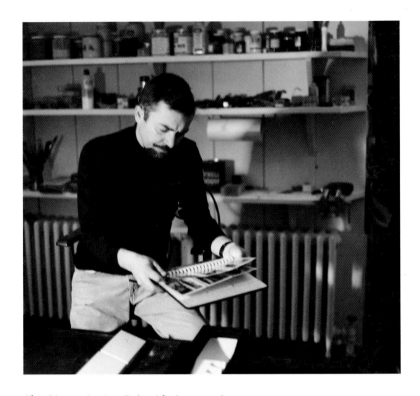

Abe Ajay reviewing Polaroid photographs of his polyester-resin castings, 1968. The artist documents possible arrangements of the castings for future reference and use in the studio. *Photograph by Frazer Dougherty.*

# Contents

Ajay surveying wooden models of his three-dimensional modular vocabulary.

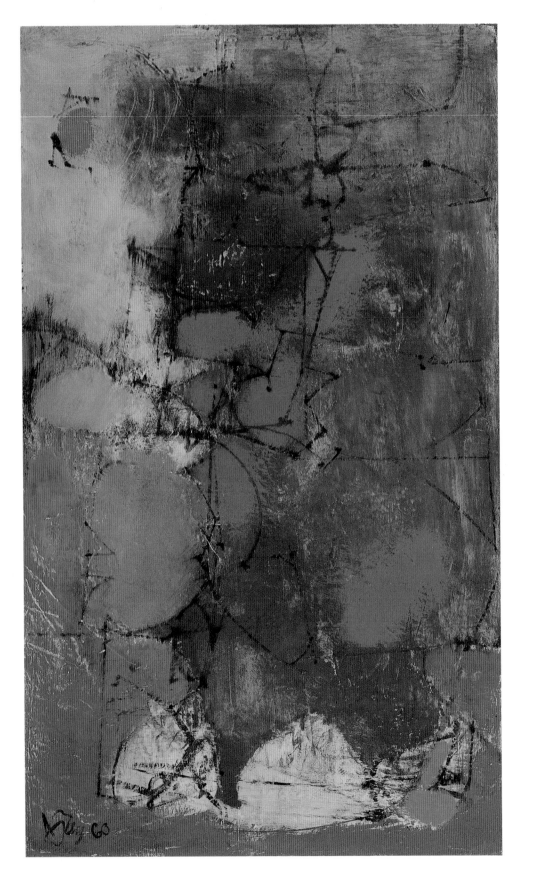

4. Untitled, 1960
Oil on canvas, 32¼" × 20";
private collection.

# *Preface*

ABE AJAY BANKED HIS TALENT when others spread theirs around lavishly. An intense, private man, Ajay holds onto things, frets over them, fusses a lot. You can guess as much from his appearance. He's a tightly built, compact man whose restlessness burrs the spaces around him, sometimes electrifying a classroom, sometimes entertaining friends. And the talent, checked and banked, emits heat; he is not a man at rest with himself or with the world.

Ajay's unrest and energy combine when he enters his studio in Connecticut. There, amidst the accumulated work of several decades, he frets and muses, grimly flaying himself for failures real and imagined, wryly joking about his discomfort with himself and the world, commenting satirically on the state of politics and the moral fiber of politicians. He shifts between intense social concerns and almost secretive passions about art. The public and private person, the detached and the participating citizen combine in Abe Ajay and in his work.

This book is about the man and his work; about the man of social conscience and fierce aesthetic convictions who came of age before the Second World War; it is about Ajay's work, richly woven amalgams of disparate threads; it is about his family, his politics, his intelligence. His singularity appears not in a simple catalogue of these factors—after all, the same factors by their presence or absence influence everybody's life—but in the tightness of the weave, the intricacy of the pattern, and the steady repetitions and variations of themes and beliefs. The artist is never far from his work.

As his work has matured, Ajay has grown accustomed to an abiding discomfort, a steady hum beneath his consciousness that tells him that something is not right: the continual psychic aches are familiar, almost friendly after all these years; he would miss them if they abandoned him. His work maps his life in the studio—stacks of drawings and collages, piles of watercolors, some paintings, and meticulously engineered and elegantly achieved constructions—reaffirm his sense of himself as an outsider; and this work, the palpable evidence of years spent in stubborn certainty that art would not betray him, now sustains him.

Perhaps he had a choice and could have done something else with time, energy, life itself. No matter. He has created a body of work that belongs solidly to the twentieth century and to all imaginable time—work that betokens the mind of one artist and reveals some of the secrets of art itself.

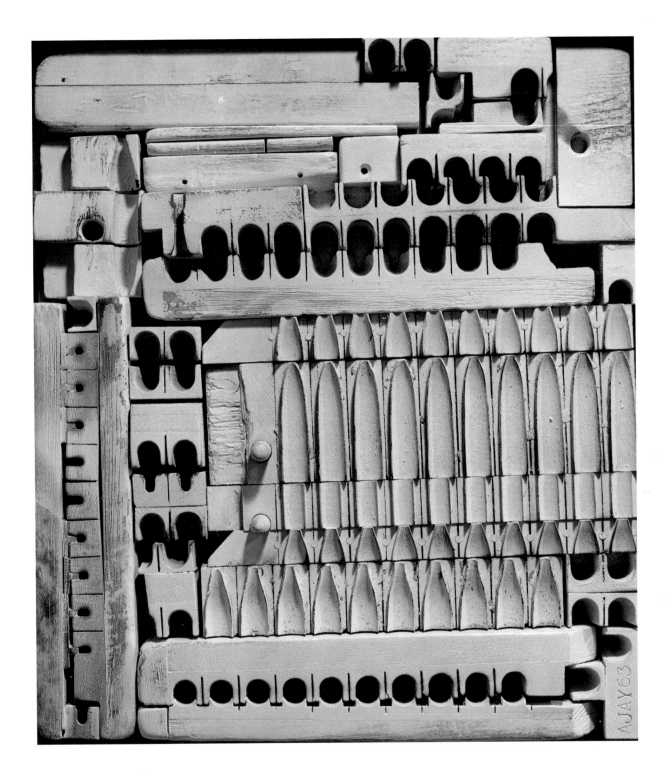

5. Wood construction 201, 1963
Cigar molds, $17\frac{1}{2}'' \times 15\frac{1}{2}''$; collection
of J. Walter Thompson Company.

In preparing this book, I have listened to Abe Ajay; I have pried into his thinking and feelings, asked him to look back over his career. With humor, agony, boredom, annoyance, he has identified high and low moments; he has analyzed and criticized and praised the patterns he has seen; he has cataloged love, hate, anger, sadness, and joy as they rose to meet him; he has answered questions and worked his way through the dark and light paths of recollection. Throughout our conversations, Abe imbued each story with irony, with paradox. Nothing is simple; everything is more than it appears. If there is *this,* then there is also *that;* if white, then black; if empty, then full. Between the opposites dwell complex continents. Or so Ajay imagines and therefore objectifies in his constructions.

Abe Ajay is a complicated artist, a many faceted personality. I hope that this book, about both the work and its maker, truthfully recounts his ideas and words, accurately introduces his work to an audience larger than that provided by the current gallery system. I hope it reveals the mind that quickens the work; if so, I believe it will bare some of art's best secrets.

Ajay with finished construction 388, 1980s. *Photograph by Joseph Kugielsky.*

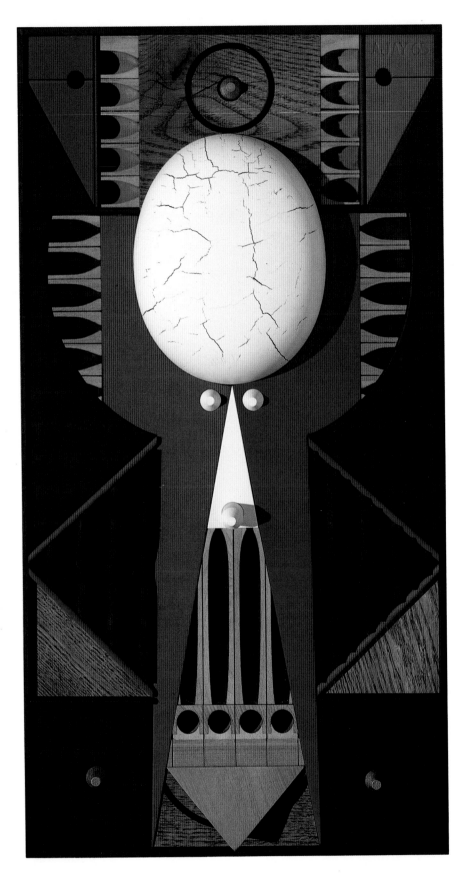

6. Totem 1, 1965
Polychrome wood construction, 25″
× 14″; Hirshhorn Museum
and Sculpture Garden, Smithsonian
Institution, gift of Joseph H. Hirshhorn.

7. Totem 2, 1965
Polychrome wood construction, 25″ × 14″;
Neuberger Museum, State University of
New York at Purchase, gift of Roy R.
Neuberger. Photograph by Steven Slomen.

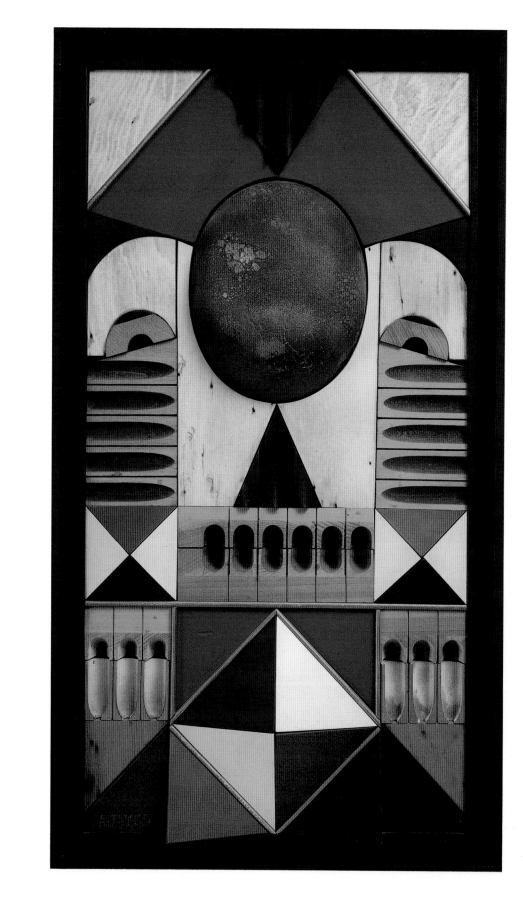

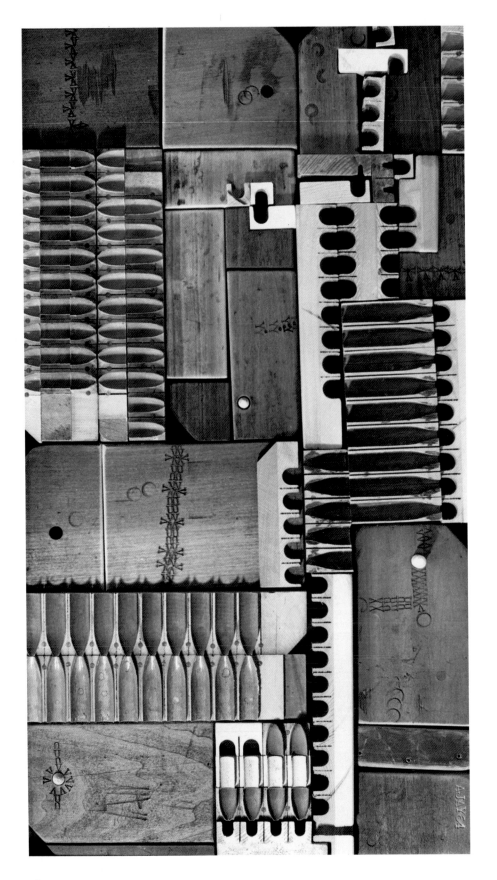

8. Wood construction 214, 1964
Cigar molds, $31\frac{1}{2}''\times17\frac{1}{2}''$; private
collection.

# *Acknowledgments*

THE ACADEMY FOR EDUCATIONAL DEVELOPMENT and I express gratitude to the foundations and individuals who contributed to this book. We are grateful to George Abbott, whose generosity of both spirit and substance transformed the project from hope to reality. His advice was valuable; his applause for the first draft heartening. Artist/photographer Joseph Kugielsky's patient and talented camera work provided most of the illustrations for this volume. He helped eagerly, a fellow artist. Betty Ajay shared forty-two years of the history recounted here. She provided wise counsel based on careful listening, careful reading.

We thank those individuals and foundations who contributed to the realization of the book—its research and production: Leon Levy and Shelby White, Marie and Roy Neuberger, Victor Weingarten, and The Hinda and Richard Rosenthal Foundation. Their generosity evidenced their affection for and belief in Abe Ajay.

I greedily sought and received information from Abe Ajay's friends, colleagues, and students. Jeffrey Hoffeld and Irving Sandler commented brilliantly on Ajay's place in American art and in the modernist movement. Martha Scott, Louise Deutschman, Silvia Pizitz, and John Johansen shared anecdotes and observations about the artist's development over several decades. Gibson Danes and George Parrino recalled Ajay's skills and values as a teacher. Sid Deutsch and Max Weitzenhoffer speculated on the uneven curves and dips that have marked Ajay's career as an exhibiting artist. I am particularly grateful to Konrad Kaletsch and Jacqueline Sindeband for their loving tributes to Ajay as a teacher. Finally, I thank Betty Mauceri for her tireless assistance with the mechanics of collecting and keeping information, with correcting and preparing the manuscript.

Writing about Abe Ajay, like knowing him, is a pleasure; the many people who assisted—and cheered the book to completion—added measurably to this author's joy in telling Abe's story.

# *Chronology*

"What a wee little part of a person's life are his acts and his words: His real life is led in his head, and is known to none but himself. All day long, and every day, the mill of his brain is grinding, and his thoughts, not those other things, are his history. His acts and his words are merely the visible, thin crust of his world, with its scattered snow-summits and its vacant wastes of water—and they are so trifling a part of his bulk! A mere skin enveloping it. The mass of him is hidden from it and its volcanic fires that toss and boil, and never rest, night nor day. These are his life, and they are not written and cannot be written."—*Mark Twain*

ABE AJAY TALKS ABOUT HIMSELF HESITANTLY, often disparagingly; he tosses his achievements into dark corners, emphasizes instances of foolishness; he keeps his own feelings at a distance and delimits the province of irony for his listener. In one such exercise, Ajay provided his chronology. Here, in his words, is a summary of his life.

1919    Born at home, on March 24, in Altoona, Pennsylvania, to William and Mary (Simmons) Ajay.

1920    Utters first word, "Dada," showing early interest in art history.

1921    Takes first step, showing late interest in mobility.

1922    A total blank.

1923    Survives measles, mumps, chicken pox, and whooping cough. Gets set of drawing pencils as reward.

1924    Draws pictures of World War I fighter planes. Mainly Spads and Fokkers.

1925    Graduates to portraiture. Emphasis on Tom Mix and his horse, Tony.

1926    Enters Mrs. Rowe's first-grade class in Curtin School, just down the block.

1927    Runs away from home with pet rabbit. Returns in time for lunch.

1928    Gets watercolors for Christmas. Paints picture of Taj Mahal for third-grade teacher, Miss Irvin. Gets pat on head.

1929    Ignores stock market crash. Joins Thrift Club at school. Loses savings when bank fails. Curses Capitalism.

1930    Serves as altar boy in church. Sees handmade oil paintings of twelve Apostles. Impressed. Decides to be an artist.

1931    Falls in love with sixth-grade teacher, Miss Kell. Nothing comes of it.

1932    Roots for FDR against Herbert Hoover. Wins bet with brother.[1]

1933    Becomes art editor of junior high "Blue & White." Wins statewide contest for cover design. Feels ten feet tall. Measures five feet two inches.

1934    Reads Van Gogh's letters to brother Theo. Is overwhelmed. Turns third-floor attic into studio. Buys oil colors. Paints landscape and still life pictures. Writes quote from Thomas Paine on attic wall.[2] Fancies himself an artist.

1. Brother, David, born in 1916, perennial Republican.

2. "My Country Is the World, To Do Good Is My Religion."

| | |
|---|---|
| 1935 | Sees first real art exhibition: Pittsburgh's Carnegie International. Wonders why Franklin Watkins wins big prize.[3] Dumb picture. |
| 1936 | First drawings published in *New Masses*. Included in show at New York, Public Library Picture Collection. Feels honored. |
| 1937 | Graduates from high school. Leaves for New York City. Scholarships to Art Student's League and American Artists School. Speaks to Artists' Union in Philadelphia. Gets ten dollars and train fare. Feels flush. |
| 1938 | Copies Orozco at League. Draws life model at school downtown. Drops out of art classes. Gets married. Paints portrait of wife à la Holbein. Paints head of Christ à la Roman fresco. First son is born. Name of Alexander. |
| 1939 | Hired by Federal Art Project. Joins Artists' Union and Artists' Congress. |
| 1940 | Moves from Manhattan to Astoria, Queens. Better air for the kid. |
| 1941 | Project folds. Moves back to Manhattan. Looks for job in graphic design. |
| 1942 | Lands job as art director at Dell Publishing Company. Cheesecake mag. |
| 1943–44 | Joins art staff of newspaper *PM*. Does daily cartoon and illustrations. Works with Ben Shahn as art director of FDR's fourth-term campaign. Exciting time all around. Son Stephen is born. |
| 1945 | U.S. Army. Infantry School at Fort Benning. Truman drops bomb. |
| 1946 | Does first job for *New York Times*. Sets up freelance studio in Carnegie Hall. Becomes design director for *Young People's Record Company*. Adds *Parents Magazine* to list of accounts. First marriage ends in divorce. |
| 1947 | Flies to Havana with John Groth.[4] Gets drunk with Hemingway. Teaches class in political cartooning with Ad Reinhardt. Falls in love with Betty Raymond. Gets married in Jersey City. |
| 1948 | Moves out of Carnegie Hall to new space on West Forty-sixth Street. |
| 1949 | Gets bug to live in country. Looks for property in Connecticut. Buys old house and barn in Bethel with 4 percent G.I. mortgage. |
| 1950 | Buys Chevrolet station wagon. Moves to sticks with wife and stepdaughter, Robin. Plants vegetable garden. |
| 1951–56 | Makes weekly trip to Manhattan. Picks up new accounts: Carl Byoir Associates; Hill & Knowlton; Owens Corning Fiberglas; General Electric; McCann Erickson; Twentieth Century Fund; WABC-TV; Elektra Films; *Fortune Magazine;* Victor Weingarten Company; *Sports Illustrated*. Awards from Art Directors Club, Society of Illustrators. |
| 1957 | Visits Puerto Rico and Virgin Islands. Photographs façades, ruins, architectural detail. Makes notes on color, shape, texture. Thinks about picking up where Project left off. Buys easel. |
| 1958–62 | Begins phase-out of commercial art. Looks up old artist friends. Visits galleries. Stretches canvas. Pushes paint around. Wife discovers talent for landscape design. Cries Halleluja! Another income is born. |

3. Philadelphia painter; picture titled "Suicide in Costume."

4. Illustrator, painter, friend.

5. Painting prize of $1,000 from Chicago Art Institute. Reinhardt had always disparaged competitions and prize money as demeaning to the artist. Exchange of letters on the subject published in *Art in America,* November/December 1971.

1963   Builds studio. Dumps commercial work. Blasts Reinhardt for accepting prize from Chicago Art Institute.[5] Lively correspondence ensues. Abandons easel painting. Makes a dozen big constructions from cigar molds. Paints them white. Rose Fried visits studio. Sets date for first one-man show. Fame and fortune beckon.

1964   One-man show opens in October. Will and Elena Barnet give party. Nice reviews in press. Sales abound. Dealer smiles. Back to drawing board.

1965   Granddaughter Heidi is born.

1966   Second show opens at Fried Gallery. Travels to Madrid and Paris to refuel. Spirits soar. Visits Stockholm. Sketches rivet pattern on SAS wing. Invests in power tools. Visiting artist at Pratt Institute. Argues at Artists' Club with Golub, Meadmore, Hendler, and Reinhardt. Loses argument. Called "new talent" by *Art in America.* Included in "Highlights of the Art Season" by Aldrich Museum. Wonders about all that.

1967   Develops modular vocabulary. Learns moldmaking and casting techniques. Begins work on Plexiglas Series. Granddaughter Sybil born. Likewise grandson Colin. Bumper crop.

1968   Shows Plexiglas Series at Fried Gallery. Commissioned by J. Walter Thompson Co. to produce edition of three-hundred identical box sculptures. Ponders mindboggling assignment. Greed prevails. Executes commission.

1969   Invited by University of Minnesota, Duluth, to be summer artist in residence. Accepts. Has first retrospective at Tweed Museum at UMD.

1970   Travels in Morocco. Happy time. Sketches cliff dwellings on road to Casablanca. Buys great rugs in Marrakesh. Invited for repeat engagement at University of Minnesota. Teaches painting and sculpture workshop. Shows series of relief paintings in New York.

1971   Travels to West Coast for Los Angeles show. First trip to California. *Art in America* publishes Reinhardt correspondence. Chuckling is heard.

1972   Expands modular vocabulary. Experiments with new materials. Reads up on hazards involved. Installs exhaust system in workshop. *Art in America* publishes memoir on WPA experience.

1973   Reviews Whitney Biennial for *Art in America.* Piece rejected as too negative. Politics' ugly head or lousy syntax? Teaches evening course at State University of New York-College at Purchase. Likes the role. Travels in Italy. Sees Rome, Florence, Venice, Milan. Head swims.

1974   Lectures at University of Minnesota in Minneapolis. Crits painting and sculpture students. Spends time at Walker Art Center. Gets idea for new casting technique. Will call it "blind casting." Asked to join full-time faculty at SUNY-Purchase. Agrees.

| 1975 | Appointed acting dean of Visual Arts Division at SUNY-Purchase. Heads search committee for replacement. Shows gray and white relief paintings in New York. Ponders getting rid of color entirely. Risky business. |
|------|---|
| 1976 | Lectures at Neuberger Museum, SUNY-Purchase. Gains tenured faculty position. Awarded SUNY Faculty Research Fellowship to explore "blind casting" technique. Takes part in panel discussion in Westport art gallery. Topic: "How and Why to Collect Art." Tells them how and why. Travels to Lausanne, Geneva, Zurich. Winds up in Munich. |
| 1977 | Shows two-dozen white plaster reliefs in New York. Reception mixed. Rethinks color drain. Sulks a bit. |
| 1978 | Begins first series of collages. Resurrects color. Lectures at Southern Connecticut State and Silvermine Guild. Joins panel at latter on collage technique. Shows twenty-five years of work at Neuberger Museum. All together for first time. Spirits soar. |
| 1979 | Appointed full professor at SUNY-Purchase. Makes big wall sculpture for fancy hotel in Saudi Arabia. Judges Pennsylvania show with Gwathmey and Marsicano.[6] Recalls "Judge not, that ye be not judged," *Matthew* 7:1. Hands out money as penance. |
| 1980 | Starts work on Portal Series. |
| 1981 | Takes sabbatical leave from SUNY-Purchase. Hunkers down in studio. |
| 1982 | Shows Portal Series in New York. Reception positive. Works with clay all summer. Low relief imagery joins modular vocabulary. Façade and Reliquary Series emerges. Travels to Granada, Seville, Cordoba, Barcelona. Photographs mosques, churches, doorways, architectural grillwork along the way. Christmas Eve in Marbella. |
| 1983 | Combines wood, metal, polyester in new round of constructions. Judges show at Bruce Museum in Connecticut. Judges all-Minnesota show in Crystal Bay. Hands out money and blue ribbons in both. Serves on team to evaluate fine art and design programs at Carnegie-Mellon University. |
| 1984 | Has big show of constructions and collages in November. Prints first poster at Meriden-Steinhour. Reception on both levels upbeat. |
| 1985 | Flies to Pittsburgh for show at Carnegie-Mellon. Does crit at Yale in Phil Grausman's fine drawing class for architectural students.[7] |
| 1986 | Cuts teaching schedule at Purchase to single semester. Allows more time in studio. Books New York show for spring '87. Cranks up. |
| 1987 | Works on dark, labyrinthine, multi-level, complex, exhausting mixed media series. Shows all new work in spring exhibition. Prints second poster at Meriden-Steinhour. Lectures at Aldrich Museum. Shows both commercial and fine-art slides for first time. |
| 1988 | Three parallel disciplines explored. Resolutions: Continue the dark series. Produce a new group of collages. Develop Portal Series II. And learn some exciting new things along the way. |

6. Robert Gwathmey, painter and friend; died in fall of 1988. Nicholas Marsicano, painter, friend, and colleague at SUNY-Purchase.

7. Grausman, sculptor noted for his distillation of sculptural form.

# ABE AJAY

"My freedom thus consists in my moving about within the narrow frame that I have assigned myself for each one of my undertakings . . . my freedom will be so much the greater and more meaningful the more narrowly I limit my field of action and the more I surround myself with obstacles. Whatever diminishes constraint, diminishes strength. The more constraint one imposes, the more one frees one's self of the chains that shackle the spirit."—*Igor Stravinsky*

"Limiting the means gives the style, engenders the new form and gives an impulse to creation. . . . It is often limited means that make the charm and force of primary paintings. Extension, on the contrary, leads the arts to decadence. . . . I love the rule that corrects the emotion . . . I love the emotion that corrects the rule."—*Georges Braque*

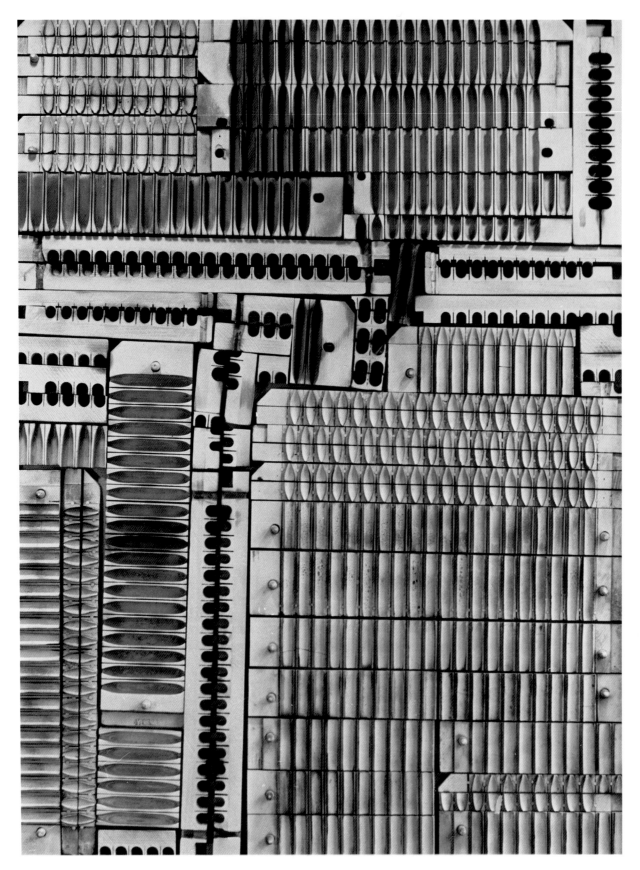

# At the Root of the Artist

ABE AJAY, SON OF ORTHODOX CHRISTIANS who emigrated from rural Syria when that country was a minion of the Ottoman Empire, speaks openly of his love for and gratitude to his family. His family, he believes, gave him a sense of pride and an obsession with responsibility; they gave much and they expected much in return. He is still attempting to honor that debt.

Retracing the years, recalling his childhood and the secure home his parents made for him and his brother and sister, he admires his parents' courage, honors their deep devotion to each other, and shares their values of hard work, honesty, and generosity toward those less fully equipped for the long run. "I can't understand," he confesses, "how anyone can *not* love their parents. For me, that would be impossible. They loved me. I love them. It's that simple."

With Moslem Turkish persecution of the Orthodox Christian population in the late nineteenth century, those Syrians fortunate enough to afford passage and hardy enough to make the journey fled to America. Abe's parents, quite unknown to each other, joined the exodus. "My father," says the artist, "came from a rocky, mountain village called the 'Meschta.' It's near Damascus but doesn't appear on any map I have ever seen. My mother's family came from the 'Muttin,' a somewhat larger village on the Mediterranean coast. My Dad was about fourteen when he arrived in this country, accompanied by a brace of older cousins. When my mother got off the boat, she was a black-stockinged four-year-old, clutching the hand of her older sister, Emma."

At the end of their long and separate journeys to Ellis Island, they would join friends and relatives who had preceded them, advance parties which had already established a beachhead or two to cushion the shock for new arrivals. The artist's father settled down in central Pennsylvania, and his mother in Hornell, New York, still oblivious of one another but destined to become the principals in an "arranged" marriage many years hence. Along the way, their names took on an American ring. Meriam became Mary; Mahfoud became William, later truncated to Bill. "My own real name, my dress-up name," Abe beams, "adds up to Ibrahim, the son of Maufoud from the house of Ajay."

Abe's maternal grandmother, Arvilla Simmons—in his judgment the original model for Women's Liberation—preceded her husband and children to this country long before travel by a woman alone was either safe or fashionable. Her formidable ambition was to send for her family, one by one, as she earned the money for their passage. A powerful woman, with enormous energy and an iron will, she succeeded, working as an itinerant peddler of handmade lace, shoestrings, and various household sundries in a persistent campaign to reach that goal. In time, Julia, Anna, James, Emma, and Mary all were transported, with her husband escorting the final contingent.

9. Construction 202, 1963
Cigar molds, 48″ × 36″ × 2½″. This work, one of the first in which Ajay used cigar molds, no longer exists. It was cannibalized, cut with power tools into sections so that its materials could be incorporated into other constructions.

The family settled in upstate New York, a few in Hornell, to begin with, but all would later establish deep and permanent roots in Ithaca, for reasons of marriage or employment. The artist has no memory of his paternal grandparents, since only his father and his father's younger brother made the transition to America.

In 1916, through the good offices of friends doubling as matchmakers, Mary Simmons and William Ajay met and married. "My Dad," Abe muses, "had settled in Altoona, for reasons that confound me, and opened a store that trafficked shamelessly in banana splits and penny candy." In November 1916, the birth of a first son, David, converted the couple into a family. The census rose perceptibly with the advent of a second son, Abe, on March 24, 1919, swelling into a modest crowd some few years later with the arrival of daughter Helen.

Altoona, Pennsylvania, the artist, recalls, "was owned lock, stock, and barrel by the Pennsylvania Railroad Company, a belching monster which could turn a pristine, white snowfall into black velvet before the morning work whistle blew. But it was home, however begrimed, and I had yet to ponder an alternative."

As a youngster, Abe escaped many a soot-laden Altoona summer by visiting, along with his mother, brother, and sister, his Ithaca relatives on the shores of Lake Cayuga. Abe reminisces that "basking in the generosity of that host of aunts, uncles, and cousins, we seemed less a family than a tribe. The camping trips, softball games, ten-cent movies, and picnics at Buttermilk Falls were only a few of the goodies. It wasn't until years later that I realized what a strain we must have been on the taught nerves and tight budgets of the Abbotts and Sheheens upon whom we descended, not quite like wolves on the fold, perhaps, but with appetites, at the very least, of voracious lambs."

Early in his childhood, however, Abe got down to the business of art. "The first drawing of my career was made in my father's candy store. I liked working with pencil on the cardboard inserts that came between layers of penny candy, probably because the smears and smudges of chocolate gave me a fair start on a picture. I remember making portraits of Charles Lindbergh, which would place the work around 1927, and many drawings of racing cars, World War I biplanes, and my film hero of that time, Tom Mix. All red-blooded American subject matter. No sissy still lifes or landscapes and, I am certain, no preoccupation with line-weight, contour, tonality, or color, excepting that of milk chocolate. Let any nine-year-old loose in a sugar-coated studio and you don't necessarily wind up with Monet at Giverny. Right?"

But Abe was not an ordinary nine-year-old boy. Harboring a grown-up graphic appetite in a child's body stirred up a keen need to draw, and in doing so, to dream worlds of fantasy into the reality of line and shape. Drawing was then, and was ever to be for this artist, an enactment of responsibility, an objectification of ethical behavior. He needed, however, to see beyond his biplanes and cowboys, his own linear strolls through imagined reality: he needed to see *art*.

"My initial encounter with serious art took place, like all good marriages, in church. I was a twelve-year-old altar boy in Altoona's Syrian Orthodox parish when I got my first look at a hand-painted picture. The works were oil portraits of Christ and his twelve disciples, complete with gold-leaf halos and Cyrillic identification; all copies of ancient

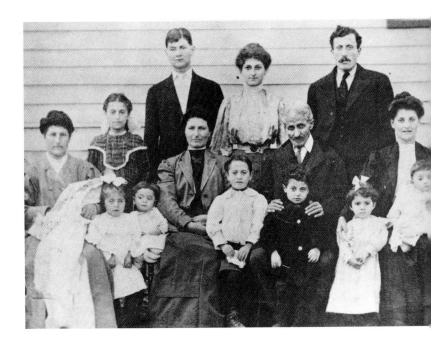

Ajay's mother, Mary Simmons (*in braids, second row*) and his maternal aunts, uncles, and cousins, photographed in Hornell, New York, 1906.

icons and the fruit of a moonlighting commission to a local sign painter. Transported by both the imagery and the technique, I would sit for hours transfixed by the pictures, and pray for the day when I might own the skill to match the performance."

Abe confesses that his first thinking about art as a profession was blatantly romantic. Books like Van Gogh's letters to his brother Theo and Maugham's *The Moon and Sixpence* "made it seem like a good way to go." Also, those summer layovers in Ithaca had yielded a role model of sorts in an older cousin, a graduate student of Cornell's art and architecture program and an outspoken critic of just about every bone in the body politic. The connection, however tenuous, proved doubly prophetic; it stimulated a serious interest in art as a career, and sparked an adolescent but receptive social conscience that would ease his way into the New York art world nearly a decade later.

Abe speaks of father, family, and the early days slowly, deliberately, carefully peeling away layers of imagery and recollection. "I am still profoundly moved by a very early memory of my father. On a day when store business was conveniently sluggish, I recall him standing proudly erect, the perpetual white apron lashed to his waist, reciting with some difficulty the Pledge of Allegiance, first in Arabic, then in English. Under the guidance of an uncle who was more fluent in the latter, he repeated the words over and over again until he had it right. It seemed Dad was preparing for a trip to the local courthouse and a final test for his citizenship papers. I think I cried that morning.

"One evening, when I was about eight or nine years old, I recall a group of local toughs kicking open the front door of my father's store, tossing in a dead rat and shouting, 'You dirty Greek, you dirty Greek.' Outnumbered and frightened, I gave feeble chase, and they vanished into the night up the nearest alley."

Not his first, or final, encounter with adolescent bigotry, it reinforced young Abe's feeling of difference, of being set apart, a feeling which tugged him not so gently toward the outsider's station. He watched life among his peers, joined in their games at will, but returned always to the watcher's post. "So I simply bypassed a lot of the early stuff, I guess. Maybe I lost out on a chunk of teenage experience by growing up too soon, but I learned important things about myself in the process."

While hard times cast a pall of gloom over life in the early thirties, not everyone was hawking apples on a wintry street corner. The close-knit Ajay family thrived, as most immigrant families do, on hard work and mutually supportive alliances within the ethnic community. "Our family suffered less than most," Abe observes, "since promoting cavities in the sweet tooth of a working class public proved not without profit, seeing us through the bleakest days of the Great Depression with something, if only a dish of lentils, on the table."

But the chill of bank holidays and soup kitchens didn't spare the Ajay ménage entirely. "We lost the house and the apartments across the way, and business dropped off to a trickle," says Abe, ruefully, "but we never really went hungry. Middle Eastern cuisine, with a mother's skillful intervention, could stretch a legacy of lamb to infinity."

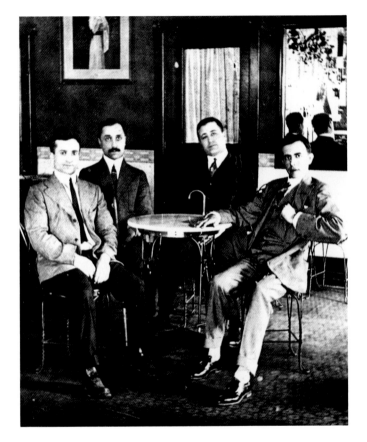

William Ajay, the artist's father, in his confectionary store in Altoona, Pennsylvania, c. 1906. *Left to right:* William Ajay, proprietor; Abd El Maseh, publisher; Albert Ajay; and John Ajay.

Recalling another Depression experience, the artist manages a wry smile and recounts: "In grade school we were conned into depositing fifty cents a week into something billed as a 'Thrift Plan,' promoted by a local bank called the Lincoln Trust Company. In 1932, just as I had squirreled away a fat hundred bucks, banks began folding right and left all over the damned country. My financial empire hit the fan. I felt betrayed, as much by 'Honest Abe' Lincoln as by the fifth-grade teacher who had passed the collection plate."

Eyes glistening with memory, Abe recalls his father, time and time again. "My father was a wonderful man. By nature shrewd, deeply sentimental, generous to a fault with both family and friends, he remained unswervingly loyal to his immigrant roots and religion. What he lacked in intellectual curiosity, he more than repaid in his sense of parental responsibility. His ethical drive translated into long, sixteen-hour days in what we called 'the store,' a tradition I have carried on with reasonable success in what I call 'the studio.'

"I remember feeling especially protective of my father, always, perhaps because he was never at ease with the language and customs of the world around him. I was less vulnerable, therefore, and thus the strong one because of at least a beginning education. I was armored, he wasn't. But he owned the best head for business in the family. When Prohibition was repealed after Roosevelt's election in 1932, Dad transformed the ice cream parlor into Ajay's Bar and Grill, shrewdly guessing that there might be more profit in distilled alcohol than in refined sugar. He wasn't wrong. For me, blowing the foam off a frosted stein of Iron City lager was a lot more fun than serving up cherry cokes to the parasol trade. And when a tipsy customer grew rowdy or abusive, I doubled as a 'bouncer,' flexing the one or two muscles I could claim at the time. I recall some ridiculous confrontations in the service of law and order."

"Rewinding the memory tape is a delicate business," says the artist, as he vaults some sixty years backward in time. "The temptation to edit is overwhelming and the need to clean up one's own act is hard as hell to resist. I think I was a very responsible son in those days, hard working and highly appreciated by both parents, without being at all 'understood.' When I helped my father in the store, scrubbed a floor, fixed a light-switch, or painted an upstairs bedroom, that was comprehensible and applauded. When I turned an attic room into a studio or walked off into the woods with a book, the circuit was broken. I might as easily have just flown in from Mars."

Asked why his formal education had stopped at the water's edge, in high school, Abe ponders a moment and responds, wistfully, "I like to answer that one by invoking the Great Depression, but that may be just a romantic dodge. The truth is that the word 'college' was not a familiar one in the family lexicon, not because of any pressing economic exigency, but simply because the world of ideas was seldom explored in our household. Books were not familiar objects, except for the Book of Knowledge encyclopedia, which was presumed to answer all questions, except the one, 'where do ideas come from, Mom?' I grew up quite a distance believing the stork brought them."

Of his mother, the artist offers the following sketch: "A hale and hearty ninety-two (in 1988), my mother moves with all the pert energy of a sandpiper on a beachcombing expedition. Still a beautiful woman, her clear mind and flawless complexion are the

envy of her few remaining contemporaries. Her present good health, however, belies her medical history, one fairly riddled with surgical procedures and medical crises, several of which brought me running to her bedside. And she has survived a thousand emotional traumas in her time, for a number of which I must claim dubious credit.

"But that's all behind us now, and we share a bond that is mutual and constant, with a deep well of tenderness on my part which I find hard to describe. I would walk on hot coals for the lady, and she for me. Of that I am certain. Looking back, I think that a great many of those seemingly selfless performances during my childhood were simply bids to earn that 'pat on the head,' that tactile confirmation of virtue acknowledged, that comforting assurance that I was a 'good boy.' I wanted a shot at the title, and won it handily without working up a sweat. And now, some half of a century later, I find myself still jockeying for position, still soliciting approval, getting it and going back for more. It keeps me on my toes.

"We do have our differences. She thinks I'm too angry, too impatient, too intolerant, while I consider her not angry enough and far too tolerant of fools, knaves, and whippersnappers. Once, served an inedible filet of sole in a restaurant (she should have ordered the whippersnapper), she cautioned, 'Now let's not be critical. It isn't the fish's fault.' Clearly a saintly forbearance which this son failed to inherit."

Unravelling another strand in the maternal bond, Abe chuckles. "She doesn't understand my work or my jokes, and at times, I suspect, considers them interchangeable. That matters not at all. We're close knit in other, more accessible, ways. I know not what, if anything, I learned at my mother's knee, but I learned something of vital importance at her elbow. How to cook up a rather credible Middle Eastern dinner."

Asked how he might describe his relationship with his brother and sister, Abe pauses a moment and responds. "Discounting the normal quotient of sibling rivalry, Dave, Helen, and I loved one another deep down and still do, with no measurable excess of understanding. I think it sufficient now that I understand myself, a contract which I am even now negotiating. I live in a different world, both in my head and beyond and I speak a different 'language.' I don't fault them for having traveled another road, for not sharing my peculiarities. But I can't help wondering at times just how and why I took off on such a different tangent. Why such a hybrid? The genetic sore thumb. Why the enormous cultural gap between me and the rest of my family. I ate the same food. I slept under the same roof. I went to the same church, the same schools. Somewhere along the line the train switched tracks, and I'd be lying in my teeth if I didn't thank whatever gods there be that I was aboard."

As his metaphorical train pulled out of the station, Abe hit on a number of schemes to stoke the engine. He wanted to become an artist, of that he was certain, but it would be three years before he graduated from high school. He would put a little flesh on the fantasy in the meantime.

"I wanted all the things I had read and dreamed about. I wanted New York, I wanted Paris. . . . I would imagine stretching a canvas, and the smells of linseed oil and turpentine, and it seemed then that all of these things were important. I set up an attic studio in Altoona, just to get the feel of it, scribbled 'My Country Is the World, To Do Good Is My Religion'—*Thomas Paine,* on the wall to keep me company, and used that space for over a year before I made the real break.

"And I began to paint."

Pausing as a frown melts into a grin, Abe adds, "But I don't think I painted very well. Then I did charcoal portraits of my six-year-old cousin, Billy. He was my first model. A very beautiful face. One that Franz Hals would have liked a lot. And then I began to work in oils, turning out some remarkably uninformed still lifes and landscapes. I wish I had kept some of those pictures. I'm curious about them.

"In 1935, I was safely past puberty and inching slowly toward the shoals of adolescence, when I began to realize that there was a hell of a lot I needed to learn about becoming an artist. I knew, through reading books and looking at pictures, that art had a history, but I was hungry to see what was being done in the here and now, by real people in my own time. I was sixteen years old. The clock was ticking. I wanted some answers.

"So I took a train to Pittsburgh to see that year's Carnegie International, combining my first trip alone on a railroad with my first look at a genuine art exhibition. Here were works by artists from all over the world, some celebrated and some unknown, but all alive and working at the trade I hoped one day would be mine. If memory serves, Franklin Watkins won the main prize that year with a fairly weak-kneed, theatrical still life. But, more than the pictures, I recall the heady atmosphere in that great exhibition hall; the rococo frames with their gingerbread detail, the sweet smell of canvas and linseed oil and turpentine, the glint of copal varnish, recently applied. I was captivated. Luxuriating in the aroma of high art, I took a deep breath, fancied myself a professional, and caught the next train back to Altoona."

An accomplished student and forever a quick study, Abe moved easily through what appears to have been, for its time, an enlightened educational system. During his high school years, he was part of an experimental program designed and monitored by the Carnegie Foundation, a gesture toward what would later be dubbed "progressive" education. He made few friends among his classmates, but developed a close and significant friendship with Robert Patrick, his high-school history teacher. "Patrick opened some exciting intellectual doors for me," declares the artist. "He was an iconoclastic, card-carrying cynic who taught me a lot about poetry and prose, engaged me in hours of abstract discourse, and flattered me no end by treating me as an equal." They were later to depart for New York together, on the same day and in the same automobile, but on totally separate missions.

Abe's gravitation toward friendships with older, more accomplished role models would overlap into his professional life. Only as mortality took its relentless toll would that generation gap be gradually diminished.

Working alone in his attic studio, getting the feel of the garret, Abe planted his feet firmly on the road to art as a career. He often talks about "professional artists," about *being* professional and what it means to be a "pro," as he terms it. While still a teenager, he determined that being a pro meant selling and showing one's work. A by-product of his political enlightenment in Ithaca had been a subscription to the *New Masses,* a radical journal of some considerable literary and graphic reputation. Venturing a shot in the dark, Abe submitted several drawings to the magazine, addressed to their New York office. A fortnight later, he was astonished and delighted to receive a note in the mail announcing their acceptance. "Oh, happy day!" he remembers, "and I was in good company, without a doubt." Among the writers they published were Ernest Hemingway and Archibald Macleish, and the artists included Raphael Soyer, Will Barnet, Ad Reinhardt, and Rockwell Kent, among a host of others. They would become his colleagues when he made the jump to New York in 1937.

By the time his junior year in high school rolled around, Abe had become a regular contributor to the magazine. In due time, he was invited by Crockett Johnson, the *New Masses* art director, to come to town for lunch with the editorial staff. A five-dollar bill was enclosed to cover the bus fare. The newly anointed "professional" artist added a dollar to that and grabbed a Pullman for Penn Station. "Goya," he decided, "would have done no less."

"I recall we had lunch at a joint called Sloppy Joe's, just off Lex on Twenty-seventh Street, and I had a wonderful time. I was piped aboard with some good talk and generous fanfare, and left town in a warm glow of contentment, due not entirely to the rye and soda I had downed at the table. I had met some damned good people, a number of whom went on to fight in Spain with the Abraham Lincoln Brigade, the year being 1936.

"The following year, I graduated from Altoona High School. Elected to a scholastic puddle called the National Honor Society, I refused induction on the grounds that they hadn't taken a stand on the Spanish Civil War. My quixotic gesture fell flat as a cold souffle. Three friends raised one eyebrow; city folk yawned in my face; small children crossed the street when I approached. Miffed and despondent, I fled to the Big Town two months later. Somewhere, somehow, at sometime, I determined, attention would be paid. The battle, some fifty years later, is just warming up."

# New York, Art School, WPA: 1937–45

I N *1937*, after graduating from high school and fortified with scholarships to the Art Student's League and the American Artists' School, Abe and his good friend, Robert Patrick, departed Altoona in the general direction of New York City. They drove off in Patrick's 1936 Model A Ford, loaded to the gills with clothing, books, personal hardware, and a lavish lunch packed by Abe's soon-to-be-desolate mother. Her second son was on his way to seek his fame and fortune. Patrick had left his high-school teaching post to pursue his doctorate at Columbia Teacher's College. Of the departure, Abe recalls, "One poignant image springs to mind, that of my mother and father clutching each other and weeping as I drove away that sunny September morning. I wept, too, for the first twenty miles."

The following day, Abe rented a room for three dollars a week next to the Armory on East Thirty-fourth Street. He was, he admits, "excited and not a little frightened but filled with wonder as to what my next move should be."

He recounts the initial adventure: "It was a rainy Sunday and all the colors were a middle gray. I had in tow a battered steamer trunk, a peculiar looking Philco radio, and a bankroll of three hundred dollars, cash money, which I hoped would last till the following spring. The trunk, I soon discovered, was only two inches smaller than the three-dollar room and the funny Philco burned out the moment I plugged it into the wall. I knew nothing about direct versus alternating currents. My building was wired with the former. In addition, the joint was crawling with mammoth, roachlike waterbugs, promoting a fresh choreography on each trek to the bathroom, a facility which seemed like a mile down the hall and possessed of nothing resembling a shower. No Taj Mahal, this, I thought. Assuming a few flaws in the landlord's security system as well, I stashed my nest egg under the mattress that night for safekeeping and went to sleep. I would find a trustworthy repository in the morning. Perhaps even a bank."

Abe's talent and ambition were not inhibited by his naiveté, however, and he had begun to pursue a career as a professional artist. Even now Abe speaks often of *professional* artists, either implying or actually making a distinction between such favored beings and "hacks," or, more recently, as the activities of American artists seem often determined by dealers and by the media, "careerists." At an early age, his drawings had won him an audience in New York among older artists; he arrived in town as the new prodigy on the art block and, by his own reckoning, was well on his way to becoming an artist in his own right. Success looked certain when, still in his teens, he was invited to speak to the Artists' Union in Philadelphia, was given an honorarium of ten dollars and train fare to sweeten the pie.

"Not long after I settled into my digs on Thirty-fourth Street, I was invited by Nick Marsicano, then president of the Artists' Union in Philadelphia, to travel down and give a speech to their members, assuring me of a ten-dollar honorarium, train fare to the city, and a free dinner after the talk. I would be the guest, it seemed, of Mr. and Mrs. Robert Gwathmey. He was a painter whose work was very familiar to me, so it appeared to be a perfectly legitimate hegira, awaiting only my acceptance of the terms. I was not very old, eighteen would be stretching it a bit, and had never before addressed an audience larger than my mother and father, but I agreed to do it. Fear does not always triumph over flattery, I am pleased to report, so I took the train to Philadelphia and my maiden lecture, a word which honors the evening's performance extravagantly. I can't possibly remember what I talked about but I do recall a smattering of polite applause at the end, a sort of sitting ovation, one might say, with only my dinner hostess, Rosalie Gwathmey coming up to grasp me by the hand. There was no congratulatory feel to the handshake, much to my chagrin, but it sufficed to move me out of the hall, into a taxicab and on to the Gwathmey abode for dinner.

"Bob Gwathmey was not present at dinner, for some reason I can't recall. So Rosalie and I dined alone, the table illuminated by a strange glow called candle light. It was a new experience for me, as was the chilled consommé, which I assumed was simply Jello without the usual bananas. I began to miss my mother's cooking and the klieg-lighted ambience of her Altoona diningroom. I was dumb, oh so dumb.

"I became good and true friends with both Gwathmeys and their young son, Charles, later in New York. I saw a lot of them at their apartment at One West Sixty-eighth Street, with frequent side trips to Barney Josephson's downtown bistros and the Village Vanguard, imbibing both juice and jazz. I was a great fan of Rosalie's culinary ability, and would grab every opportunity, however transparent, to drop by just before dinner. I remember an incredibly edible, whole-baked shad that was totally out of this world. That would go back to maybe 1940. Bob was a legendary raconteur, with a talent for embroidering a down-south joke to within an inch of its life. Fun, we had, and a lot of it. Most often with Fats Waller as a back-up.

"Gwathmey had a connection with the ACA Gallery, then on East Fifty-seventh Street, and introduced me to just about all the artists in their stable, including Phil Evergood, Raphael and Moses Soyer, Doris Lee, and, of course, Herman Baron, the gallery owner. The year was 1938, and Baron held a competition each season for a one-man show by a new talent who had never exhibited solo before. Gwathmey and I both entered the race that year, Bob with a typical painting of oppressed, downtrodden sharecroppers picking cotton under a blazing sun; I with a Romanesque head of Christ, sans even a crown of thorns. Gwathmey won the competition, hands down, and I came in second. Bob had his first one-man show the following season."

When Abe left Altoona, Pennsylvania, for New York City, he expected to acquire the *bona fides* of a professional artist through study at art school. "I had arrived in town with two scholarships, one to 'the venerable Art Student's League and the other to the American Artists' School, on Fourteenth Street. Both had been awarded me by faculty who were familiar with my published work, providing yet another dividend for this young acolyte. I remember feeling not quite comfortable at the League because of what seemed more lunchroom than classroom activity, although I was not unhappy with Harry Sternberg's class on Orozco and the other Mexican muralists. Accordingly, I trailed off at the League after about a month of desultory fiddling and concentrated on the American Artists' School program. I felt much more at home on Fourteenth Street. Here, in a life class, I met Ad Reinhardt, beginning a friendship which flourished until his death thirty years later. Among the faculty were Anton Refregier, all of the Soyer brothers, Sol Wilson, Max Weber, Adolph Dehn, Robert Cronbach, and a host of others who were there less for the pittance it paid than for the love of teaching."

Even in the august company of such teachers and their eager students, Abe found art school at first slightly dispiriting and, as days dragged by, he was increasingly disappointed in the experience. He describes his reluctance to confine his energies and ambitions to art schools. "There was a sizeable gap between what I imagined and the reality I plugged into. Most of my images had come from extensive catalog browsing, feeding the notion that there wasn't a hell of a lot of serious work involved, just a short round of fun and games and then you walk out of the picture looking and sounding like Ronald Coleman in *The Light that Failed.* But with twenty-twenty vision.

"Looking back, I doubt that I learned much at either school during my brief masquerade as a student, although one drawing teacher did open my eyes a bit by insisting that I draw the figure from the feet up instead of the other way round. That was an interesting idea, and punctured a clichéd approach to the figure, but not much else. I learned a lot more by hanging out with working artists whose studios were generously open to me and by haunting museums with those same artists after the day's work was done. I discovered the work of Goya, Daumier, Rouault, and Klee, falling into particular love with the latter two. There were few commercial galleries at the time, except for Edith Halpert's Downtown Gallery and a couple of others, so the museums were my main source of education. I could not have done better."

If the young artist found art schools a poor source of companionship and an inadequate stage for playing out his life-of-an-artist fantasy, he found both companionship and informal but intense mentoring in New York's artist community. There were the artists and publishers who first recognized talent in his drawings and, too, Abe met other artists who became lifelong friends. Friends, for him, would always be teachers as well: friends, knowingly or otherwise, bring gifts of information, insight, political heat, or personal drama; and as they peel from themselves a layer of their experiences and perceptions, Abe collects those fine films and lays them onto life's collage. This truth from this friend, that truth from that friend; these jagged edges laid against these sharp and clear definitions—Abe collects and considers the reports his friends bring in from the outposts of living. He reflects, edits, tinkers: someday, he tells himself, he'll get it right. The quest for that rightness and the habits it engendered began in the early days in New York.

Abe Ajay, Betty Ajay, and Robert
Gwathmey at the opening of an exhibition
of works by Ad Reinhardt at the Betty
Parsons Gallery, New York, 1947–48
season.

"I was far from lonely, having forged some warm and valuable friendships during my few months in town. Many of them would last a lifetime. In addition to Ad Reinhardt, whom I met early on, I developed close, personal ties with Will Barnet, Robert Gwathmey, and John Groth, all of whom were inordinately generous with time and space and professional counsel. I was the new kid on the block, somewhat younger and more than a little naive in matters of career development, while they were already accomplished practitioners, producing, exhibiting, and occasionally selling their work. If I wasn't careful, I could learn a lot."

In the future, Ajay and Reinhardt would cross verbal swords in many a mock battle, sharpening one another's wits on a whetstone of jokes, quips, and pseudo-insults, hurled back and forth via the U.S. Mails. The artist recalls his friend.

"Ad Reinhardt was a well-muscled bear of a man and a walking abstraction. Moody, preoccupied, often withdrawn, he lived in a walk-up studio on Gansevoort Street, smack in the middle of a meat-packing slum. He struck a brotherly chord in me right from the start. We talked about Mondrian and politics and nonsense, in both conversation and extended correspondence (no expletives deleted) often to the consternation of friends, wives, and mistresses who were privy to the exchange. Some of this postal jousting was published in the magazine *Art in America* (Nov./Dec. 1971). Later, we were to gain check-by-jowl employment on the WPA Federal Art Project, the newspaper *PM,* and a number of publishing and advertising ventures from which we tossed one another an occasional freelance plum. His most memorable largess in my direction was a subway car-card assignment touting a 'Luvable Brassiere.' I wrote him a thank-you note averring that 'my A-cup overfloweth.' "

Another artist who would influence and encourage Abe was Will Barnet. "I first met Will Barnet at the Art Student's League, where he worked as master-printer in their graphics department. In his soft Boston accent, he invited me to dinner one evening and I got my first look at his studio on West Fifty-sixth Street. I had known his lithos and etchings before but hadn't suspected that he was a powerful painter as well. I felt a connection immediately. Many of his formal concerns matched mine: space, line, texture, and tonality, all of them elements I had been struggling with during my short, searching time as an artist. But Will had already handled some of the tough ones with moves that seemed confident and assured. I envied that patina. It was professionalism on the hoof. Will was always more than generous in evaluating my work, dwelling on the successes and playing down the failures. I arranged for him to pull proofs of the things I did for the Project long before I handed in the assignment to my supervisor. I valued his critiques. Friend and teacher became one and the same. I think the profit was all mine. He and his lovely wife, Elena, gave me my first post-opening party after my 1964 debut at the Rose Fried Gallery."

John Groth, an artist-about-town in New York in the thirties, added measurably to young Abe's map of the universe. An artist of the old school—whether turning out money-making commercial work or slaving all night over a painting—Groth honored craftsmanship, talked passionately about the need for an artist to draw, to connect eye and hand in a lifelong marriage that would be both intimate and contentious, both giving and demanding.

"I can't recall precisely where and how I first met John Groth, another key figure in my early New York experience. He had only recently come to the city from Chicago, where he had been the first art editor of *Esquire Magazine,* but I knew his work very well. *Esquire* was an exciting new publication in 1937 and had even graced a newsstand or two in Altoona long before I pulled up stakes and departed. John was delightful. More than a bit of a dandy, he looked for all the world like a proper English gentleman, complete with homburg, suede gloves, and shooting-stick, and he lived in an elegant townhouse studio at One West Forty-seventh Street. He had just been divorced from a White Russian princess named Alexandra, and was paying her fifty-five dollars a week in alimony. I was impressed.

"We spent a lot of time together, in and out of his studio. John made his living by juggling a myriad of freelance accounts, turning out cartoons and illustrations by the dozen for both editorial and advertising assignments, and I was fascinated by his performance. For every one item to be reproduced, he would provide fifty, and day's end would see his studio literally plastered with alternative gems, all equally publishable.

"Tandem to Groth's commercial activities, there ran a deep interest in the so-called 'fine' arts. He was an accomplished painter and printmaker, laboring in the tradition, or so he thought, of Goya, Delacroix, Daumier, and Forain. A Romantic to the core, his subject matter abounded in bullfights, sporting events, and war scenes; anything, I suppose, that would give him a chance to use his favorite color, cadmium red medium. Some of his finest work was done in the role of artist-as-reporter during World War II, when he became the first American war correspondent to enter Paris after the Nazis surrendered the city in 1944.

"I loved John. He was very kind to me and took me along while he delivered jobs just finished, or picked up new work, and I got to know the ropes: the do's and don'ts of the commercial game, and above all, how to meet a deadline. It came in handy not many years ahead, when the Project folded. We did a hell of a lot of walking, often through Central Park at midnight, talking about color and girls and politics and sometimes about the rats that scurried out of the shadows when we passed the zoo. And we spent long hours in museums, discovering new things about Goya or Rubens or Velásquez, and later Picasso. We pored over books and portfolios in his studio, making connections between Gustave Doré and Daumier and Forain. We would get excited. Later we would go to Cuba together, in 1947, and spend a drunken day with Ernest Hemingway. John had met him as a correspondent in Paris at the end of the war and they had become friends. We had lunch at Hemingway's finca, near Havana, breaking bread with Papa and a defrocked Spanish priest who had been exiled by Franco some years before. The wine flowed like wine that day, and we all ended up at dusk, arms around each other for support, singing the Internationale. It was nothing if not romantic."

Accompanying Groth on the rounds of his commercial accounts spawned an immediate dividend. Abe was introduced to Jack Shuttleworth, art director of the old *Judge* magazine, a precursor of the *New Yorker,* and was given his first freelance assignment. He was to attend a preview of the movie *Tom Sawyer* at Radio City Music Hall and come up with a drawing of the heroine, Becky Sharpe. "It was my first shot at the 'Big Time,'" Abe recalls, "and I was a bit nervous. I'd been published before, in the *New Masses,* but never in what you'd call a respectable publication. To my surprise, the

drawing appeared in print the following week, followed shortly by a check for the magnificent sum of fifteen dollars, not to be sneezed at in those days of the ten-cent beer and the five-cent subway ride. I took John to lunch at McSorley's wonderful saloon."

Abe continued to supply drawings to the *New Masses,* an effort which did little for his bank account but much for his general education and for his self-esteem as an artist. "The magazine didn't pay anything, alas, but they kept an elaborate set of books, carefully crediting each artist contributor with the sum of two dollars per drawing," Abe remembers. "Years later, during an afternoon of economic distress, I approached the editors for a few bucks on account and was told, 'Sorry, boychick, we're broke, too, but we do happen to have two tickets to the Ballet Russe. Tonight's performance.' I took them. The *New Masses* was, for years, the beneficiary of many a prime cultural event of its time. Among them was the famous Benny Goodman 'From Spirituals to Swing' concert at Carnegie Hall in 1938. A landmark in jazz history."

In the springtime of 1938, Abe met Margaret Thomas. All of nineteen, he had grown an assertive mustache two months earlier and, as he puts it, "felt thoroughly equipped for a serious dalliance with an older woman. I proceeded to court the lady shamelessly, like any ordinary grown-up, and so one thing led to another, nature taking its inexorable course, and we were married before the spring leafed into summer.

"It proved not the wisest of calculations, for we were divorced some eight years later, sadder and wiser for the experience but richer for the parenting of two fine sons, Alexander and Stephen, in that order. We had lived, meanwhile, in a brownstone apartment in Yorkville, in upper Manhattan, except for a minor digression to Queens in 1940. These were productive years, however disjointed in a career sense, and I have some important recollections to record.

"In early 1939, in desperate need of a steady income, I applied for employment on the Federal Art Project. I was accepted with little delay and went to work within a day or two for the Graphics Section, under the supervision of Lynd Ward. I was ecstatic, feeling now an integral part of the New York art scene, if only because the Project *was* that scene, and vice versa.[1]

"The Federal Art Project quite naturally spawned the Artists' Union, a bargaining unit to which most of the Works Progress Administration artists belonged. Rockwell Kent was its president when I joined, and I grew to admire him enormously for his clear sense of principle and his oratorical skill. He was succeeded by Philip Evergood, a marvelous painter, who brought to the office his own brand of stentorian passion; a booming, blasting excoriation of anti-union chicanery and Congressional double-dealing, earning one standing ovation after another from his audience. I sat mesmerized, entranced, feeling mighty proud of the fresh union card in my breast pocket and more than ever like a part of the professional community. The transit from small town to big city had been made. I was an artist, or so I thought.

1. See Appendix 1 for Ajay's article on the WPA.

"No amount of union fervor, however, could keep the Project alive in the face of Congress's cultural myopia. Little by little, the program was nibbled away and the rolls trimmed, the terminal axe swinging closer to home each day. The handwriting, if not yet on the wall, was being penciled in and I knew that my commitment to the 'fine' arts would have to be modified once the Project folded. I had a wife and one child at the time. I had to put bread on the table."

Abe had watched John Groth earn a living through commercial art and, while his heart did not entirely belong to the venture, he set to work with, as he enjoys recounting, impish purpose.

"As luck would have it, Third Avenue from Forty-second Street to Forty-fifth Street housed a strip of back-number magazine establishments. They proved my salvation. A single day's judicious foraging yielded a sizeable portfolio of design material which I could sheepishly call my own. I extracted the best-looking layouts from the slickest magazines I could find, making quite certain that they had ceased publication at least a year before. I had heard of something called Graphic Design, and that some benighted souls actually worked at it for a living, but only if they lacked sufficient genius to be painters, and then only as a last resort. Bereft of a range of career choices, I tossed the fat in the fire and hit the street with my portfolio, fake leather and all.

"I was not without luck, that season of duplicity. Within a week, I had gained employment at the Dell Publishing Company as 'art director' of a rather prurient publication called *Film Fun*. Forty dollars a week was nearly twice what I had earned on the Project, so I didn't allow my fear of disclosure as a fraud to dampen my euphoria. The visual material I dealt with was clearly 'cheesecake,' grist for the mill of adolescent fantasy, and hardly high art, but a leg up—no levity intended—on the job market. Our main source of material seemed to be public relations handouts from the United Fruit Company, featuring upwardly nubile nymphets cavorting on a bed of grapefruit. My job was to make certain that our crew of photo-retouchers removed any visible bellybuttons, thus complying with postal regulations of the time. Pre-Pearl Harbor morality, circa 1940.

"As can be imagined, the title of 'art director' gave me an exhilarating sense of power. So I engineered the hiring of my then unemployed friend, Reinhardt, for a spot in the Dell promotion department. Ad could draw a straight line with the best of them, so I wasn't risking much with this nepotic gesture. His job, accepted with no audible bleat of enthusiasm, was to convert huge blowups of Hollywood starlets into posters for *Modern Screen*, yet another Dell publication. Reasons for our eventual departure from Dell escape me, but I would hope they were tinged with a modicum of nobility, like trying to organize a union shop. I wouldn't swear to it."

Supporting a family demanded nearly all of Abe's energies, as well as his native cunning and his rapidly developing skills in commercial art or graphic design. Of his early adventures in the unstable world of magazine publishing, the artist recounts that "my spasms of gainful employment over the next couple of years were not especially notable. A new fashion magazine, in a moment of editorial weakness, hired me as

assistant art director, only to give up the ghost six months later. Rumors that my name on the masthead hastened its demise are basically without foundation. From there I went on to a series of ill-starred periodicals with odd names like *Pic* and *Click,* all trying frantically to cash in on the new trend toward photojournalism, for which *Life* and *Look* had paved the way.

"Having been blooded on the least savory of print journalism, fate decreed me now ready, it would seem, for a more elevating job experience. It had been my good fortune to have as a friend and neighbor in Yorkville a man named Charles Martin. He was an artist/journalist of the first order and, in the early forties, a pioneer staff member of the newspaper *PM*. *PM* was a new and exciting venture in publishing, a daily newspaper that would accept no advertising, cater to no special interests, but simply tell it like it was, employing the finest reporters, artists, and photographers that money could buy.

"Through Martin's good offices, I was hired as a staff artist and went to work for the paper immediately, providing graphics, daily cartoons, and an occasional jaunt into prose, and loving every minute of it. Except for the very first day.

"That day saw me handed my first rush assignment. A long yellow sheet of copy, freshly torn from the ticker, was tossed on my desk. I was commanded to read it, extract an idea, and come up with a finished illustration in twenty minutes. The presses were waiting. I was scared but, as luck would have it, not completely undone. Zooming in on Lee Tracy in 'The Front Page' as a role model, I grasped my trembling right hand firmly with my left, lured some ink squiggles into the trap of an 'idea,' and made the deadline, with moments to spare. That travesty appeared, to my utter relief and amazement, in *PM*'s morning edition. Gadzooks: I was now a newspaper man. I had made the team.

"An ambience chaser from way back, I loved working in the huge, loftlike city room that housed *PM*'s art and editorial departments. The clatter of news-tickers and typewriters and the shouting of copyboys and reporters built an atmosphere of energy and excitement unlike any I had known before. It was a heady brew. Working in the midst of breaking news of war and peace and politics, corruption and disaster, one felt somehow enlarged, and not a little smug at having scanned history before it hit the streets. Working with me were reporters like I. F. Stone, critics like Louis Kronenberger, and totally mad photographers like Weegee, who prowled the midnight streets of Manhattan for the bizarre and bloody images the city afforded. Not a bad crew.

"I don't know how the ubiquitous and perennially hungry Reinhardt landed next to me at *PM,* but he did. I may have had something to do with it, but am not certain. In any case, he was put to work in the chart-making section, a skill at which he was more than adept, and we were overjoyed at the reunion. It was here that he began his hilarious 'How to Look at Art' series, parts of which were published in *PM* during his tenure there. I recall a session in which he concocted a devastating 'Tree of Contemporary Art' cartoon, in which he shafted anyone who had ever lifted a paintbrush, including me. I sat next to him, naming names, and chuckling all the way to the guillotine."

In recent years, attention has been directed toward the public debates and arguments, the exchanges of letters and bantering accusations, the grandiose name-calling and throwing-down-of-gauntlets between Abe and Ad. These were serious intellectual exchanges, cast in the vitriol of paradoxes that the two men had shared in the thirties and at *PM*; these remain succinct references to the issues which shape any artist.

"It needs to be said here," Abe points out, "that Reinhardt and I were never, in any sense, true adversaries. We would rush into mock battle at the drop of a mock hat, certainly, but never had a major disagreement on matters of substance such as art or politics. That is not to say that our views of art or the art world were synonymous. They were not. Ad had already established a professional beachhead as a working artist, while I had not yet come to grips with my own capabilities. He was fully formed, while I still occupied, for the moment at least, a fetal position. I had no similar quarrel with the gallery or museum world, simply because I had yet to be engaged.

"Our political views coincided beautifully, and that was a bonus. But an equally vital symbiosis occurred in our attraction to the patently absurd, toying with it in a cat-and-mouse game of shared language. His approach was surreal in its obsession as he cudgeled a concept to death. I took the more formal approach, backing off when it cried 'uncle.' In any case, we shared much the same tunnel, however dissimilar in wattage that light at the end."

The early years in New York provided the nutrients for Abe's development as a professional artist even though, at the time, he fretted that he had been pulled by circumstance away from the pure pursuit of fine art. He reflects: "Thinking back, I can't recall anything smacking of 'fine art' coming from my hand in the early forties, after the Project folded. I was hostage, above all, to the often grim exigencies of earning a family-sized income, and that took a bit of juggling. Concurrently, I felt a compelling need to move beyond the thralldom of graphic design into the more visible and appealing showcase of satirical illustration. *PM* afforded me a perfect window of opportunity in that direction, and a chance to check out both my capabilities and an audience reaction. It worked, and I began slowly to develop a comfortable graphic identity.

"That identity was exercised early on, in the service of Franklin Roosevelt's 1944 reelection campaign. Ben Shahn, a friend of long standing, and I served as de facto art directors for the CIO Political Action Committee, the driving force behind that long and contentious campaign for a fourth term. Ben produced some powerful and effective posters and billboard broadsides, while I concentrated, for the most part, on pamphlets, illustrating copy written mainly to encourage registration and propel voters to the polls on election day. I was only one of the many artists toiling in this vineyard of conviction, but we worked together warmly and well, converging in a most memorable victory binge on election eve. I was proud to be aboard."

Abe's sense of professionalism, his need for craftsmanship and precision, for meticulous completion of well-defined tasks, expanded during these years. The pressures of newspaper work required his attention and, at the same time, provided clear standards against which he could measure his achievements.

As the Second World War mobilized the country, Abe, the newspaperman, saw it "in constant, banner-headline focus; from Pearl Harbor to Guadalcanal, from D-Day to the Battle of the Bulge." From the beginning, he recalls, "I had been deferred from military service because of a wife and two children, a draft classification which clung to me until the winter of '44. I didn't argue. But as that year drew to a close, I was informed by my draft board that I could be called momentarily, and I began to set my affairs, civilian and otherwise, into some kind of order. Although Germany appeared to be near collapse, there was much talk about an invasion of Japan, and I can but assume that the Joint Chiefs of Staff, in their infinite wisdom, had decided I was just the guy to administer the coup de grace. I begun to sharpen my wits. I began to study karate.

"Early in 1945, I was called to the colors, kissed wife and kids goodbye before dawn on a chill, gray morning and went off to war. It was a Saturday, and I was trundled to Fort Dix right off the bat for a weekend of processing. Arriving before midday, I was issued a wardrobe of the latest military toggery, tossed a mess kit and a mattress, in that order, and pointed toward the barracks which was to be my 'home away from home' until command decisions were made concerning my disposal. I was not a happy man.

"Falling out for reveille at 4 A.M. on a Sunday morning was not my idea of heaven, but there seemed little alternative short of the stockade. Arraigned in a formation simulating 'attention,' my group of forty fledgling warriors was asked who among them would like to attend church that morning. Feeling secure and not a little smug in my agnosticism, I demurred, the lone dissident in the platoon. I was immediately assigned to scrub the officers' barracks on my hands and knees. Enlightenment has its dark side.

"I endured eight weeks of basic training in the boondocks of South Carolina with no pensionable physical trauma, sprouting some neat little bulges called biceps and triceps where none had existed before. Medical charts listed them as muscles, so I was shipped off to Fort Benning, Georgia, for further refinement as an infantry officer. I was being measured for a uniform befitting that high station when the bomb was dropped on Hiroshima. Two months later, I was discharged with honor from the armed forces and returned to square one in New York City. I had not stormed a single beach nor fired a shot in anger. What would I tell my grandchildren, aside from my name, rank, and serial number?"

# The Artist's Terrain

THE SECOND WORLD WAR ended and, as if on signal from the mushroom cloud over Hiroshima, the essential elements of art responded to a fusion which produced a hitherto unknown energy; the basic form of art changed and, seemingly overnight, the world confronted abstract expressionism. Yeasty talk, punctuated by references to European existentialism and to the new world that science had created, hung in the air of artists' clubs and bars. European artists, having fled Hitler's terror, clustered around Manhattan and submitted to conversation the doctrines and personal passions they had brought from twentieth-century modernism in Europe. American artists, no longer bound by regional or even nationalistic aesthetics, accepted no limits to freedom: *limits to freedom?* Is that an oxymoron?

But *freedom* and *accident* and *discovery* and *expression* became key words, identifying both concept and problem for American artists. Examination of these and other abstractions exactly met the personal requirements of Ad Reinhardt (among other artists), who habitually discussed, probed, and fretted at primary questions in art. Abe was hardly immune to these emerging new forces in the art community, joining Reinhardt, Will Barnet, and other artist friends in an on-going debate of the issues. But other forces, more private in nature, exerted an urgent pressure.

Ajay's marriage, entered in youthful haste and increasingly lacking in design or dialogue, was beginning to come apart at the seams. Torn between a profound love for his two sons and a pressing need to restructure his life, a painful decision was made. He initiated divorce proceedings and, with them, a suit to gain custody of his children; he won the divorce, lost the custody battle.

"Not the proudest time of my life, nor the happiest," he recalls, "but a thorny thicket I needed to cut through if I were to reach a clearing." At the head of that clearing was posted a fresh list of priorities.

"I needed to find a job before my army separation pay was exhausted. Being a vet had some immediate advantages over and above the famous GI Bill of Rights. The Art Directors Club of New York had set up an employment service to place qualified returning servicemen in the industry, so I took advantage of it without further ado. Within a remarkably short time, I was hired as an assistant art director at *Parents Magazine* at the not unreasonable salary of a hundred dollars a week. It seemed to me that with this steady income as a base, I might meet my financial obligations without stress if I could pick up a few freelance drawing assignments as a cushion. In time, I could change the rules of the game entirely, ditch the nine-to-five containment of a staff position and set up shop for myself. With a little help from my friends, that's precisely what transpired."

Ajay and sons Stephen (left) and
Alexander, c. 1948. *Photograph by Morris
Engel*.

Abe describes one of those friends, a highly gifted writer named Raymond Abrashkin: "He had been a colleague at *PM* when we met and our friendship quickly bloomed into a comradeship transcending our work on the newspaper. Ray exuded a bustling, aggressive energy which leapfrogged journalism, reaching into areas of theater, film, and literature hitherto unexplored. His enormous enthusiasm was infectious and could carry you along for the ride. He was a treasure. Early in 1946, Ray and I and a cartoonist named Howard Sparber set up a freelance partnership in one of the Carnegie Hall studios at Fifty-sixth Street. We called it 'The Artery,' and let it be known in the professional network that we were open for business. The phone began to ring."

One caller was Arnold Hoffman, Jr., an old friend from Abe's Dell days, now working as art director of the *New York Times'* Sunday edition, who provided Abe regular assignments. The magazine section was then, as now, the principal feature of the Sunday edition and soon made Abe's graphic work visible to both the design community and the *Times'* readers. As Abe summarizes, "Thus began a long and happy relationship with the *Times* as client, involving countless assignments and literally hundreds of roughs, finished drawings, and their attendant deadlines. Standard procedure went something like this: I would get a call from Arnold saying he had a 'piece' in the house for me to read. Could I come up as soon as possible and give it a look? I allowed that I could and proceeded to the eighth floor of the *Times* building to pick up the job. I would be handed a fluttering bundle of galleys to peruse and ponder and plumb for illustrations that would inform the copy. I would then produce a series of pencil 'roughs' for the editors to approve or disapprove, before I would be given the OK to depart and return with the finished product, usually the next day. It was pressure, but of a rather exhilarating sort and I liked being able to handle it." The professional at work.

Within its first year, the Artery triumvirate accumulated a healthy number of clients and prospered. Whenever possible, the three partners shared accounts; sometimes they embarked on a joint venture to align their talents. Abe, for example, became principal designer for a children's record company for which Abrashkin wrote lyrics and commissioned the music. Sparber and Abrashkin collaborated on a comic strip. Abe, the professional artist, began to make a living in a difficult and highly competitive field.

He worked long, hard hours and found little time now for the artists' bars or for lingering, searching conversations with his artist friends. But early in 1947, he recounts, his life altered dramatically.

"I met Betty Raymond and fell in love for the first and last time. I had been teaching a class in political satire in a loft on Seventeenth Street and a cousin elected to return an abandoned cigarette lighter to me on a night that saw me teaching. She and Betty were close friends, and so they arrived together on that fortuitous errand. Naturally, I was introduced, perceived her as a lass after my own heart and she walked away with it before the night was over. I dismissed the class, political satire giving way to carnal design, and we taxied downtown.

"Departing Max Gordon's Village Vanguard long past midnight, I escorted my treasure home. She occupied, with her young daughter, Robin, a penthouse apartment on West Sixteenth Street, and I sensed immediately an addiction to gracious, if not opulent, living. Strolling out on the roof that night, I recall sharing an apple (a reprise of Adam and Eve, no less) and calculating my next move. Flushed with what I scented as victory, I went for the gold, only to be mercilessly rebuffed and sent packing after but an hour's struggle. I floated home, ego bloodied but unbowed, and began carefully to plot my campaign."

The campaign worked. They were married on December 16, 1947. Still proud of that triumph, Abe proclaims: "It was a brilliant flash of good fortune for me. My wife was endowed with great physical beauty and owned a mind to match. She was logical where I was impetuous, decisive where I was vacillating, a rock where I was weak. She brought enormous strength of character to crises in which I was an open wound. I had never known such a woman. I wasn't certain I had earned such a blessing."

Betty, Abe, and Robin lived in Manhattan for the next two years while Abe pursued his freelance activities from Carnegie Hall. The family spent summers on Fire Island, with visits from Abe's young sons who were "on loan" since he had lost the bitter custody battle in 1946. Robin, he fondly recounts, "my daughter in true spirit, if not in fact, melded beautifully with the boys, all three reacting like natural siblings, complete with occasional fireworks. This proved a comforting dividend as the years rolled by and life became a bit more complicated." The professional artist was now a father, the center of a family: life was taking on form.

Betty and Abe had lived together for a year before their marriage. During the summer on Fire Island, and at Betty's invitation, his mother was welcomed as a guest, not only an opportunity for her to see her grandchildren, but a chance for the two women to become better acquainted. They were more than polite to each other, but a wary tension filled the air.

"The atmosphere," Abe recalls, smiling, "could hardly be described as 'relaxed.' Betty has always been a very positive woman, quite the opposite of my first wife who was timid and unassertive by comparison. Betty has always generated and been receptive to ideas, perhaps too many at times, and not at all backward about putting them on the table. Not exactly the brownie-baking, pipe-and-slippers-fetching spouse for which every mother yearned as a daughter-in-law."

Harking back to a specific incident during his mother's visit, Abe remembers that "as Betty and I were lying in bed one morning, my mother tapped lightly on the door, entered the room and sat down on the edge of the double bed, a clear sign of rapprochement. She knew we weren't married and was inclined to frown upon such unsanctified goings-on. But she was, it developed, taking that giant step and bestowing her Good Housekeeping seal of approval. The Ice Age was over and the Great Thaw began."

Not so with Abe's father, however. It would be many years before he could feel comfortable in Betty's presence. "Dad could never quite understand her," Abe laments. "She was a little too assertive, not sufficiently deferential to her husband, a basic character flaw I might easily have avoided, he suggested, if I had married a Syrian

woman. I didn't disagree but assured him that I was fully in charge of my senses, knew pretty well what I was doing, and was determined to make a go of it. Forty years later, it still checks out as one of the few prescient resolutions of my life."

Betty and Abe had friends living in Connecticut and would travel up from the city for country-style visits, falling more and more in love with the landscape and its pre-Revolutionary architecture. Late in 1949, the newly married couple drew a perfect circle on a map of Fairfield County, the area closest to New York, and began a search for a house, barn, and acreage which might fit their modest bank account.

"I had to be in town at least twice a week," says the artist, "to stay active in the freelance game, so commuting distance was a vital factor in our choice. We discovered a 1760 colonial, with an adjoining building perfect for a studio and several acres of land as protection, clinched the deal with a 4 percent GI loan and moved in a couple of months later.

Abe admits that he had feared the move from New York might cripple his ability to service vital accounts, now more necessary than ever with the transition to "landed gentry." All went well, however, and he quickly adjusted to the commuting routine. None of his clients defected and he even added new ones to the list. While Betty took in hand her labor of love, the renovation and restoration of the old house, Abe spent most of his time at the drawing board, coming up for air when a mechanical crisis developed or when a contracting decision had to be made. Meanwhile, he maintained a stable freelance income, adding and subtracting accounts as life in the country took on a patina of permanence. In addition to the inevitable mortgage payments and the mounting costs of refurbishing, the couple anticipated college expenses for the three children.

"Thus," says Abe, "the grindstone remained fairly intimate with the nose, encouraging me to press on with the meeting of deadlines and the courting of new clients when I got the nod. Caught between the relentless pressure of earning the household income and a nagging sense of having missed the last fine arts ferry to fame and fortune, I rode an emotional rollercoaster for years, refining the art of marital brinkmanship to a science. And I kept the pot boiling, often stewing the bones of contention long after the recipe was forgotten."

Although life was frequently bittersweet for Abe and Betty in the Connecticut countryside, the marriage matured and flourished as each became more deeply committed to its design. And professional engagement on both their parts would soon reveal in each a new dimension, one which favored discussion over altercation, embrace over confrontation.

Then, in 1954, as he remembers, "I received a call from an old friend and artist named Jerome Snyder, who told me he was preparing the dummy issue for a new Time-Life publication to be called *Sports Illustrated.* Would I want to get involved. Yes, indeed, said I. I made some drawings for the final presentation and landed the account. For the next five years, I would sit in on the magazine's Friday editorial meeting, rough out some ideas to match the copy and then take a train home to work on the finished art. The completed job had to be in before noon the next day because they went to press each Saturday. Frequently, I would work till dawn on that Saturday morning, sweating to

finish the job, and stagger in to the city for the delivery. Finally, I felt secure enough with the account simply to hand the finished package to a Danbury/New York bus driver, to be met at the other end by a Time Inc. courier. But I was growing weary. Not so much of the tough deadlines, but of the continual need to be clever, on call. Formulas, short-cuts, graphic clichés sprang to mind too easily. The hand became uncomfortably facile, and the brain acquiesced, surrendering with all its troops after only a token struggle. I needed, in more ways than one, to get back to the drawing board."

As Abe fretted, his attention drifted more and more toward fine art; his winter of discontent was kicking up a storm, one that would blow him back, finally, onto his original course, abandoned when the Federal Art Project folded in 1940. But, as the only breadwinner in the family, the voyage promised to be a rough one.

"At about this juncture," he grants appreciatively, "Betty began receiving calls from friends asking if she could help solve their landscaping problems. They had seen what she had done at home and were impressed. Night classes at Columbia University and a drafting course at Abbott Tech in Danbury had provided a practical footing for her fledgling career, but over and above the quickly assimilated groundwork, Betty owned an uncanny and supernatural talent for reading the land. Approaching landscape design problems with the eye of a sculptor, she moved mountains and molehills alike if the plan required and was far more interested in a cohesive design structure than in a cosmetic overlay of horticultural flora.

"Slowly, the word began to spread to total strangers, and the jobs would grow more complex and a good deal more challenging. Commensurate with the number of problems to be solved, the capability grew, as did the income, and it became increasingly clear that a viable career was at hand. It might mean that I could ease up on the freelance hustling, maybe even think of stretching a canvas again."

Predictably enough, Betty and Abe made good friends after their move to the country in 1950, including artists such as Peter Blume, Philip Evergood, Jimmy Ernst, and Antonio Frasconi. Will Barnet, Abe's old confrere from the early days in New York, had a summer place in Danbury; Reinhardt traveled up for an occasional weekend, as did Ben and Patsy Cunningham and Blake and Petra Cabot, close friends from Betty's early life in San Francisco and Manhattan.

"Talk of art was not entirely absent during these get-togethers," admits Abe, "so I gradually began to hunger for some personal engagement again after my long furlough. I would visit the museums and galleries when time allowed during my trips to the city, so my sense of rediscovery grew into a need to take part." But Abe-the-husband-and-father established conditions for participating: if he could manage it on a couple of levels, he told himself as he reinvented his own personal wheel-of-fortune, he might turn again to easel painting, to fine art. With the children grown and soon to take off, he reasoned, and with Betty bringing in some money and building a business, he began gingerly to set the stage.

"I redesigned the space I had been using for commercial work," says the artist, "I tore out walls, raised the ceiling, installed a huge north-light window, and turned the studio building into a proper place to begin my exploration. I began to stretch a few

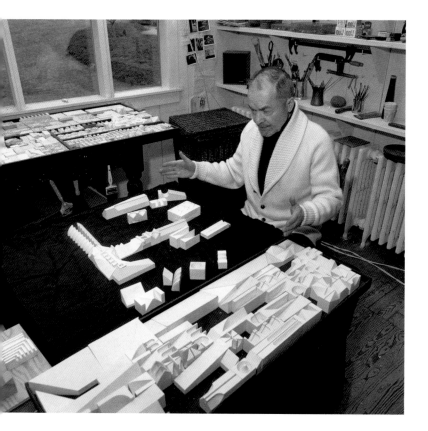

Working with light coming through windows to his right, Ajay explores ideas and composition. *Photograph by Joseph Kugielsky.*

canvases, laid in the necessary paints, brushes, and solvents, and purchased a sturdy easel. It felt good."

But Abe had been absent from the painting act for a long time. His need to apply the pigment, he recalls, "resulted in a pile-up so heavy that I stopped using the easel, laying the canvas instead on a couple of sawhorses to counteract its quarrel with gravity. I had become more than a little interested in painters like Dubuffet and Tapies, with their heavy, earth-toned impasto, and felt somehow close to both the technique and the subject matter they employed. There was a sculptural, tactile feel to their work which attracted me, with its three-dimensional bumps and grinds and the shadow-play the surface invited intrigued me no end.

"Could it be that at heart I was really a sculptor? It wasn't a stupid question. The imagery I had been returning to over and over again in the paintings was mainly landscape. Once in a while, the figure would surface, usually as a kind of imaginary portrait and that would fade out eventually to become a still life. I was quite taken with the work of William Scott, the British painter of exquisitely simple, distilled shapes resembling tables, cups and saucers, and other kitchen paraphernalia, all of it devoid of perspective or fabricated space. I liked the way one shape kissed another, and the negative space between them excited me as much as the positive objects which created it."

The gods of serendipity struck again, as they had when Betty Raymond walked into Abe's life. He nods, smiles, and recounts in wonder: "On a sunny April day in 1962, I dropped by a fleamarket display in nearby Ridgefield, and saw something which excited me immediately. Lying on the grass, some closed and some open to reveal their construction, were a group of Connecticut River Valley cigar molds. The sun hit them in such a way that I saw them as x-rayed, somehow transparent, and my mind's eye saw them in cross section, cut at an angle, chopped, sliced or otherwise scrambled and reassembled in endless permutations. It was worth checking out, I thought, so I bought the whole kit and caboodle."

Fired with curiosity, the artist enlisted the services of the man, Bill Cabral, who had built his studio, and they began the process of autopsy and dissection. The operating procedure took place in Cabral's workshop, the surgical instrument a ten-inch table saw.

"We spent the afternoon playing with cross-cuts and compound angles," Abe recalls, "I grew more and more excited as the ripping revealed more and more possibilities, so by the end of our first session I felt my initial impulse had been a fruitful one. I didn't exactly yell 'Eureka,' but I came up with a reasonable facsimile. I sped home and began to work." Thus, in the hands-on process of exploring materials, the artist declared himself a sculptor, and the three-dimensional search began. "During the next few months, I turned out a fair number of large relief constructions, all of them built exclusively from the cigar-mold material. And I replenished the dwindling supply with a wagon load from an abandoned cigar factory in Bristol, Connecticut.

"I had let it be known in the commercial world that I was phasing out that end of my work life, so the phone began to ring less and less in the studio. The message had been received. I wasn't at all certain of anything, but I was determined to take the risk."

Risk and purification intertwine in Abe's mind with its residue of Christian orthodoxy. The risk was taken in making the constructions, purification demanded a coat of white paint. But purity, the artist knew, defined itself against impurity as simplicity against complexity or thesis against antithesis.

"Accordingly," he relates, "I began to alter the surfaces with a blowtorch, making passes over the white enamel, igniting it at times, even burning through to produce a charcoal gray or black. Playing with fire or painting with fire, I wasn't certain which, but felt pretty good about what was coming out. So I had a couple of pals take a look. Reinhardt said I was nuts to want anything to do with the art game, but made out a list of ten dealers he knew and said I should use his name.

"Jimmy Ernst sent me to Grace Borgenicht, only recently returned, he said, from a summer sojourn in Greece. Apparently the layover in that cradle of classicism had rendered her numb to anything this side of Pericles. She yawned, and waved goodbye. Less than an auspicious beginning, I lamented, but I still had the Reinhardt list to explore.

"The first two names on Ad's list were hardly more productive. Eleanor Ward, holding court at the Stable Gallery, was wrestling with a huge tunafish sandwich (pickle and chips on the side) when I approached. "Damn it, can't you see I'm eating my lunch?" she sputtered, a fine mist of tuna bidding adieu to her mandibles. Wiping a speck of mayonnaise off my glasses, I grabbed slides, fedora, and trenchcoat and slunk, properly chastened, toward my next ordeal.

"Johnny Meyers, at the Tibor De Nagy Gallery, did little to brighten my day. With all the graceless skill of a Lord High Executioner, he brought the axe down hard, snarling, 'I don't look at anything after three o'clock (it was then 3:04) no matter who sent you.' Handed my head, I took the stairs two at a time on my way out. The abattoir known as the art market was taking its toll. I called a time-out.

"Repairing to a corner bistro to lick my wounds and the olive in a dry martini, I debated prolonging the massacre. Why not pack it in now, I sighed, accept as gospel what friends had told me about the gallery game, and cut my losses? Or might I make just one more pass at the brass ring, just one more try at scaling those lower depths before calling it quits. The gin did its familiar work and I walked on my knees up Madison to Sixty-eighth, turned right toward Park and climbed the brownstone stairs at Forty East. The Rose Fried Gallery was on the second floor. I got lucky.

"Rose, the saintly proprietor, said immediately that anybody Ad Reinhardt would recommend deserved a serious look. She examined my portfolio carefully. After what seemed like a century of silence, she stood up, smiled warmly, poured me a jigger of scotch and asked when she might visit my studio. Overcome, I said, 'Good Lord! I'll drive down next Sunday and pick you up!' It was arranged, and I floated home on a cloud."

Abe would learn later that Rose Fried was, in fact, a maker of art history in her own right. She had helped inaugurate the modern movement in America, introducing and launching such artists as Mondrian, Arp, Klee, Leger, Kandinsky, Balla, Ernst, and Duchamp, and giving Schwitters, Sonia Delauney, and Torres-Garcia their first New York exhibitions.

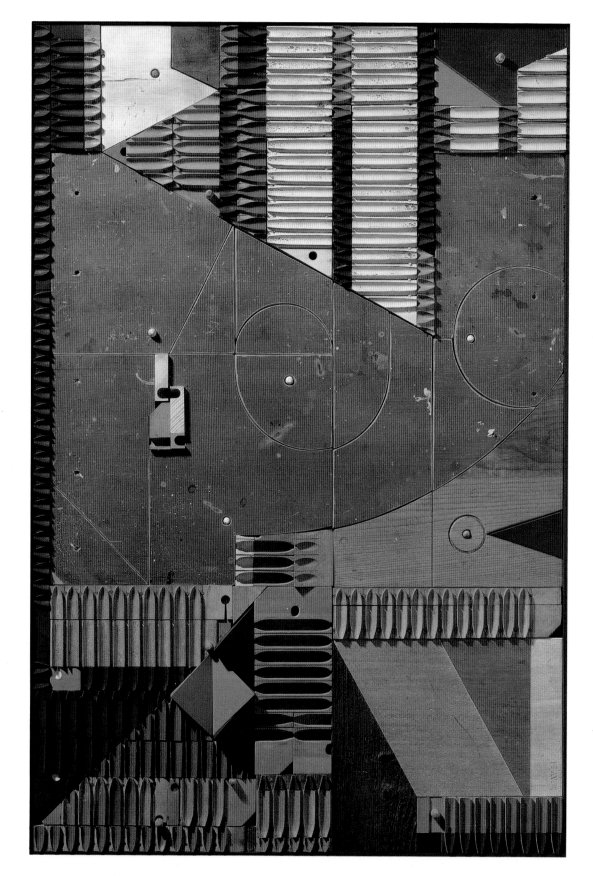

10. Polychrome wood relief 209, 1964
Oil stain and enamel on wood, 48″ × 32″
× 3″; collection of the artist.

On the day after Abe's buoying visit with Rose Fried, John Kennedy was assassinated. The nation was traumatized. He was certain that Fried would not want, at this juncture in history, to contemplate some cigar molds, however magically transformed, through a veil of tears. He was dead wrong. She kept the appointment.

"Rose was a very emotional woman," recounts the artist, "given to broad swings from one mood to the next, and I had caught her at a bad time for business talk, I feared. I wasn't sure how to deal with it. Amazingly, when she walked into the studio, she became a different person. Seemingly tranquilized, she became engaged with the work, and after what seemed like an agony of suspense, turned to me and said, 'When would you like to have your show?' I was overjoyed, kissed her on both cheeks, and we both walked over to the big house to break the news.

"The rest is history," says Abe with a wan smile, "but not necessarily art history."

The date for the artist's show with Rose Fried was set for November of the following year, giving him almost a year to prepare. But, propelled by the restless energy that filled his work in those days of rediscovery, Abe proceeded to "disown" the work which had persuaded the dealer to take him on. He chose, instead, to embark upon a totally different tack, as he recalls, "jumping off from what I had learned about myself and the material in that preliminary exploration. The show was a success, as the gallery scene evaluates success, and I felt as though I had negotiated the distance between applied and fine art fairly gracefully. Sales were made and attention was paid; John Canaday, art critic for the *New York Times,* wrote a generous review, as did six or seven other newspaper and magazine writers of the time."

The professional artist, it appeared, had done the impossible, had turned the neatest trick of all: he had crossed the bridge from the never-never land of *commercial* art to the ethereal grandscape of *pure* art. And if Abe needed further proof of his success in eluding the commercial pit, it came the following year, in 1965.

In August of that year, Joe Hirshhorn paid a visit to the artist's studio and added eight works to his collection, later to become the Hirshhorn Museum and Sculpture Garden in Washington, D.C. Soon other collectors signed on, sparking a gleam in the eye of both artist and dealer, who could now look forward, with reasonable equanimity, to plotting future exhibitions.

The euphoria which came with acceptance by both the gallery and collecting ends of the spectrum was short-lived. It wasn't long before the imprimatur of the Grand Acquisitors wore thin, and Abe discovered that access to nirvana was more tightly held than he had imagined. As he tells it, "I had felt that my 'success' of the year before would have swept me to the mountain top. I was wrong, dead wrong. Naively oblivious of the political network which called the shots at the time, my virginity pilfered, I began to grow up. But not without a fight."

Abe Ajay and Ad Reinhardt at opening of Ajay's show at the Rose Fried Gallery, New York, 1966. *Photograph by Frazer Dougherty.*

Ajay at work on wood-shaper, tooling wooden prototype from which he will make a silicone rubber mold for casting. *Photograph by Frazer Dougherty.*

The professional artist confronted the intrigues and Byzantine permutations that characterized the art world. Earlier, when Abe introduced himself to art and artists in New York, no one made money; hardly anyone seriously collected American art, let alone modern American art. Abe believed artists were joined in a fraternity of alienation, the shabby philosopher kings who lived to do daily battle with debts and indigence. As he plied the skills of graphic design, a commercialism denigrated by the "fine" or "pure" artists, the art world, ironically, had invented a new breed of commercialism: the lore of American abstract art included mythic success stories. Guys (few women applied; fewer were accepted into the brotherhood) made it big and boasted bigger. Overnight, both riches and fame became prizes for artists who caught the approval of museums and collectors, of artists who provoked attention to their work.

Rose Fried, happy with the critical affirmation and sales from Ajay's first show, booked another for 1966. Abe, the disciplined professional with a deadline before him, turned his attention from the intricacies and political machinations of the art world. "I worked very hard," says the artist, "moving logically, away from the blatantly found material. It had been too easy for me with the molds and they began to bore me profoundly. I bought power tools for my studio, no longer relying on friends or local woodworking facilities and learned to use them safely, counting my fingers each night before I went to bed. New shapes began to emerge, fresh ideas crowded one another for my attention. I became interested in color and methods of application. Technology reared its ugly head. Other materials beckoned. We would see."

His 1966 show seemed to him a leap forward. "I had learned a lot, I thought, since 1964. A clear dialogue with shape and color was emerging. Aware now that my interest lay in a three-dimensional, sculptural direction instead of the flat picture plane, I set about designing a vocabulary of modular sculptural forms which I could use over and over again. After I fabricated a basic system—the word *system* is most apt here—on my power tools, I then needed a safe and certain way to reproduce the modular units in materials other than wood. I had in mind a system such as the twelve-tone scale in music, in which infinite repeats and permutations added up to a constant rediscovery of new sound; or the twenty-six letters of the alphabet with which one could write the *Holy Bible, War and Peace,* or *Sex and the Single Werewolf,* depending on the author's particular appetite and proclivity."

The alphabet. Modular units. Repetition and variation. Single units fitting into larger schemes and themes, much as an individual belongs within a family or a clan; much as a measure of time eventually occupies a position in the limitless cosmos of space-time. From the small piece—the single unit, the character of the personal alphabet—to the infinitely expanded freedom and necessity of Art, Abe would, bit by piece, measure and map the terrain of art and, in doing so, would locate himself in the big scheme of life, that great tapestry of universals. Order and precision would dominate.

Slowly, first things first, he had confronted the technical problem of replication, of repetition of a single unit so as to develop "runs" or "passages" in which those single units are placed in the context of other units.

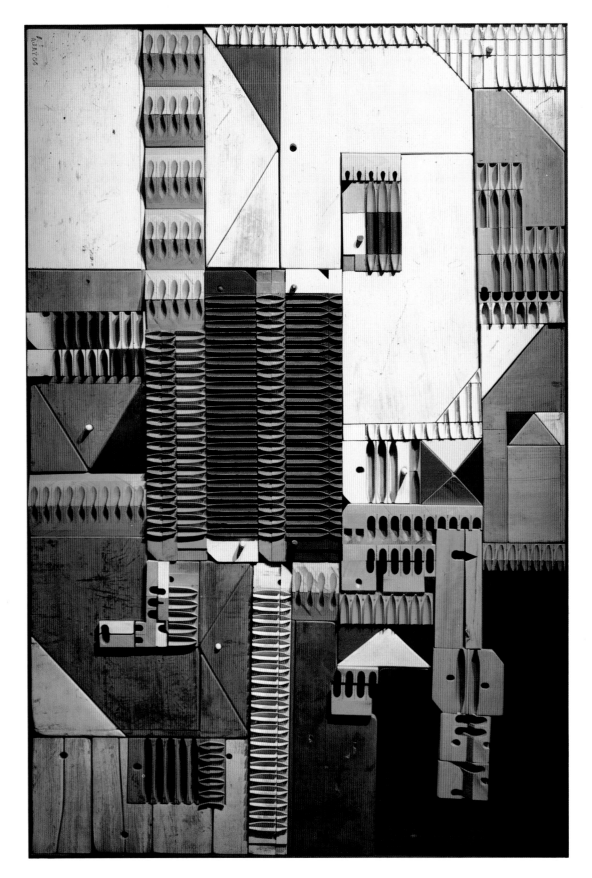

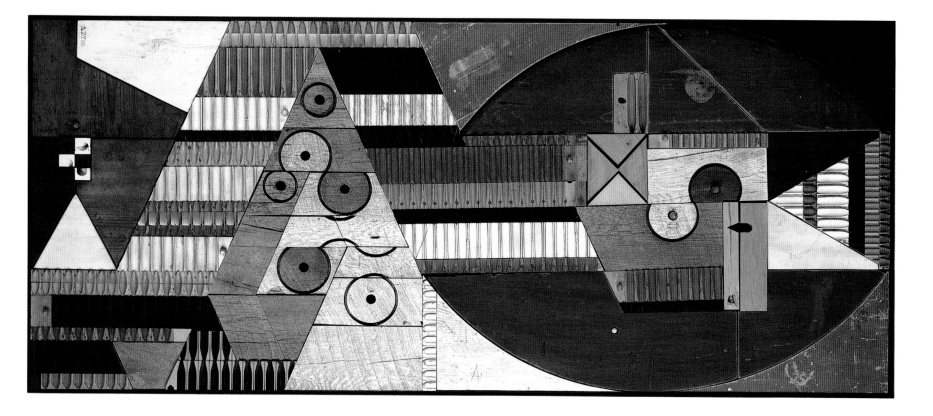

11. Polychrome wood relief 211, 1964
Oil stain and enamel on wood, 63″ × 42″
× 3″; Solomon R. Guggenheim Museum,
New York.

12. Polychrome wood relief 212, 1964
Oil stain and enamel on wood, 31″ × 72″
× 3″; Tweed Museum of Art, University
of Minnesota, Duluth.

"I like these very much," Abe affirms, picking up one of the prototypical models. "But I didn't want to go back to the machine every time I wanted a duplicate. Too risky, both physically and philosophically. So I hit upon the idea of mold-making. I'd turn out the original model very cleanly, precisely, perfectly crafted, exactly as I wanted it. Then I would make a silicone rubber mold of the piece, and pour any number of reproductions at will. The material I chose was a polyester resin, a quick-setting compound that would be stable, machineable, and comparatively inexpensive."

The combined forces of good research and good technical skill, the fundament on which an artist's technique rests, encouraged Abe. The results made up the major ingredient in his next show with Rose Fried, in January of 1968. "Bone white castings of my modular units were installed in boxes behind two layers of transparent, colored Plexiglas, one color layered over another, creating new colors and mixes of colors as the white castings reflected the colored light. I had a positive feeling about this show from the outset, a mood measurably enhanced by the post-partum champagne bash given by Frazer and Frances Ann Dougherty. This would be the first of many such celebrations owed to the generosity of this loyal couple, friends with whom we share much ancient and current history. The show was a success in other important ways, well reviewed in the public prints and business was brisk. This happy ending notwithstanding, I wasn't certain I wanted to continue in the same vein for my next exhibition."

As he walked the path of the professional fine artist, Abe would change directions and ricochet off his own findings onto another path or plateau to be explored. Restlessness. Boredom. Introspection and self-criticism. His studio work table contained these elements as surely, if not as materially, as it contained the elements of his alphabet.

Abe admits, "I was becoming bored with the technology and the craft of box-building which had occupied so much of my time in the previous eighteen months. I had received a commission from the J. Walter Thompson Company to produce three-hundred boxed sculptures for their executive gift program, a Christmas ploy. They had to be identical, a limited edition exercise, and the project drove me up the wall. I farmed out some of the technical stuff but did all of the asembling in my studio. I vowed never to be so stupid again, or so greedy."

An artist learns and moves on; but there is no guarantee that he won't find himself in the future repeating, with variation, his own steps. Abe moves to another format, regenerates his interest in exploration, the after-show compulsion. He says, "For some unknown reason, it is essential for me to become involved in another search, and I think *search* is the proper word to use because it promises discovery along with the risk. Somewhere in my head, a private conviction exists that *Search is the Process, Discovery the Art Form.*" He pauses, considers and insists: "I do believe."

The artist's litany of complementary forces punctuates his conversation just as opposing forces, antithetical units, comprise his constructions. He acknowledges the yes and no, push and pull, positive and negative energies, the passionate and dispassionate, embrace and arm's length in the same format, one informing the other.

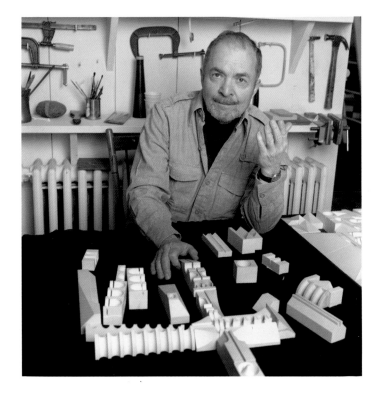

Ajay with polyester-resin castings.
*Photograph by Joseph Kugielsky.*

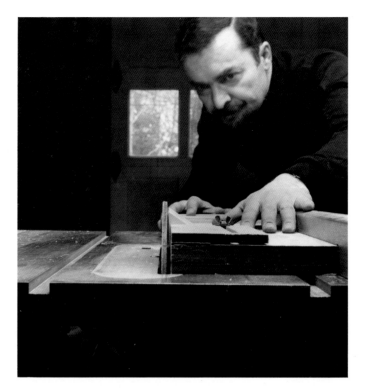

Ajay machining the cured module on an abrading disc to eliminate any distortion in the casting. A special jog is used for this operation to hold the unit firmly.
*Photograph by Frazer Dougherty.*

Where does it all lead? Where can an artist travel in the craft he builds for himself? Looking back to his official entry into the art world, Abe summarizes, "When I had my first exhibition in 1964, I felt quite in tune with what was happening on the scene and with whatever art history was being made. I don't feel that way at all now, for a number of complicated reasons. First, so many of my artist friends are gone and the dialogue has diminished to a whisper, except for an occasional exchange with faculty colleagues who share my perception."

After more than twenty years of solitary search, Abe remains solitary. Solitude is elected; loneliness a condition without escape hatches. "By and large, the making of serious, thoughtful and occasionally valuable art has become a lonely persuasion, while the marketing of art has become a boutique operation, manipulated by fashion, self-serving art scholars and the vagaries of the auction block," Abe reminds himself; he checks the door, making sure it is locked; he turns back to his work table, to the trays of units waiting to be organized into his metaphor of reality, of life.

And that metaphor is characterized by *precision*. The exact right cut, at the correct angle; no hesitation; no hedging or second-guessing: Ajay pushes the blade through an object at a predetermined angle, revealing the innards of the object, spilling a new essence into the studio. Examined, analyzed, perhaps cut again; turned on end and cut once again; reassembled. The cutting and marking, excavating and revealing continue; fragments cut loose from objects become new objects. After reduction palls, Ajay begins slowly to assemble, a process that echoes the precision of disassembling. A simple object offers infinite paths for the blade; a universe of edges and planes, of cavities and textures to be exhumed. Precision that is dispassionate, inquisitive, analytical, is served.

A line, to be believed by Ajay, to be trusted and assigned function or position within a work of art, must be precise: it cannot approximate or miss its path by the slightest angle or edge. In the same proportion that he honors precision, Ajay loathes cleverness, facility or easiness, the approximate location, the sloppy life. The slipshod, making-do; the quick, the fraud.

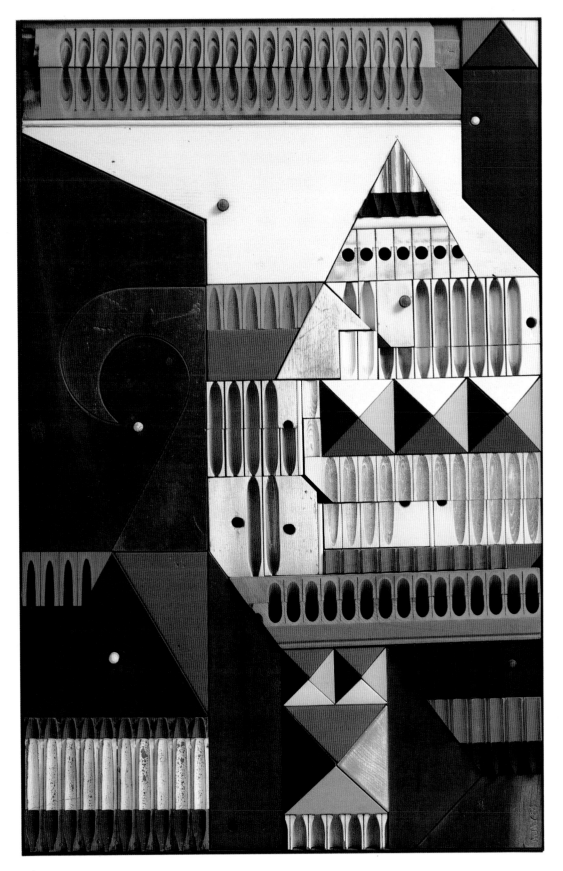

13. Polychrome wood relief 213, 1964
Oil stain and enamel on wood, 41″ × 27″
× 3″; private collection.

14. Blue, Yellow, and Red, 1965
Painted wood construction, 31$\frac{1}{2}$″ × 26$\frac{1}{4}$″
× 2$\frac{5}{8}$″; Hirshhorn Museum and Sculpture
Garden, Smithsonian Institution, gift of
Joseph H. Hirshhorn, 1966. Photograph
by Lee Stalsworth.

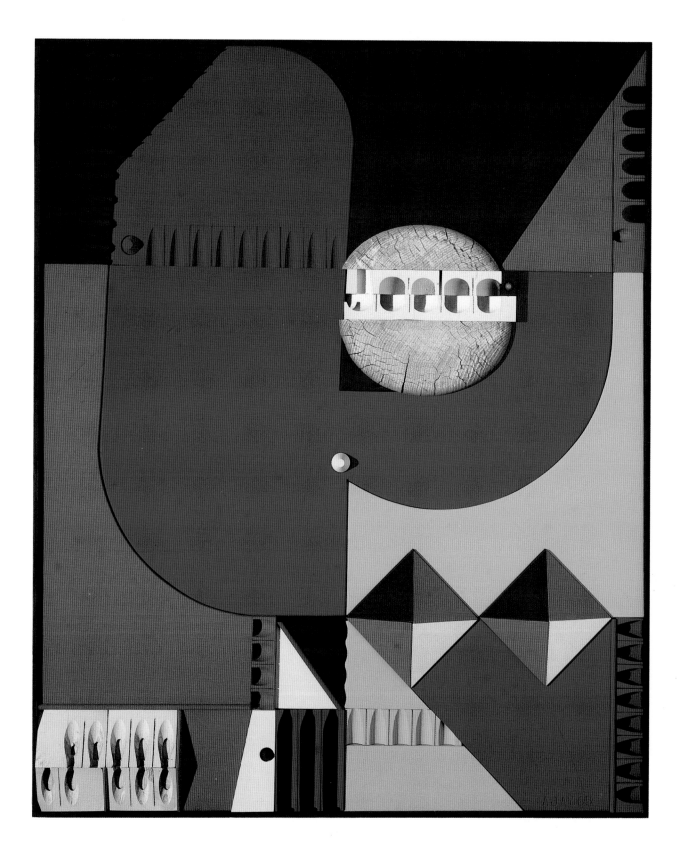

# The Artist at Work

ABE AJAY'S DEVELOPMENT AS AN ARTIST began with a romantic but certain conviction of his vocation. It climbed the predictable path of youthful high hopes and full energies which carried him through his student days and early apprenticeship on the Works Progress Administration, leveled off for a few years when he worked as a commercial artist, and then, in 1964, soared sharply toward high achievement with his first show, at the Rose Fried Gallery. In his review of the show, John Gruen, of the *New York Herald Tribune,* wrote that Ajay's constructions were "integrated with greatest subtlety to produce a visual fugue as inventive as any of Bach's . . . an arresting, genuine talent."

But long before this first exhibition, Ajay displayed both his passion and his intellectual concern for the basic principles of art. They took form as an act of painting, a good quarter of a century before that first exhibition in New York City.

In the earliest extant sign of the artist's hand, *Head of Christ* (Plate 2), we see his nineteen-year-old affinity for the dynamic blacks and strong expressionism of Rouault and the Romanesque frescoes he had seen at the Metropolitan Museum of Art. It also reflects upon his first encounter with oil painting, those portraits of Christ's twelve apostles he had studied so intently as an altar boy, age twelve, in Altoona's St. George Syrian Orthodox Church. It seems clear that this simple, early influence, as well as the historically significant Rouault and Romanesque frescoes, equally inform this first oil painting. "In an attempt to create a painting surface more sympathetic than the raw linen canvas, I laid on a heavy ground of white lead pigment," Ajay recalled. "It was a dumb thing to do, and I regret it now, because the painting has cracked severely over the years. I am a lot more sensitive to matters of 'conservation' now than I was in those early days."

However unsuccessful this initial wedding of idea and technique may have been, the interrelationship of these two forces, and indeed their mutual dependency, remained strong and highly visible in the artist's work as its evolution took on flesh over the years. There would be times, too, when idea and process would be in conflict, when signs of struggle became signs of stress, only to be resolved by abandoning the field or turning abruptly to an entirely new and fresh investigation. "I seldom accept a concept or material as it comes to me, right out of the box, so to speak," says the artist. "I find it necessary to give it a real hard time before trusting its value and taking it aboard. I have to run it through my own mill, make my own mark on it, before I welcome it into the family": thus his distrust of the raw linen canvas beneath its crust of pigment, and his later crushing, crumpling, and creasing of fine oriental papers before calling them to the colors as collage material.

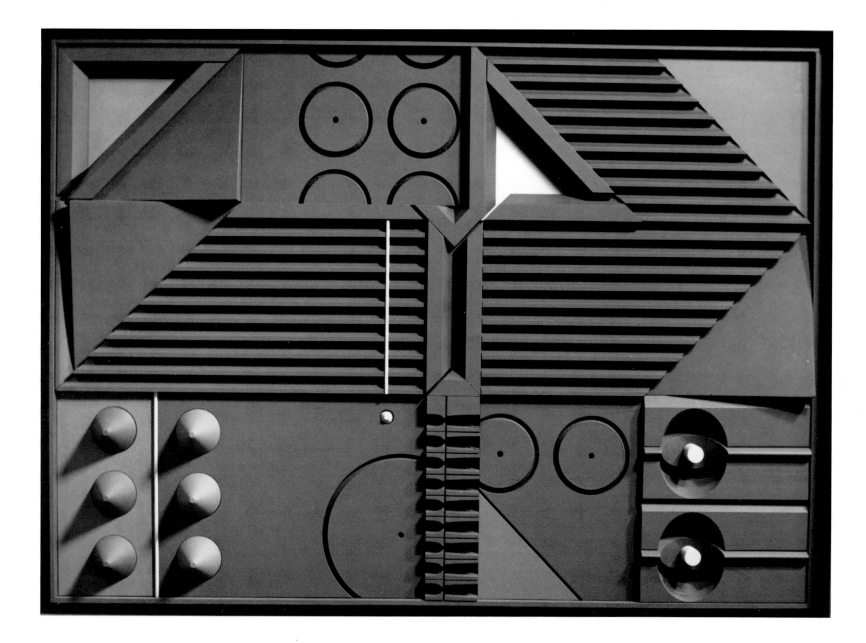

19. Triple Play, 1965
Polychrome relief, acrylic on wood, 32″
× 26″ × 3″; collection of the artist.

20. Equation, 1966
Polychrome wood relief, 26″ × 36″ × 3″;
private collection.

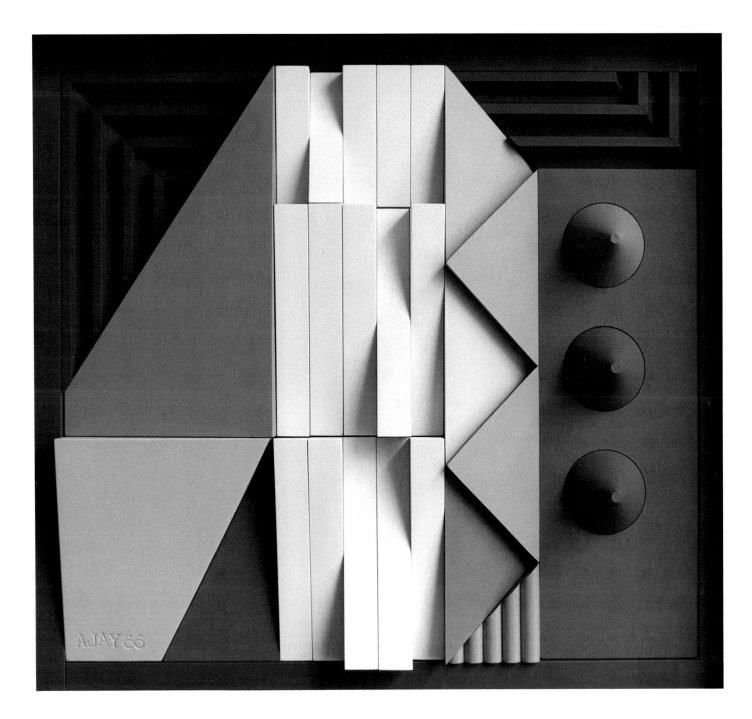

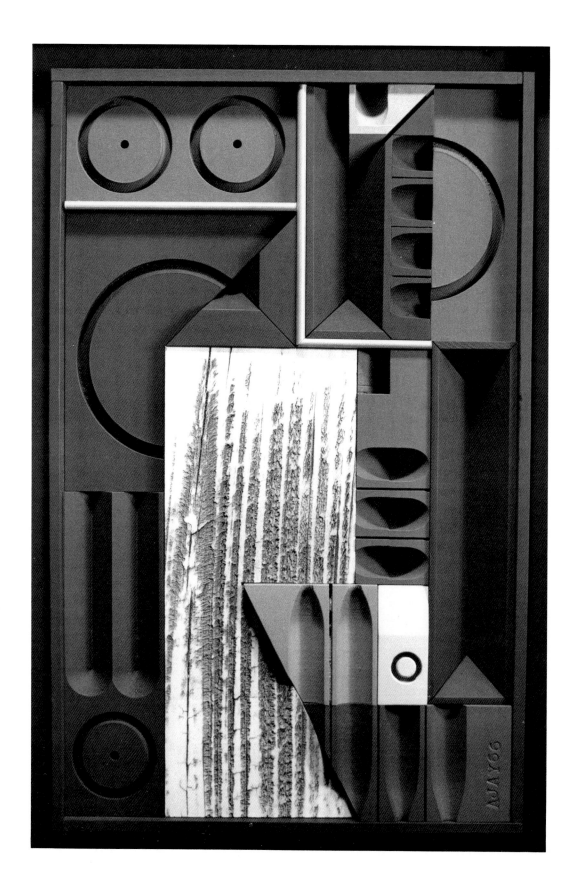

21. Ordonnance, 1966
Polychrome relief, acrylic on wood, 16″
× 18″; Johnson Museum of Art, Cornell
University.

22. Double Recess, 1966
Polychrome relief, enamel and acrylic
on wood, 16″ × 11″; private collection.

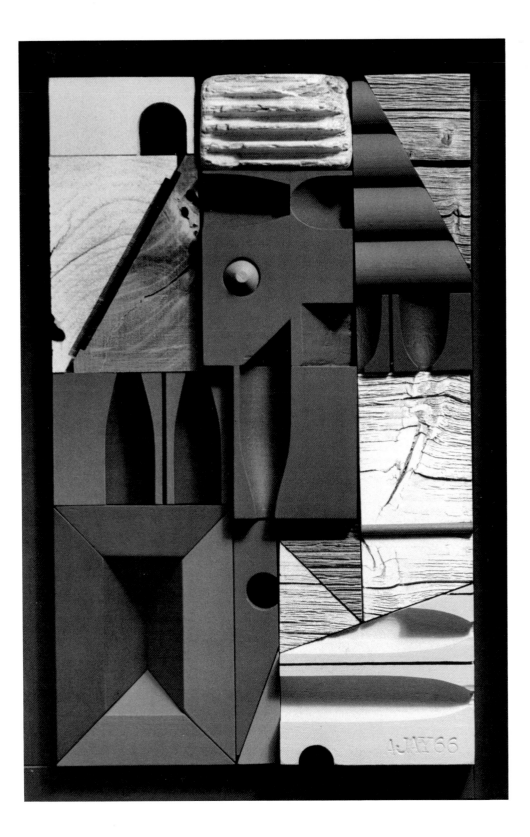

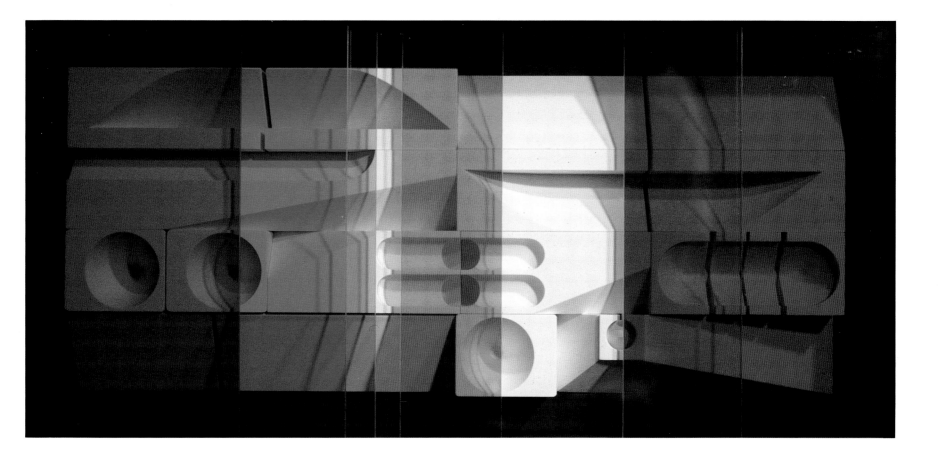

23. Epode, 1966
Polychrome relief, acrylic and enamel
on wood, 11″ × 7½″; private collection.

24. Boxed sculpture 167, 1967
Polyester resin, Plexiglas, wood, 8½″
× 17½″ × 3″; Aldrich Museum of
Contemporary Art, Ridgefield,
Connecticut.

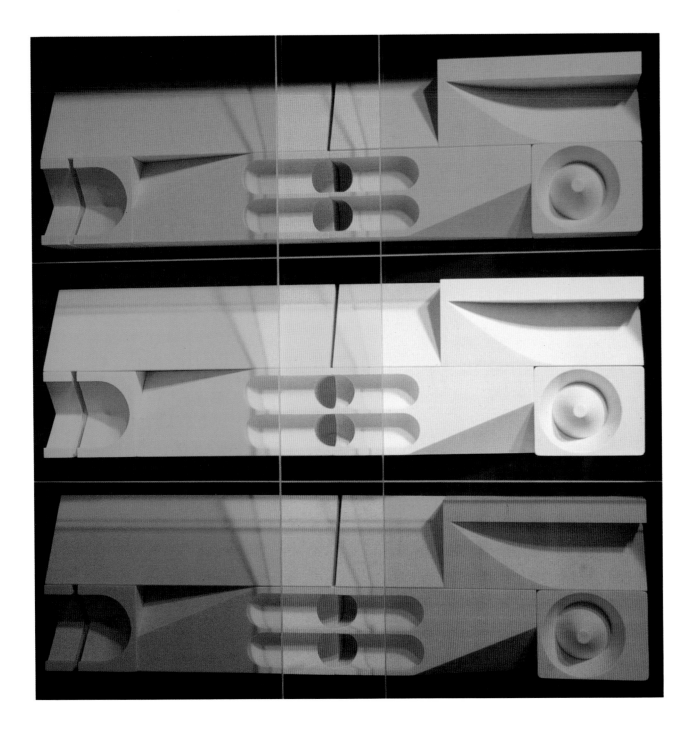

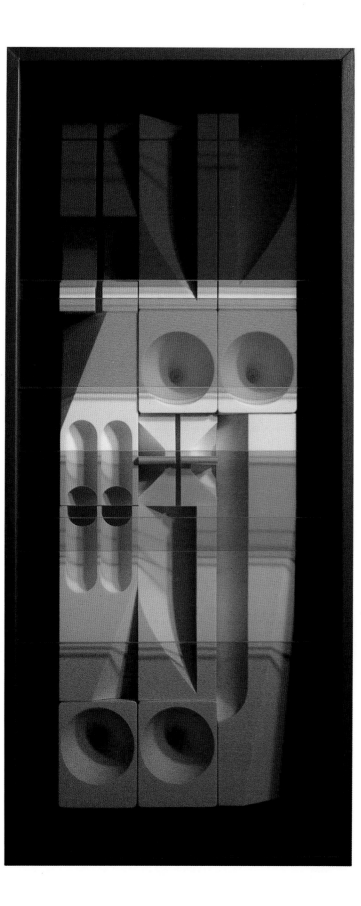

25. Boxed sculpture 1467, 1967
Polyester resin, Plexiglass, wood, $13\frac{1}{2}''$
$\times 14'' \times 5''$; Birla Academy of Art and
Culture, Calcutta, India.

26. Boxed sculpture 867, 1967
Polyester resin, Plexiglas, $15\frac{1}{2}''$
$\times 7'' \times 5''$; private collection.

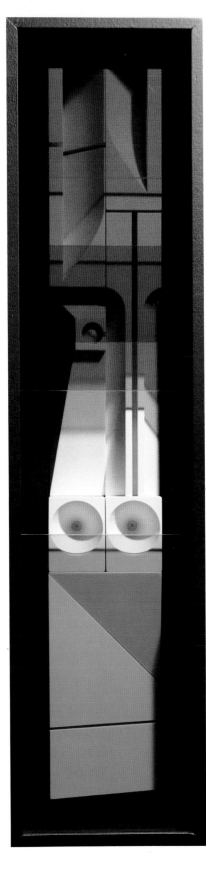

27. Wall sculpture 268, 1968
Polyester resin, Plexiglas, and wood,
$22\frac{1}{2}'' \times 5\frac{1}{2}'' \times 3''$; private collection.

28. Boxed sculpture 667, 1967
Polyester resin, Plexiglas, wood,
$13\frac{3}{4}'' \times 7'' \times 5''$; private collection.

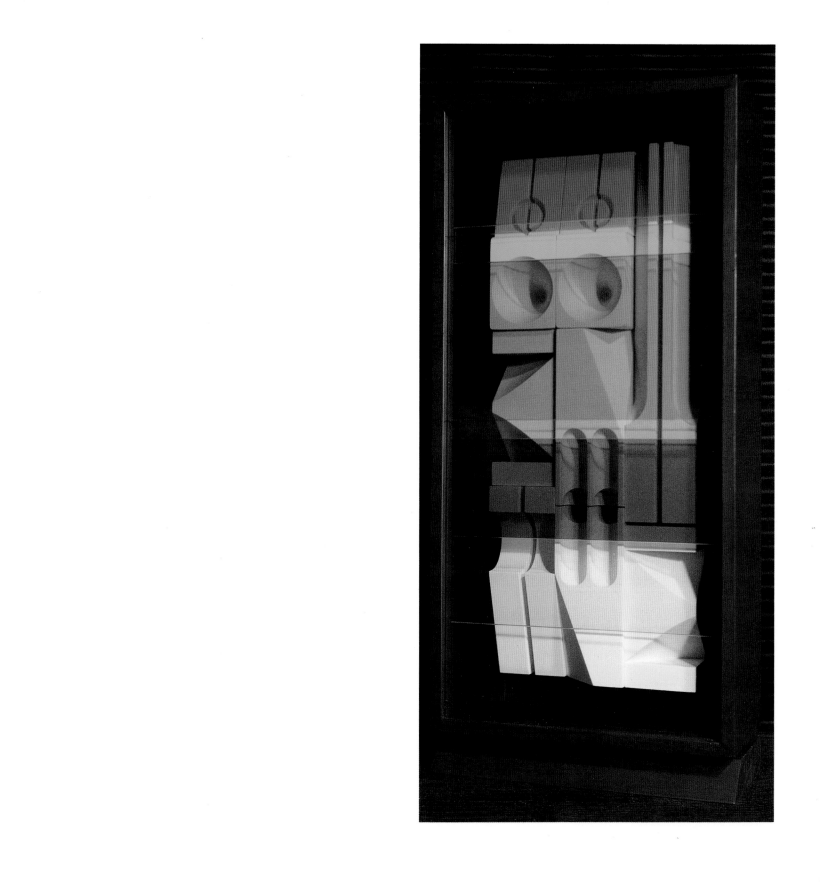

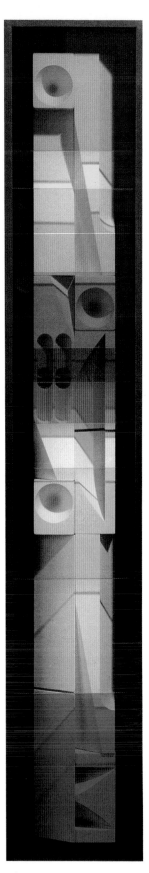

29. Wall sculpture 668, 1968
Polyester resin, Plexiglas, and wood, 32″
× 5½″ × 3″; collection of the artist.

30. Construction 26–70, 1970
Polyester resin, canvas, and wood, 37½″
× 48¾″ × 3″; Allentown Art Museum,
Allentown, Pennsylvania.

31. Relief painting 471, 1971
Acrylic on canvas, polyester resin, $50\frac{1}{2}''$
$\times 25\frac{1}{2}'' \times 3''$; collection of the artist.

32. Relief painting 1672, 1972
Acrylic on canvas, polyester resin,
$48'' \times 37'' \times 2\frac{1}{2}''$; private collection.

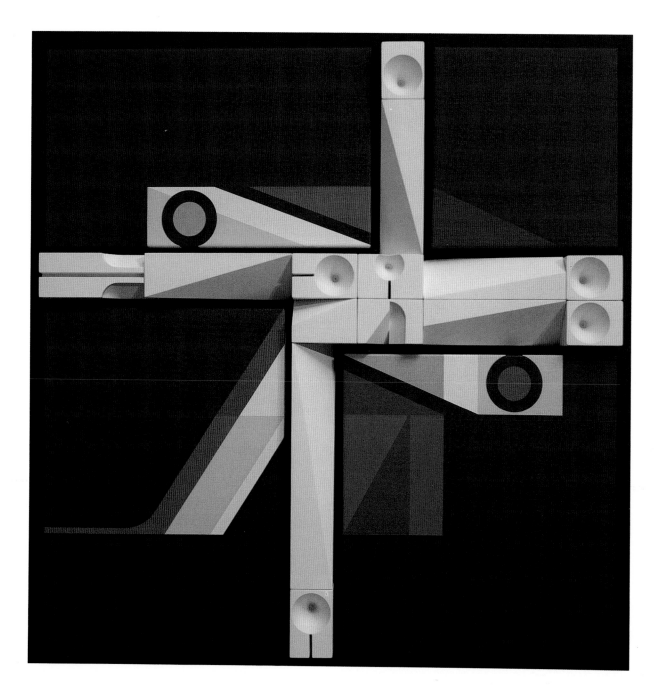

33. Relief painting 1272, 1972
Acrylic on canvas, polyester resin,
$50\frac{1}{2}'' \times 45'' \times 2\frac{1}{2}''$; private collection.

34. Relief painting 2072, 1972
Acrylic on canvas, polyester resin,
$24\frac{1}{2}'' \times 24'' \times 2\frac{1}{2}''$; private collection.

35. Relief painting 7W75, 1975
Acrylic on canvas, polyester resin,
$79\frac{1}{2}'' \times 25\frac{1}{2}'' \times 2\frac{1}{2}''$; private collection.

36. Relief painting 10W75, 1975
Acrylic on canvas, polyester resin,
$61\frac{1}{2}'' \times 18\frac{1}{2}'' \times 3''$; private collection.

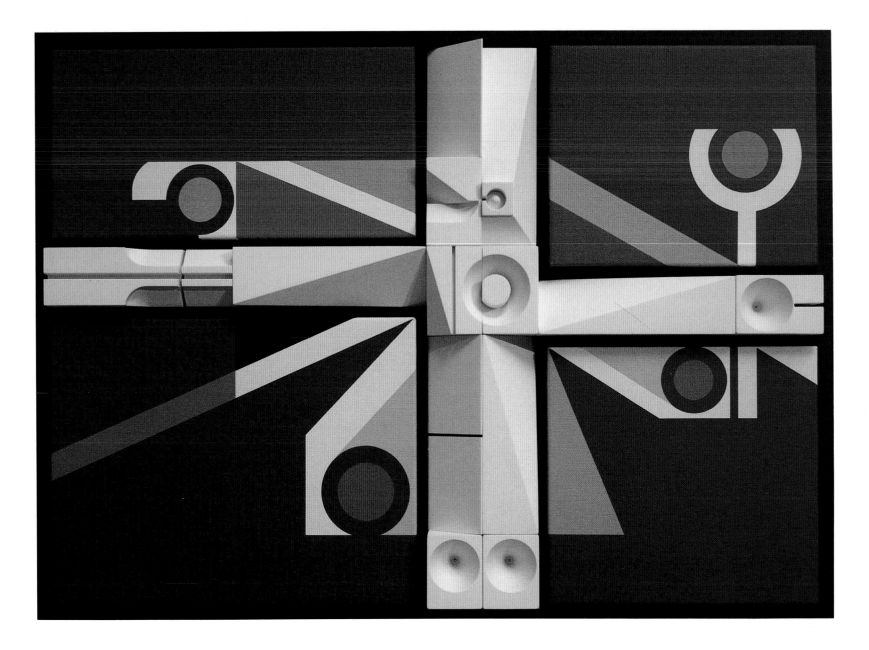

37. Relief painting 172, 1972
Acrylic on canvas, polyester resin,
18″ × 24½″ × 2½″; private collection.

38. Relief painting 173, 1973
Acrylic on canvas, polyester resin,
28½″ × 24½″ × 2½″; private collection.

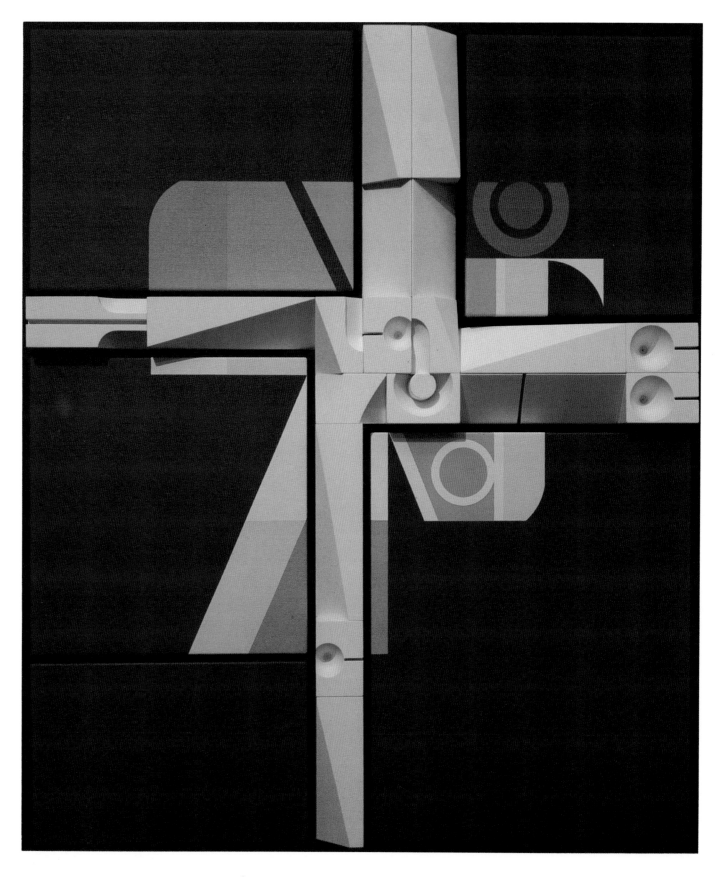

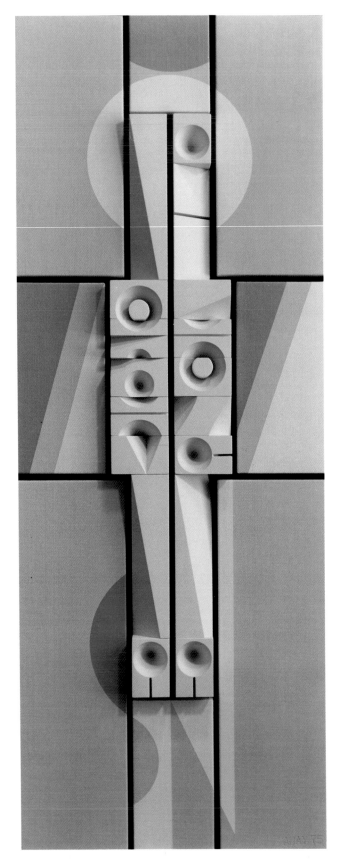

39. Relief painting 12W75, 1975
Acrylic on canvas, polyester resin,
$37^1_2'' \times 15^1_2'' \times 3''$; private collection.

40. Relief painting 8W75, 1975
Acrylic on canvas, polyester resin, 80″
× 25″ × 3″; collection of the artist.

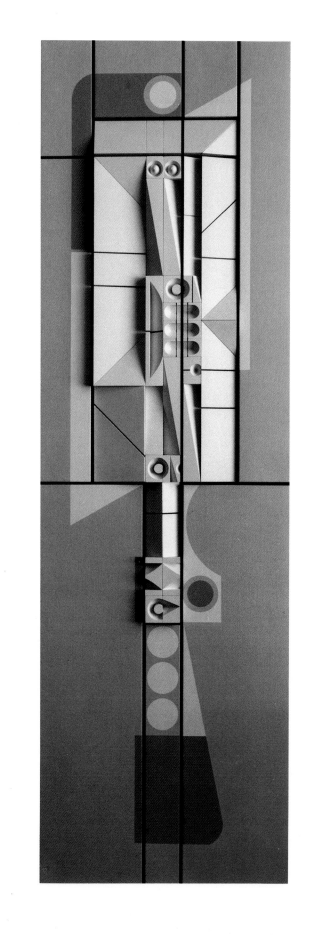

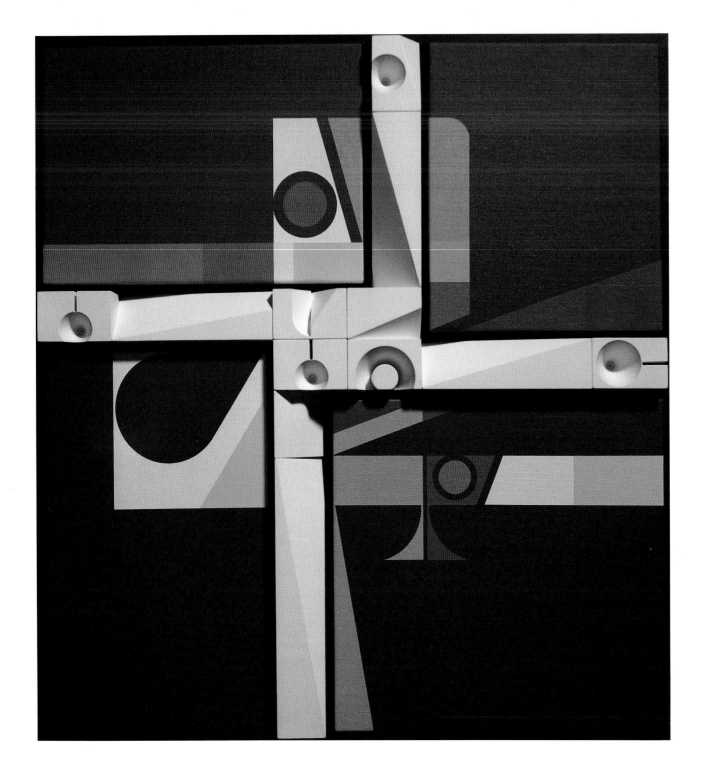

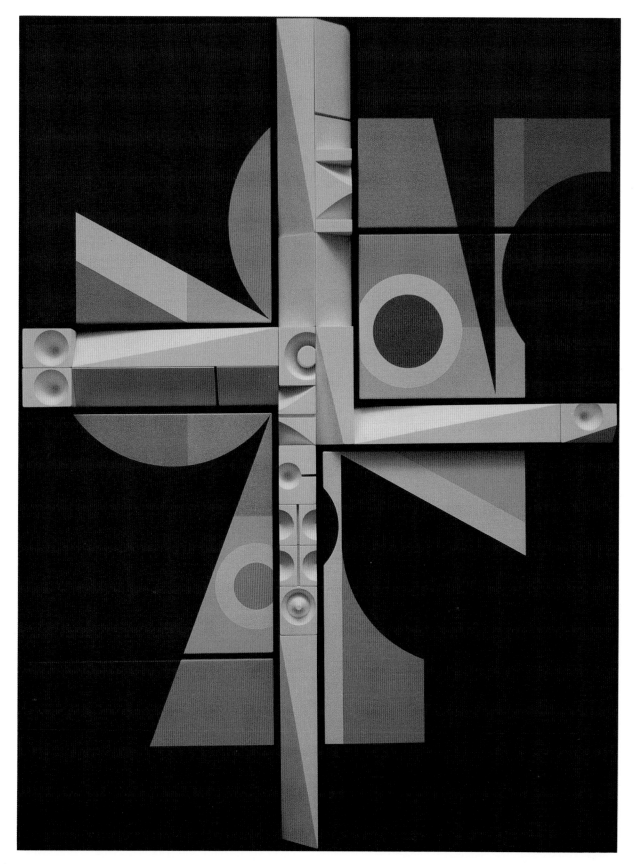

41. Relief painting 473, 1973
Acrylic on canvas, polyester resin, 24¹₂″
× 23″ × 2¹₂″; collection of the artist.

42. Relief painting 1174, 1974
Acrylic on canvas, polyester resin,
36¹₂″ × 27¹₂″ × 2¹₂″; private collection.

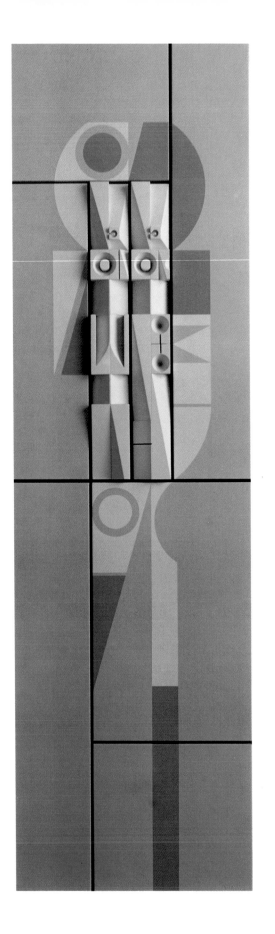

43. Relief painting 6W75, 1975
Acrylic on canvas, polyester resin,
$72\frac{1}{2}''\times 22\frac{1}{2}''\times 3''$; private collection.

44. Relief sculpture 6WP76, 1976
Gypsum, Fiberglas, and polymer, $18\frac{1}{2}''$
$\times 18\frac{1}{2}''\times 3''$; private collection.

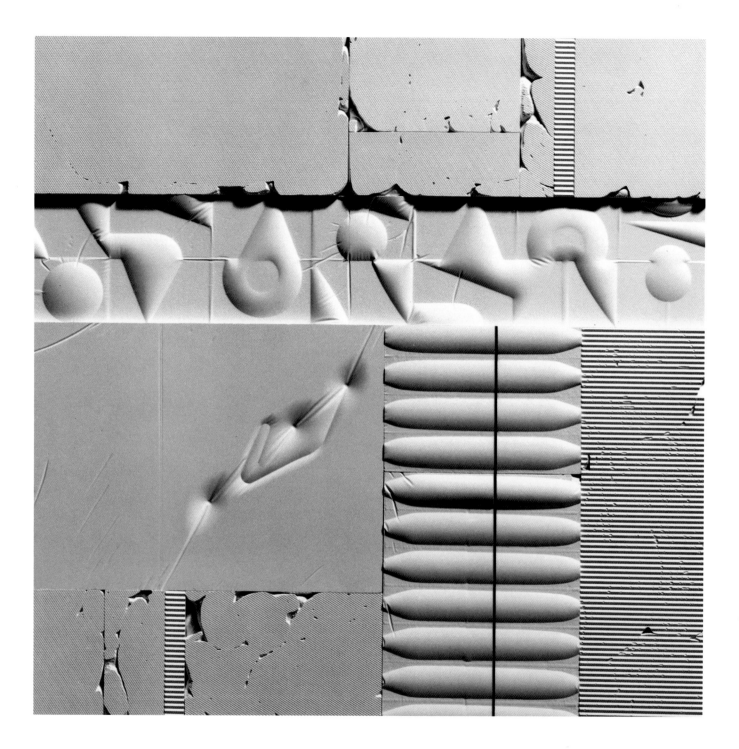

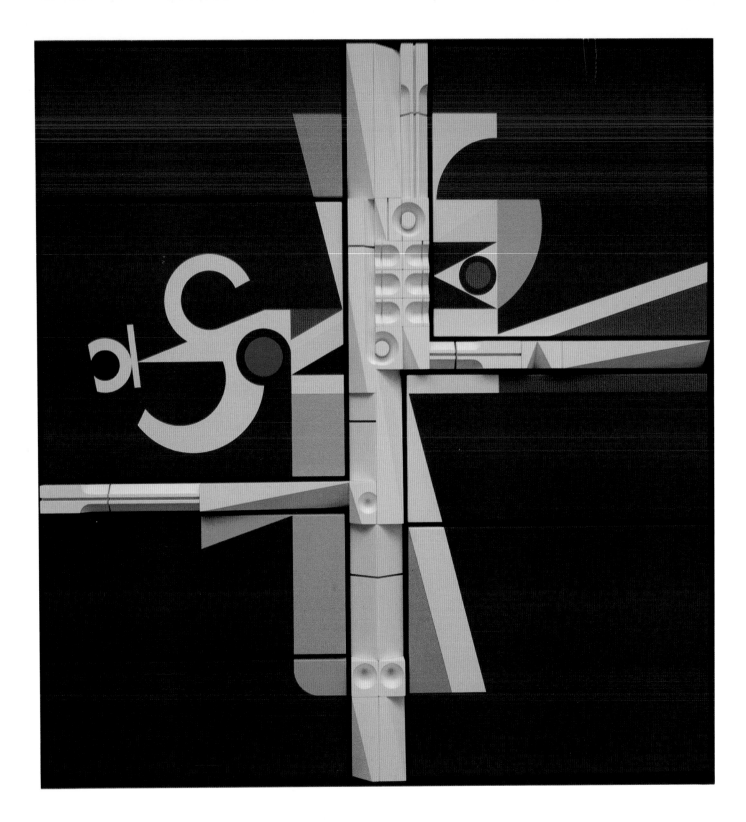

45. Relief painting 1274, 1974
Acrylic on canvas, polyester resin, 44$\frac{1}{2}$″
× 42″ × 2$\frac{1}{2}$″; Pennsylvania Academy of
the Fine Arts.

46. Relief painting 974, 1974
Acrylic on canvas, polyester resin, 60″
× 25$\frac{1}{2}$″ × 2$\frac{1}{2}$″; collection of the artist.

47. Relief sculpture 1278, 1978
Gypsum, Fiberglas, and polymer,
14$\frac{1}{2}$″ × 13$\frac{1}{2}$″ × 3″; private collection.

48. Relief sculpture 1178, 1978
Gypsum, Fiberglas, and polymer,
13$\frac{1}{2}$″ × 14″ × 3″; private collection.

49. Collage construction 2CC77, 1977
Mixed media, $21\frac{1}{2}'' \times 15\frac{1}{2}'' \times 2\frac{1}{2}''$;
collection of the artist.

50. Collage construction 4CC77, 1977
Mixed media, $24\frac{1}{2}'' \times 15\frac{1}{4}'' \times 3''$;
collection of the artist.

51. Collage 2WCC79, 1979
Watercolor on paper, 25″ × 21″;
private collection.

52. Collage 6WCC79, 1979
Watercolor on paper, 22″ × 16½″;
Heublein Corporation.

53. Collage 1WCC79, 1979
Watercolor on paper, 18½″ × 15″;
private collection.

54. Collage 5WCC78, 1978
Watercolor on paper, 19″ × 24″;
private collection.

55. Collage 3WCC84, 1984
Watercolor on paper, 12″ × 9″;
collection of the artist.

56. Collage 9WCC84, 1984
Watercolor on paper, 8″ × 7½″;
collection of the artist.

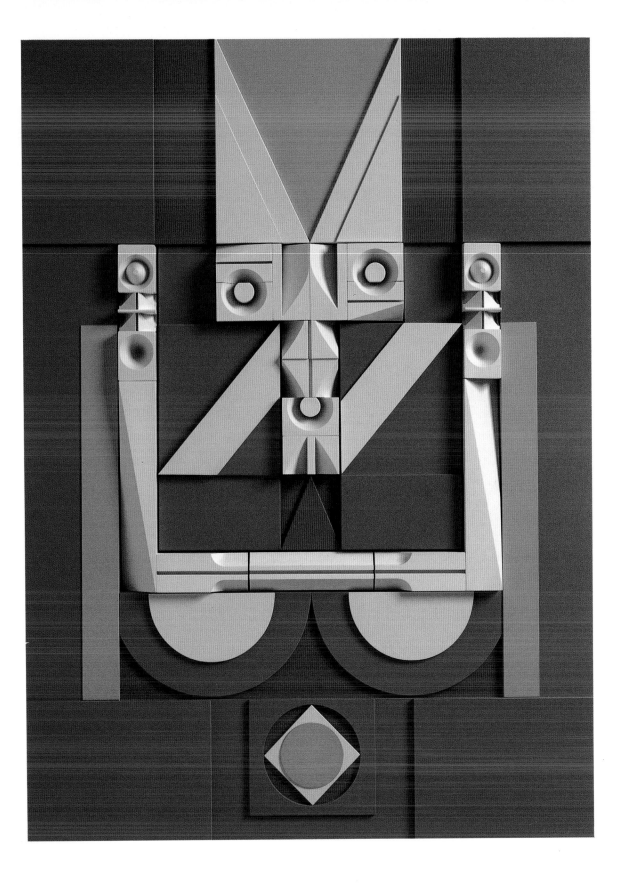

57. Relief painting MI79, 1979
Acrylic on Masonite, polyester resin,
35″ × 27″ × 3″; collection of the artist.

58. Relief painting M279, 1979
Acrylic on Masonite, polyester resin,
42″ × 36″ × 3″; collection of the artist.

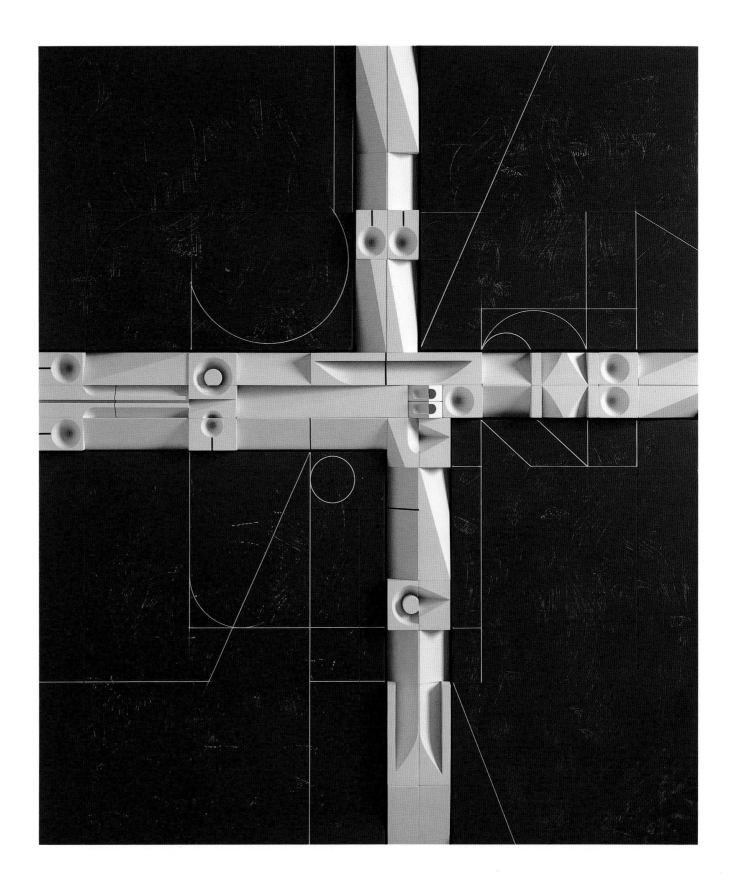

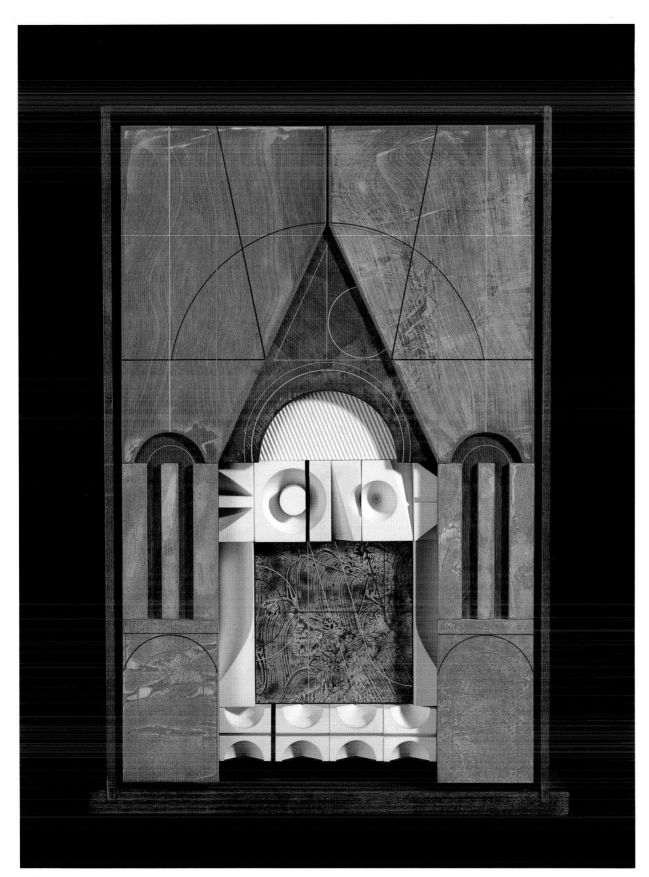

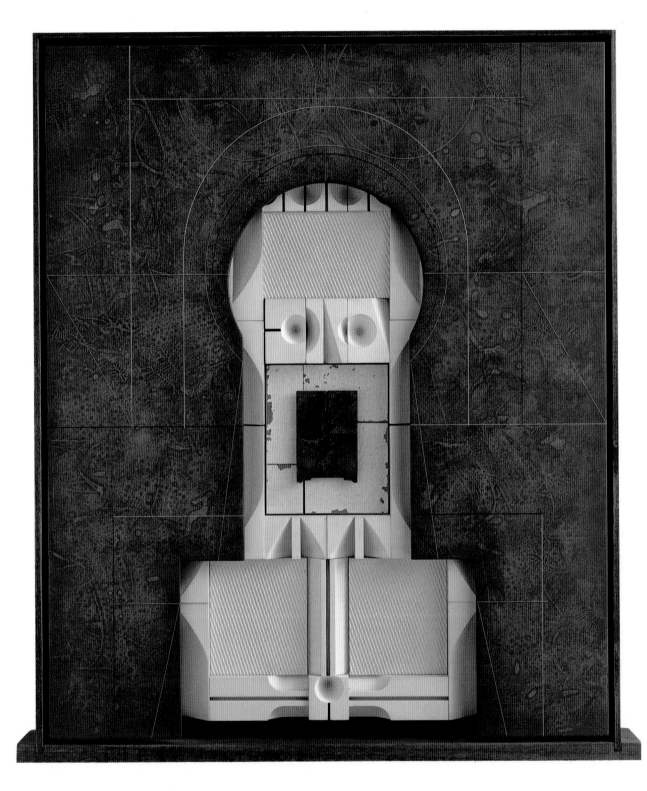

59. The Portal Series 2MC80, 1980
Mixed media, 21″ × 14″ × 3″;
collection of the artist.

60. The Portal Series 9MC80, 1980
Mixed media, 27″ × 22½″ × 3″;
private collection.

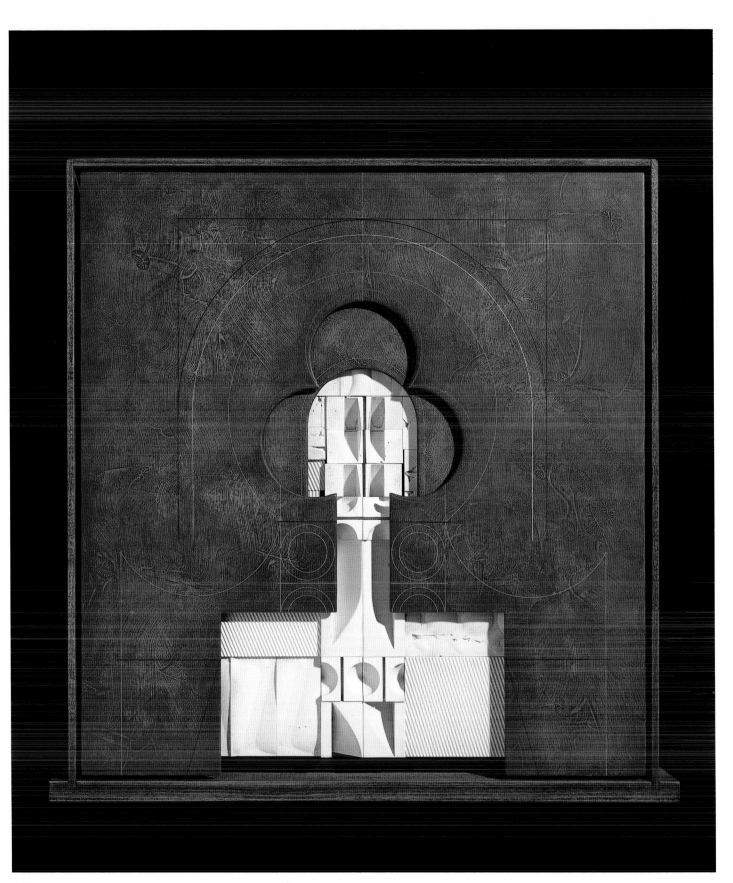

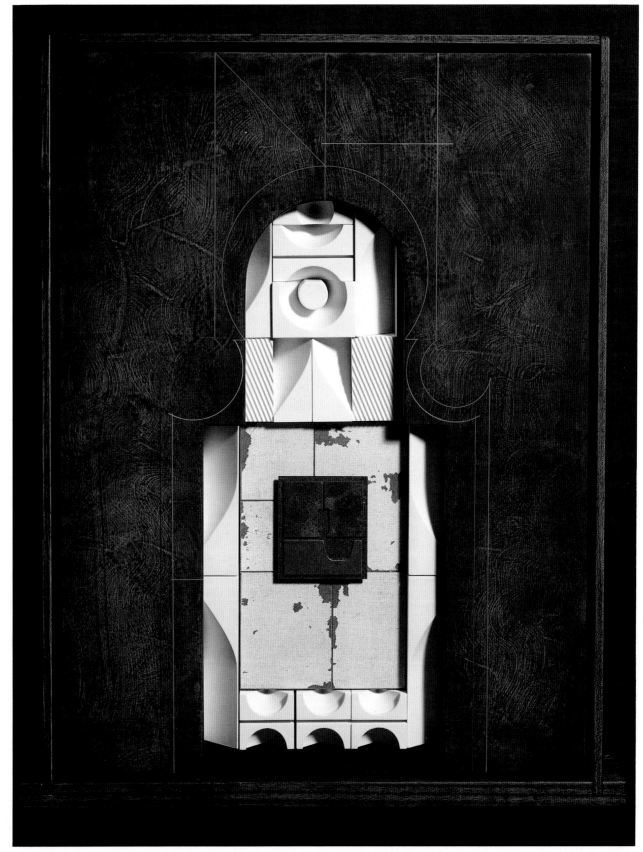

61. The Portal Series 7MC80, 1980
Mixed media, 23″ × 22½″ × 3″;
collection of the artist.

62. The Portal Series 8MC80, 1980
Mixed media, 22″ × 16½″ × 3″;
collection of the artist.

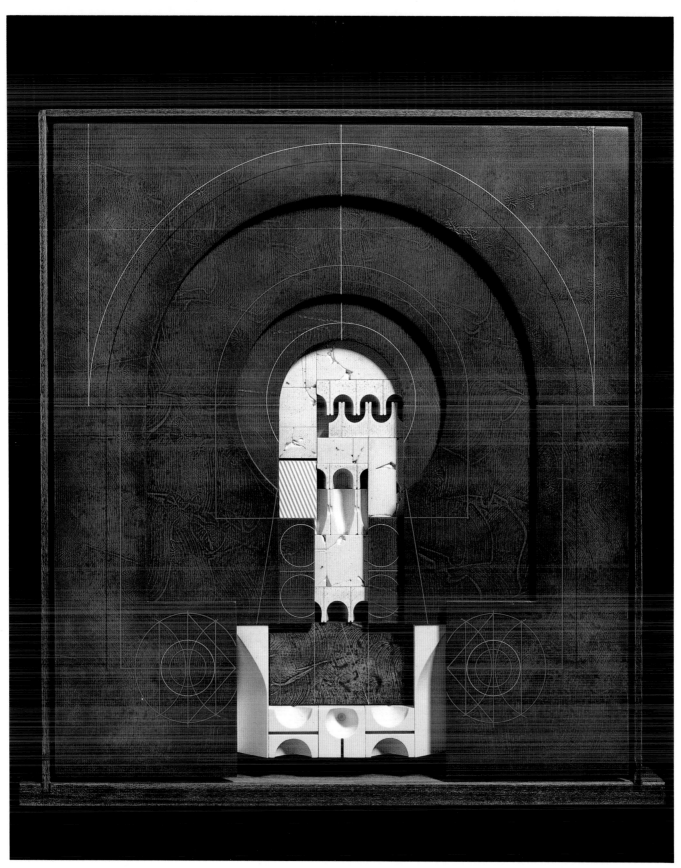

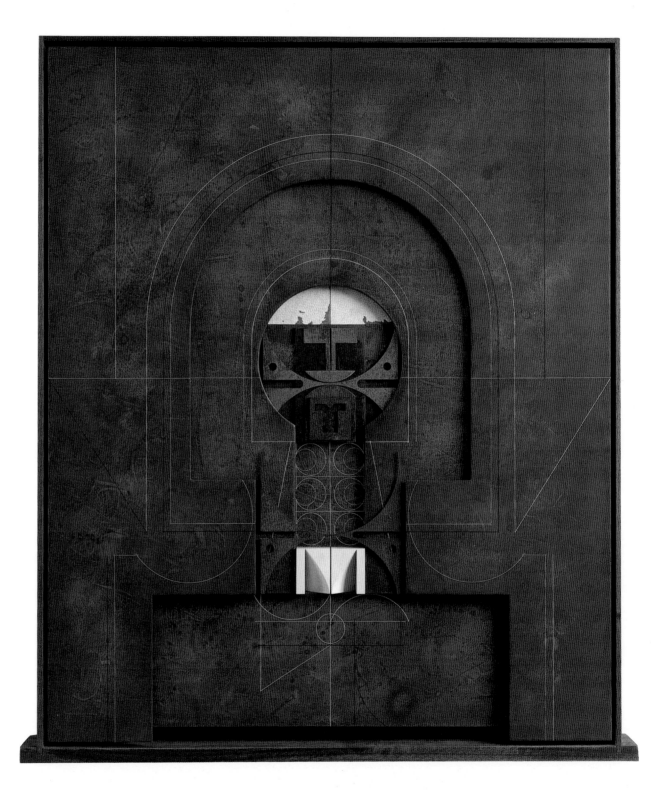

63. The Portal Series 12MC80, 1980
Mixed media, 22″ × 20″ × 3″;
collection of the artist.

64. The Portal Series 13MC81, 1981
Mixed media, 33½″ × 27″ × 3″;
private collection.

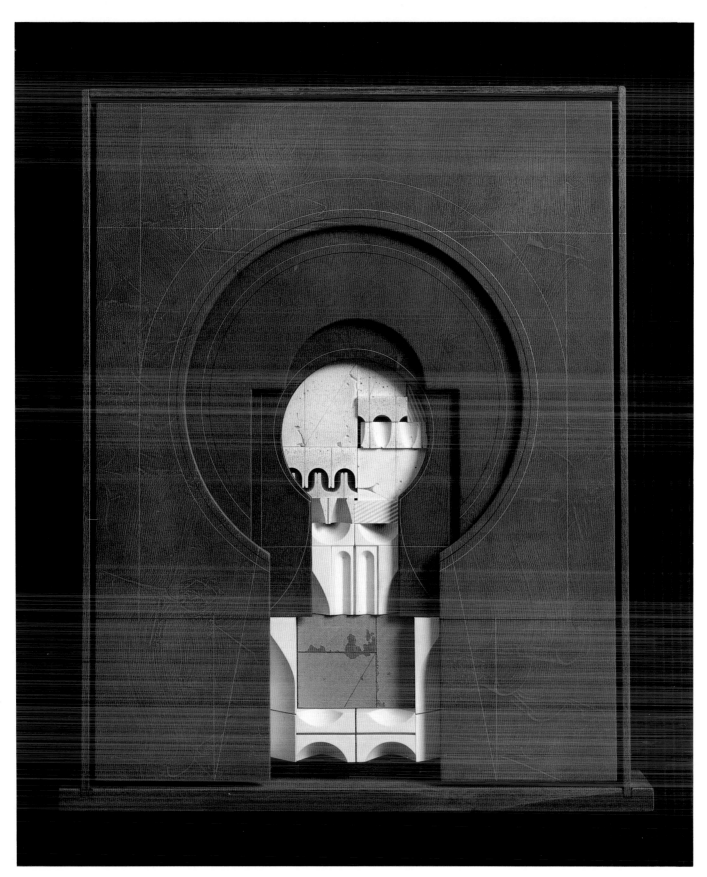

In 1978, on the occasion of an exhibition of Ajay's work at the Neuberger Museum at the State University of New York, College at Purchase, Vivien Raynor, writing for the *New York Times* (31 Dec. 1978), recalled the artist's WPA days and described a cartoon he drew to protest the ending of the project. "Nothing," she offered, "could be further from the artist's sculpture and collages, now at the Neuberger Museum . . . than that crisp little sketch from the depression days of the Works Progress Administration, in the 1930's." She continued, "But then, the cartoons of the late Ad Reinhardt did not have much to do with his purist canvases either. . . ."

In reviewing the retrospective exhibition, Raynor notes that the show includes thirty-six works, "roughly classifiable as collages, assemblages, relief paintings and combinations thereof, and a series of relief casts in dazzling white gypsum mixed with fiberglass and polymer. They cover the period 1964–78—in effect the span of Ajay's career as a fine artist." Raynor refers to the cigar mold works:

Their prime components are cigar molds that the artist discovered in a Connecticut flea market. Sliced in half, they became the corrugated ribbons that separate the rectangular planes of smooth wood. That the elements were found objects modified by the artist accounts for the overall quality of antiqueness, augmented by sweet color—rosy reds, oranges and blues all combined with white—through which the grains and cracks in the material are allowed to show. But the picturesqueness is confined to the surface, for the designs of basically clean rectangles, triangles, circles, and ovals amount to exercises in classical symmetry.

Almost as soon as it appears, the romantic quality recedes, with forms growing denser, higher and sharper, their colors reduced to black and strong red, blue, yellow and brown. But more important is the disappearance of accidental effects. For a few moments in the show, Ajay seems about to plunge into the abyss of automatism, a realm that, at that moment in the 60s, Louise Nevelson was making her own. However, he appears to have drawn back sharply and taken a course which, no less idiosyncratic than Nevelson's, is as masculine and puritanical as hers is feminine and baroque; for the next ten years there are no fingerprints to be found on an Ajay. . . .

In the late 60's Ajay began carving elements in wood and then casting them into polyester, whitened. He installed them in tall, narrow boxes glazed by colored Plexiglas arranged in bands so that they look rather like saints standing in illuminated niches—an impression reinforced by the cruciform images of the following phase. In these, the central polyester shape is combined with canvases that fit between the four arms. Narrow forms that are faceted and pocked with circular depressions, the reliefs are buttressed by related shapes painted in white, greens, sour yellows and an occasional turquoise and brown on an olive ground. Next comes a group of related works involving more canvases and more compact sculptured images and painted in grays and white.

The critic concludes:

In recent years, Ajay has allowed chance to play a part in his work. Assembling objects that include some used in the early wood pieces, he has cast them "blind," hence presumably the cracks and chips in the final surfaces. The matrices of these strange reliefs are unidentifiable, but the alternatively hard and soft, quilted forms suggest fragments of a dead civilization—ours.

65. The Portal Series 17MC81, 1981
Mixed media, 23½″ × 18½″ × 3″;
collection of the artist.

Whether the artist sought consciously to symbolize a dead civilization or simply arrived at the suggested imagery by chance, he clearly employed shapes that resembled bone structure and frequently veiled his work in layers of white, off-white or gray pigment. He allows that "in 1975, I departed from color entirely, working in the same basic format as before, but with color virtually abandoned."

These haunting works, as stark and pure as they were skillfully constructed, held viewers at a distance. They were uninviting, reticent at best; they required much of the viewer and revealed themselves and their world but gradually. These were not everyone's cozy choice for an over-the-sofa wall sculpture. (See Plates 35, 36, 39, 40, and 43.)

If Ajay responds to the lure of technical or material discovery, he also finds new direction as his attention span waxes and wanes, as he grows excited or bored, as he identifies or abandons an intellectual, often abstract notion about vision and image. Contrived excitement, playing small games with minor aspects of a mastered skill may beguile an artist, but more likely will drive his work into the arms of *mannerism* or, worse still, will imprison it behind the bars of recognizable *signature*. Ever fearful of cleverness and of the over-control which nourishes it, the artist tacked onto a new course.

## Collage Constructions, 1975–84

"It was at this point," Ajay admits, "that I felt the need to switch from the tightly controlled, premeditated moves I felt easy with to a more exciting and less predictable method of working. Courting the elements of chance and accident in process seemed a likely way out of the impasse."

Throwing out some materials and adding others, Abe revised the rituals and skills of his studio activity. Clearing the way for change in the belief that change is energy and that art appropriates and transforms energy, he began to work almost exclusively with plaster, developing what he would soon call his "blind casting" technique (Plates 47 and 48).

He discovered that a polyethylene membrane, stretched tightly over carefully selected forms, would serve as a mold for a pour of hot plaster. Contained on four sides by an adjustable fence, the resulting casting would be a mirror-image reflection of forms beneath the polyethylene. This might then be sliced and dismembered in various ways, revealing fresh possibilities for reassembly. The phrase "blind casting" is applicable here because the image is unavailable until the cured plaster-pour is inverted.

Immediately after the white plaster works of 1975–76, Ajay returned hungrily to color (see Plates 49 and 50). "I combined white castings with stained canvas as a ground for superimposed found material," he says, "but I've never been quite sure how I feel about the results. I made about six of them, I believe, most of which were never shown. After the all-white show in '77, I thrashed about a bit, searching for a new excitement, but this particular direction was short-lived."

In 1977, Irving Sandler examined Ajay's work for *Arts Magazine* (Feb. 1977), remarking that "sudden conversions in style are common in the history of modern art."

He traced Ajay's metamorphosis from his "encounter (in the most profound sense of the word)" with wood cigar molds in a flea market in Ridgefield, Connecticut in 1963, through the permutations of skill and form that followed, to 1977. As he speculated on the causes of Ajay's history of shifting styles and directions in his work, Sandler speculated, "The deeper causes of Ajay's change in style are most likely unfathomable, but it is possible to venture a few reasonable speculations. For example, he began his career on the Federal Art Project in the late 1930's, when geometric abtraction was the dominant avant-garde tendency. The Cubist and Constructivist ideas he assimilated then remained with him (as they did with his life-long friend, Ad Reinhardt)."

This essential concern with form, argued Sandler, prepared Ajay to be

. . . drawn to the cigar mold, because its shape is hard-edged—a narrow, rounded hollow tapered at each end, tunneled and tipped—like an arch, a favorite motif of his. Moreover, he was struck by its potential as a found object at a time when many artists were venturing into junk assemblage. Ajay was also taken with the form's allusions to both man-made artifacts and biomorphic nature. Finally, cigar molds are flat solid objects that can be built with and painted on. This dual use was enormously appealing to Ajay who has fluctuated between being a painter and a construction-sculptor, and more often than not has tried to be both at once.

[Recounting Abe's dissection and reconstitution of the cigar mold to develop modular units, Sandler contended that the artist's work possessed] the thoughtfully conceived structure and fine workmanship associated with Neo-Plasticist, Bauhaus, and Russian Constructivism, and the improvised, rough look of junk assemblage. This mixture was a paradoxical one, since the found materials evoked the disorderly industrial and urban environment that Constructivism, with its will to perfection and its Utopian aspirations, historically strove to eliminate.

Thus, according to Sandler, Ajay's obsession with form and his faithfulness to the highest standards of craftsmanship predisposed him to exploration as a means of discovering and perfecting form. Such a quest necessarily results in changes in direction, changes in style. Once Abe had recognized the cigar molds as a means for examining *form,* compulsion set in: he had taken the first step, he would walk the distance.

Blind casting enabled Ajay to fabricate some new sculptural forms and, simultaneously, to be surprised by their variations on or deviations from his original models; in this manner, he both created and found the pieces needed for his constructions. "As Ajay's process changed, so did his subject matter," wrote Sandler. "Instead of the futuristic figures in his earlier constructions, he half-discovered, half invented abstract landscapes containing what looked like the multi-arched façades of Byzantine churches, not cathedrals but primitive, tottering buildings. The plaster surfaces, in places wrinkled, cracked, and bubbled, enhanced the romantic, archaic feeling of the imagery. It was natural for Ajay to think of architecture. All Constructivist artists have." But Abe's architecture grew from mind and memory, shaped by his cultural heritage, inducing him, as Sandler saw it, to turn from the "impersonal Constructivist vision of a future society as a kind of ideal machine whose cogs would be perfect persons. He replaced it with a private, poetic vision closer to his own roots."

Still, Ajay's vision is marked by a sense of aloofness, of detachment; he discovered and captured his ideas and images through a largely intellectual process, after all, and not through the more visceral operation of recollection.

Sandler recognized the disparate and contradictory forces in Ajay's work: the private imagery impeccably presented to public view, the passion both checked and quickened by rationality, the flirtation with chaos that informs order and the pristine techniques that conjure freedom for the artist. Moreover, Sandler saw Abe as a part of art history, not as an outsider forever pressing a visual argument for his case. That was in 1977.

The *Arts Magazine* article truly reflected Ajay's past and has proven true, as well, for work that Ajay has accomplished since Sandler's analysis. Typically, Ajay works in series, establishing an idea or image and then redefining and exploring it through several stages of development. Although he employs similar techniques and materials, courts similar ideas and compositions, each piece in a series gains uniqueness, identity. Moreover, taken as a whole, each series allows the artist the time and space to complete a total exploration, including cul-de-sacs which may end the series, sometimes precipitously.

"Collage seemed like a good, quiet harbor to sail into back in 1978," recounts the artist. "At least until I could get my sea-legs again. Deep, rich color, sit-down work for a change, no sawdust or noise, no lugging or lifting or junkyard excursions. clearly a painting involvement once again, with landscape as the image and an infusion of suggested architecture here and there."

Thinking back over the collage inception, he admits, "Here is where I might really explore some elements of chance and accident, controlled by my choice of edge, shape, and position, and quickly reversible if I regretted a decision I made the day before." (Plates 51–56.)

Ajay continues, "I found the collage activity a perfect counterplay to the constructions I turned out during the same period. Both were acts of building, layering, adding-up, although collage-making took a big bite out of the painting act for me. Thus, I could indulge both appetites at one and the same time quite easily. I included a dozen or more collages in my shows of '82 and '84 as a foil for the three-dimensional constructions."

At his first exhibition of collages in New York, Abe prepared an artist's statement:

"It may be said that those who do not learn from art history are doomed to repeat it. I bow to no one in my admiration for that progenitor of the collage, Kurt Schwitters, but have studiously avoided his example in my choice of materials.

"The list of materials not to be found in my collages is fairly extensive: tickets to La Scala, Gauloise wrappers, sheet music, tear-stained love letters, attic cobwebs, turkey feathers, dried leaves, butterflies, logos, names, addresses, dispossess notices; all of these I leave to those manufacturers of 'good taste' who still sense some redeeming aesthetic grace in nostalgic memorabilia.

"My collage materials are not elaborate. They consist solely of a wide variety of oriental papers which I saturate with a deeply concentrated watercolor. The concept develops when I begin to cut, tear, or otherwise fragment the materials, at which point the image seeds itself.

"These collages are, in fact, paintings in which the brushstrokes are fixed color swatches, superimposed, reversible, and happily amenable to second thoughts. The materials are weightless, portable, and clean and the process is agreeably sedentary. These works might easily be made in a wheelchair or sitting up on a high stool in a monastery. It pleases me to report that I am, at the moment, confined to neither."

## Portal Series, 1980–82

"I consider the Portal Series (Plates 59–66) to be a major watershed in my evolution as an artist," acknowledges Ajay. "Perhaps the imagery harkens back to those church paintings I had seen as a child. I don't know. But I do know that I had never, until this moment, been so deeply and profoundly engaged in a body of work which seemed so self-generating. One piece would beget another and then leapfrog itself into three or four more.

In 1979, before embarking on this series, the artist made two trial relief paintings, *M179* (Plate 57) and *M279* (Plate 58) using Masonite as a substitute for a stretched canvas support. "It could be cut into any shape or size I chose with hand or power tools and was far less expensive than any good grade of linen or cotton duck. It was absolutely stable, unresponsive to changes in temperature or humidity, and would not need to be pegged or restretched from time to time to regain a taut painting surface.

For his exhibition of the Portal Series in 1982, Ajay wrote the following statement:

"My work has always explored an elemental geometry, basically the straight line, the circle, and a myriad of coalitions thereof. It is disciplined, motionless, silent, and devoid of anecdote, metaphor, or surrealist mystique. The imagery is strictly architectonic, free of sentimental reference or autobiographical chit-chat. It toes no line, promotes no cause, purveys no gossip, and dispenses no information. It leads no one beside any still waters. It is not very tricky. It does not sit up and beg.

"While the subject matter, or lack of it, has remained constant in my work over the years, the format and choice of materials have varied considerably since 1964. After a nearly total reliance on found material for my first exhibition at the Rose Fried Gallery, I developed methods of moldmaking and casting which allowed me to design and fabricate my own found material. Since then, the forms with which I have worked more clearly reflect my own sensibilities rather than those imposed by some chance encounter in a junkyard.

"By designing these forms to a modular scale of measurement, I allowed for an infinite variety of matings and exchanges among elements of the vocabulary. Moreover, the restrictions I placed on the number of master units involved multiplied, in inverse ratio, the opportunities for invention within the system itself. These forms became the armature upon which I have modeled each stage of my evolution as an artist and that progression, with all its stretch-marks of search and discovery, has been clearly documented in a dozen or more exhibitions since 1964.

"This most recent body of work, which I have called 'The Portal Series,'
represents an amalgam or coming together of all the things I have taught myself in
the past decade and I have married elements of painting, drawing, and sculpture in
the process. In the series, I have sought to combine the immediacy and sensuality of
the gesture or brushstroke with the bleached-bone anatomy of some imagined, long-
lost, medieval architecture. Essentially, the works consist of one or more layered
picture planes in a box construction, revealing, as the planes recede, a totally
subjective world of two- and three-dimensional iconography. While they may, at
first glance, affect an ecclesiastical presence, they are in fact profoundly secular and
reflect no religious predilection on the part of this artist. He has none."

## Façade and Reliquary Series, 1982

"In the summer of 1982," Abe recalls, "I felt the need for a new vocabulary of three-
dimensional imagery, less formally geometric than the '67 crop, and devoid of any
power tool connotations. Working with clay and Plasticine, I produced a series of relief
models (Plates 67–70) reflecting signs of my hand and the cuneiform impressions of
found objects I had collected for just such an enterprise. I made rubber molds of the
images which interested me so that I might cast any number of repeats as the need arose.
A light glaze of raw sienna served to reveal the detail of the castings, giving them, in
addition, the rich patina of ancient ivory.

"Years before, I had discovered some old ironing boards in my eighteenth-century
attic and was hoarding them for an appropriate occasion. This seemed the proper time
to haul them down into twentieth-century service.

"I was pleased with the combinations of castings and found material. The stains and
signs of traffic on the wood played nicely against the ivory-like patina of the new
vocabulary. A series resulted, with a dozen or more works being realized before the attic
windfall was exhausted."

## Rock Maple Constructions, 1984–85

After the Façade and Reliquary Series, Abe began working with wood acquired directly
from the lumberyard, a hard rock maple carefully selected for its color and markings
(Plates 71–78). "These were obviously informed by my Portal works, with their use of
the arch and nearly central placement of main elements. The three-quarter-inch maple
stock gave me a thickness which worked well in suggesting depth on various levels of
the construction. In the niches and apertures of the work were installed castings from
both 'vocabulary' series. Sometimes, to create another level of interest, I would
superimpose a wire overlay on the central image, harking back to the grillwork I had
seen in Barcelona in '82. The wire work was fabricated from several thicknesses of
welding-rod, which I would bend to my will and solder, with considerable attention to
design. The wire then served as a three-dimensional drawing device, casting its line

shadows on the surface beneath. These works are basically monochromatic, with the sienna range of the maple and the ivory color of the castings working hand in hand."

In 1984, Abe showed his work at the Sid Deutsch Gallery and, as customary, prepared an artist's statement for visitors to the gallery.

"It is reasonable to assume that the artist is not tongue-tied, knows more about what he is doing than anybody else and is willing to share that information with his audience. Therefore, the following commentary:

"The fact that my work bears little resemblance to anything on the contemporary scene may be either a boon or a burden, but, to purloin a quip from Groucho Marx, I am not at all certain I would want to be a part of any movement that would have me.

"While I swim with no school in the current mainstream, I have been known to do a respectable dog-paddle with Constructivism, a tag which may not exactly bring me up to date with the crowd, but which does, on occasion, earn me a nod from perceptive art historians. Even dinosaurs have their day.

"A new relief vocabulary is introduced in this exhibition, going beyond the machine-made modular units I designed in the late sixties. Working with clay in the summer of 1982, I developed a series of images reflecting signs of my hand rather than the geometry of the power tool. I made molds of the ones which interested me and cast the new forms in a special blend of polyester resin. Consequently, I am now able to combine both high- and low-relief elements in a single format, furthering the three-dimensional dialogue so central to my work.

"These pieces are built almost entirely of wood; pine in the earlier 1982–83 series and a hard, rock maple in the most recent constructions. In addition, I eliminated the surface application of line in these later works and am now drawing with light and shadow alone through a change in elevations within the picture plane. The soldered metal overlays add another element of shadow play and were inspired by a recent journey through southern Spain. The imagery reflects a private architectural fantasy, with its variety of apertures, projections, and secret places claiming territory as the piece moves toward completion.

"Collage-making, for me, is basically an act of painting, allowing me to indulge an appetite for immediacy and providing a respite from the technical demands of the complex constructions. The materials are simple and straightforward and consist solely of watercolor applied to a variety of oriental papers. I build them with as much concern for structure as their three-dimensional counterparts and invoke no subject matter except that of imaginary landscape or invented architecture.

"Few of the materials employed in my work are used in their original state. Many are exposed to the tender mercies of chance and accident, courting a metamorphosis in color, texture, and tonality. These fragments, or shards, then become a sort of special-effects bank upon which I may draw months later to punctuate a work in progress.

"Although they may appear some distance apart in media and execution, it should be clear that these two bodies of work come from the same head and hand. Both are informed by the same aesthetic concerns, private conceits, and professional compulsions. As the artist grows wiser, his work develops accordingly and takes on exciting new form, if he is fortunate, with each passing season."

The artist admits that he is uncertain how he feels about his construction 985 (Plate 76); for example, the tall free-form wall piece, he says, "represents my only attempt to break out of the box format I have favored since the beginning." He pauses, "Another attempt to loosen the Constructivist hold on me? Maybe so."

## Mixed Media Constructions, 1986–89

In reviewing his dark and complex constructions of 1986 (Plates 79–81), Ajay speculates: "In many ways, I feel this batch may be some of my best stuff, although I found their intensity so exhausting that I've only produced about a half dozen in the series."

In discussing a tandem and current body of work (Plates 82–97), the artist describes it as a replay of the Portal Series which so engaged him in 1982–83. "The arch remains ubiquitous but the centrality of image has all but disappeared. Now both sides of the court are being played, main elements off-center very often, icon giving way to landscape, plus or minus architecture with a Florentine or Italian Renaissance look around the edges. But still within the earth-tone palette, an acid green and a sharp vermilion here and there for accent and some careful line drawing pulling the whole panorama together."

At the time of Ajay's 1987 exhibition at the Sid Deutsch Gallery, a statement by the artist invited his audience to think with him about the making of the works displayed.

"The search which takes place in my studio might best be described as a mining operation, a vertical dig in which a number of discoveries are apt to surface from a single shaft. This show, for example, is comprised of three distinct, yet affiliated, bodies of work. Although the color and surface handling may vary from series to series, the relief elements employed are frequently identical, however varied the context in which they appear.

"In the darker series, both found and fabricated forms combine with units of the three-dimensional modular vocabulary I have used since 1968. Soldered wire overlays add illusory depth to these labyrinthine façades whose shadow play and complexity recall the burnt sienna cliff dwellings I saw in Morroco.

"The other two groups of work are less dramatic in their departure from my usual norm. One series employs a highly finished rock maple, selected for its color and markings, while resin castings and fragments of metal occupy strategic points in the basically Constructivist design. Works similar to these were exhibited in 1984.

"The final series consists of four pieces, identical in format and reminiscent of the Portal Series shown in 1982. Each work contains, in its upper circular opening, an antique, hand-colored print. I discovered these prints in an old, abandoned astronomical atlas titled, 'The Geography of the Heavens,' published in 1835. Below this collage element is a recessed installation of ivory-like castings which form a three-dimensional counterpoint to the graphic insert above. The frontal planes of these constructions are surfaced with a heavy, gestural impasto and glazed with several coats of raw sienna and umber. Finally, a network of thinly drawn lines is superimposed, making connections with the collage axis and key points in the textured surface.

"This, then, is a brief glimpse of the nature of this exhibition. It does not reveal how and why certain decisions were made, or how an artist knows when a work is fully realized. That remains a mystery. Logically, every studio triumph should be marked by a blast from a full symphony orchestra. Failing that, the warbling of a simple, but affirmative choir of angels will do the trick."

# The Artist Interviews Himself

ABE AJAY SITS IN A SMALL ROOM AT THE BACK of his studio, an office of sorts, with a desk against one wall, a workshelf against the opposite; bulletin boards contain neatly pinned mementos and messages; a small radio sings softly in the corner. He thinks back over the conversations and reflections that congealed in this book; enough looking back, enough raking through the hot coals of previous times and work arbitrarily called *finished*. It is time, now, to sum it all up and take the next step, open the next door, conjure up the next batch of work. The artist interviews himself; the two sides meet. This is their conversation:

*Ajay vs. Ajay*
Unfettered by any ethical considerations, the artist interviews himself.

*Q*: You sound impatient, to say the least, with what is happening in the art world today. Just what, specifically, do you find discouraging and how do you account for it?

*A*: I'm pretty tired of the "look, Ma, no hands" approach which is so fashionable in just about all of the plastic arts today. With few exceptions, the frantic scramble for a trendy "new" look has robbed painting of its discipline, sculpture of its coherence, and printmaking of both. Too much of what we see celebrated as high art today isn't just dumb, it's literally brain-dead on arrival.

*Q*: Who's responsible for the decline?

*A*: In a society on the prowl for instant gratification, it may be inevitable that the heady mix of money, sex, and violence intoxicates the art world as well. And why not? Making it big in Soho and hitting the jackpot on Wall Street are not that far apart. "Know-nothingism" and greed call the cultural tune today and a hedonistic art market trips the light fantastic. Who's responsible? The artist, dealer, critic, and collector, all bear equal responsibility for the betrayal. What more can I say?

*Q*: How has the artist, for example, contributed to this sorry state of affairs?

*A*: By signing on. By scrambling aboard the bandwagon. By lending a talent (or lack of it) to the get-rich-and-famous-quick shellgame. By not learning how to draw or paint or spark a sculpture by rubbing two sticks together. By pumping the bowels rather than the brain and offering the effluent as a blessed sacrament to the faithful. If I were to design a banner for a trek through current art history, the heraldic image comes to mind quite easily: Narcissus rampant on a field of raw sewage.

*Q*: OK. So you don't think much of what's happening in the so-called "mainstream" art world. Is is possible to detach yourself so completely from the scene that the fallout doesn't bother you?

*A*: Indeed I can. Hell, I've been "out of the loop" for so long now that I don't even feel lonely anymore. There's a certain serenity connected with walking into my studio at six in the morning, closing the door on a world I never made and then working a twelve-hour day constructing a universe for which I'm totally responsible. It's not always peaceful and never easy, but it feels good and once in a while something not entirely hopeless rolls off the assembly line.

*Q*: Describe your work, if you can, and tell us a bit about its historical roots, its current direction, and where it might be headed in the future.

*A*: I can deal with the first part of that question but I'm not sure about the last. The future, I suspect, will come down the pike under its own steam. As for the work itself, I remain an unrepentant "object maker," a full decade after that currency was devalued in favor of performance art and self-immolation. The work is usually three-dimensional, hangs on the wall and makes a credible pass at Constructivism, a word not likely to whet a collector's appetite these days, especially one raised on such high-calorie munchies as Neo Geo and Arte Povera. My imagery is abstract, totally, and looks a lot like invented architecture or a recycled archaeological dig. The colors are, for the most part, low key, ranging from muted earth tones to acid yellows and greens with an occasional overlay of cerulean blue, vermilion, or gold in the drawing. The medium is mixed, incorporating found objects, polyester resin, wood, canvas, wire, and any likely flotsam that washes ashore. There is no subject matter, no metaphor, no autobiography, no narrative, no jokes, and no tortured assessment of the human condition. No rebate, no coupons, and no shot at winning a trip to a warmer climate. What you see is what you get, and that, clearly, is all. If I were to venture a musical equation, a quiet mix of Bartok and Vivaldi would win hands down, I trust, over the amplified cacophony of "The Grateful Dead."

*Q*: Why have you alternated, at times, between collage and construction as a format for your work?

*A*: For me, collage-making is an act of painting. Blessedly silent, peaceful and clean, it can be done anywhere, with few, if any, tools or equipment. Constructions, on the other hand, are messy, full of sound and fury, a complex technology and involve some element of physical risk. When I need a respite from all that noise and debris, I sneak in a dalliance with collage, always a compliant mistress when the nagging gets heavy at home.

*Q*: How come you don't title your works? They seem eligible for something a bit more romantic than code numbers. Ever consider it?

*A*: I tried it once, a long time ago. Back in 1966, I titled the second show I had with Rose Fried. Called myself "Fried's Fraud" for months after. Spent days flipping through things like the Koran, the Holy Bible, Bartlett's Familiar Quotations, Washington's Farewell Address to his troops. It felt pretty sleazy and I knocked it off after that. I decided that if the work needed frosting, I'd better take a closer look at the cake. Anyway, most titles seem tacked on to the work, gratuitous, extra baggage. And titles with "homage to" up front are often amusing, if not ludicrous. Somebody once said, maybe it was Isaac Newton, "I am never so tall as when I stand on the shoulders of giants." So I don't put names on my things anymore. Just rank and serial number.

*Q*: What are your feelings about an artist sounding off politically through his or her work?

*A*: I have no problem with that. I think it's just fine, perhaps even admirable for an artist's political convictions to be right up front if he so chooses. But unless that artist is a syndicated cartoonist with at least a dozen papers under his belt, a film maker with a prime-time TV connection, or a standup comic with an enormous following, it's pretty silly to pretend the message is reaching any significant audience.

*Q*: If you don't believe an easel painter, say, can be politically persuasive through his work, how do you see him influencing the social and political climate around him?

*A*: He can work like hell to get out the vote, for one thing. Register the disenfranchised, canvass door to door for progressive, liberal candidates, march in demonstrations, give money if he has any, lick stamps, hand out leaflets, risk getting hit over the head. It's too damned easy, in the smug safety of the studio, to practice a voodoo political activism, sticking pins in a few battered effigies, slaying the usual dragons with the flick of a palette knife. One's ego may do a high-wire act after such an exercise but the audience wouldn't fill a telephone booth. All things considered, self-service is best confined to the gasoline pump.

*Q*: What significant contribution can an artist make today to the crazy "out-of-order" world in which we live?

*A*: I make few demands on art and artists which I don't impose in my own studio. Namely, that art should be intelligently conceived, well made, and reasonably good to look at. By following these simple rules, the art scene might, in a century or two, begin to look a little less like a toxic-waste dump. That in itself would be a magnificent contribution to the environment, cultural and otherwise. I might even go a step further and suggest that galleries and museums be required to contribute to a clean-up "superfund" much like that required of the oil companies, to pay for scrubbing away some of the visual pollution for which they're responsible.

*Q*: If what you say about the contemporary scene is true, how do you account for the fact that the art market is booming? How come all those trendy folk, some of them still in their teens, are riding around in stretch limousines? How about that long list of collectors waiting in line for just one teeny weeny Anselm Kiefer? Isn't yours really a voice in the wilderness?

*A*: Ah, Wilderness. I'll admit that a single voice doesn't make a choir, if that's what you mean, but there are a hell of a lot of people out there who share my view of the current scene. I know that's true because I've talked to some of them and they're as disturbed as I am about what's going on. The art world is now a fashion industry, led around by its Whitney Biennial "nose for the new look." But nobody, it seems, has the guts or the brains to blow the necessary whistle and holler, "Hold on guys? What the hell is *this* ugly bit of business?" Every time some new huckster of angst-ridden metaphor is anointed by *Art Forum,* the congregation genuflects, stroking the catalog like a handful of Rosary beads, and starts spreading that Old Gospel according to Hyperbole. No questions asked. Intimidated by the media and awed by the sweet smell of success, folks begin to think ugly art looks ugly only because they're not sufficiently "with it" to know it's beautiful. And thus the bill of goods is sold, all along the line. An art historical snake swallowing its own tale.

*Q*: Hold on a minute, Abe. Aren't you pulling that old shtick about the emperor ain't got no wardrobe? We've run that one into the ground.

*A*: You got it all wrong, pal. This particular emperor is a real dude: briefs by Calvin Klein; outer wear by Christian Dior; patent leather pumps by Gucci. And an avant gardenia in the buttonhole. Not exactly sackcloth and ashes, in anybody's book.

*Q*: Words that begin with the letter "P" are frequently used in discussion of your work. *Precision, Pristine, Perfection,* spring to mind. How do you feel about this, and what does it mean?

*A*: I guess I'd rather have somebody say, "I caught your show last week, fellah. It sure was real *neat,* no kidding!" No ambiguity there. I would think that they liked the work, not the tidy housekeeping or the attention to craft. So I'm not a slob. What else is new? What is often described as a reach toward perfection is simply the mark of the power tool. Motor driven, it is inclined to cut a clean, true line if kept in shape. So I've been hostage, in a sense, to that power technology. And I've tried to break away from the "machined" look in a number of ways. In 1982, in order to court some sign of my hand in both the imagery and the casting process, I worked with clay. That move spawned a new, low-relief vocabulary which marries well with the crisp geometry of the original modular alphabet. I am perfectly aligned (there you go again!) with Robert Lowell's statement that "Imperfection is the language of art." No argument there.

*Q*: You describe the contemporary scene as a "toxic-waste dump." Is there any work being done these days of which you do approve? Any artists you admire?

*A*: When I say negative things about the stuff that is getting attention these days, I don't mean to imply that works of real quality are not being produced. That would be stupid. But I do think a great number of first-rate artists are so turned off by the gallery system that they've hopped off the merry-go-round. And there are others just hanging on by a thread, hoping for the day when quality becomes fashionable again. But fine painters like Richard Diebenkorn are still highly visible. Sculptors like Philip Grausman, too little known, are turning out extraordinary work with regularity; Will Barnet, an elder statesman at this point, still shows signs of his gifted hand each year. No, there are indeed good people around doing valuable work, quietly, sans fanfare, and most often with far less attention than they deserve. So I'm not quite the curmudgeon you expected, right? Let it be so recorded.

*Q*: In addition to being a working artist, you have taught and lectured at a number of universities for nearly twenty years. What drew you to the teaching profession? Does it conflict with your studio activity? How do you manage the juggling act?

*A*: First, let's be damned clear about the bookkeeping. Artists who make a living solely from their studio activity are rare indeed. Add the loneliness of the long distance painter to that bottom-line and you wind up with teaching as a natural extension of the studio, a closed circuit in which it's all too easy to imagine oneself the center of the universe. And that's very risky business. So go get a teaching job, I said to myself, as I tossed my hat in the academic ring. The year was 1968.

Always the loyal friend, Will Barnet eased me into a summer slot at the University of Minnesota in Duluth and I did well enough to be invited back the following year. After that teaching experience, a good one, I would read a piece by my friend Howard Taubman (then critic-at-large for the *New York Times*) describing a new SUNY campus to be opened in Purchase, New York, an hour's drive from my studio. An innovative marriage of the arts and humanities, said Howard, and I thought that an exciting idea. I still do. About a month later, fortune smiled auspiciously when Betty and I met the Purchase arts dean, Gibson Danes, and his wife, Ilse Getz, a fine artist in her own right, at the Barnet's summer home in Danbury. We soon became good friends and have exchanged studio visits and culinary adventures ever since. When I was asked to join the Purchase faculty I didn't demur, and remain enormously grateful for that benediction.

As for conflict, I see none at all. There are times, of course, when I find it hard to tear myself away from the studio to make an early class, but that's OK. If I'm feeling strong about my own work, I'm a pretty good teacher. If I don't feel on top of what's happening in the studio I have some trouble making a connection with the students, but, ideally, the two activities should marry well. One informs the other if everything falls into place.

Q: Since you, yourself, never had any formal art training, do you feel at any disadvantage in your role as professor in a university art program?

A: Not at all. I teach out of my own history. A clear advantage, really, because I don't have to cut through a lot of fat to get to the bone. Of course, one may miss the brief comfort of bringing in a ready-made syllabus to that first day in class, one lifted bodily, perhaps, from some memorable graduate experience at Yale or Cranbrook. I don't own a notebook filled with gleanings from an Albers color course, for example. Failing that, I advise students on the subject of color as follows: "If it looks good enough to eat, use it."

Q: It is rumored that you like to teach a freshman class each year because they haven't heard your jokes before. How true is that, and why the fun and games routine?

A: Well, I do like dealing with freshmen because I think it's important to get in on the ground floor, if possible. They come to you with very few preconceptions, not tainted, as yet, by much traffic with theory or practice. Most are graduates of a highschool program in which the art experience begins with play dough and ends with papier mâché. As for the jokes, let it be known that I frown a lot, too. Maybe it's just that the whole notion of an art school seems so utterly absurd to me. That, plus the fact that the profession to which these children aspire is so cruel and destructive, making a moment of levity, if not a fortnight of prayer, seem a simple act of humanity.

Q: On March 24, 1989, you celebrated your seventieth birthday. It cannot be said that an infinite number of productive years lie ahead. How does this knowledge affect your studio activity and your plans for the years to come?

A: With a little bit of luck and a benign genetic inheritance, the work should get better and better as the artist grows older and wiser, making up in skill and vision and grace of execution for what the physical plant loses in muscle tone. In all of this, the neatest trick may be simply that of staying alive. I've lost so many dear friends in the past several years that I can no longer do the arithmetic. Accordingly, every dawn which sees me able to rise and shine and crank up another day in the studio is a blessing of which I take the fullest advantage. And every good work which comes from my hand puts a further distance between me and that inevitable rendezvous with oblivion.

Q: Thank you very much. It's been nice talking to you.

A: Likewise. Have a nice day.

66. The Portal Series 19MC82, 1982
Mixed media, $33\frac{1}{2}'' \times 29\frac{1}{2}'' \times 3''$;
collection of the artist.

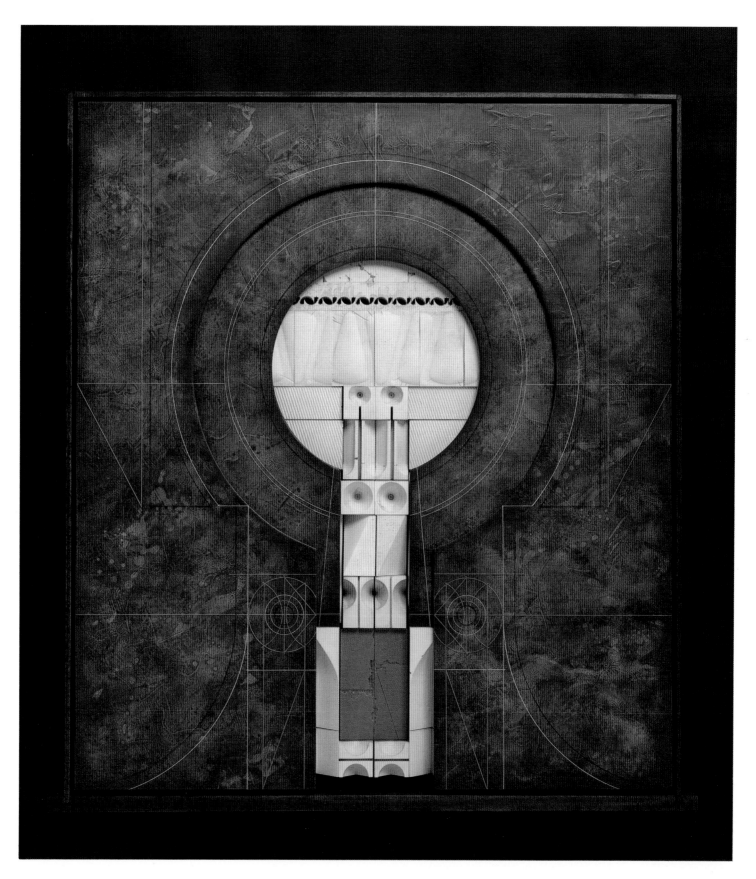

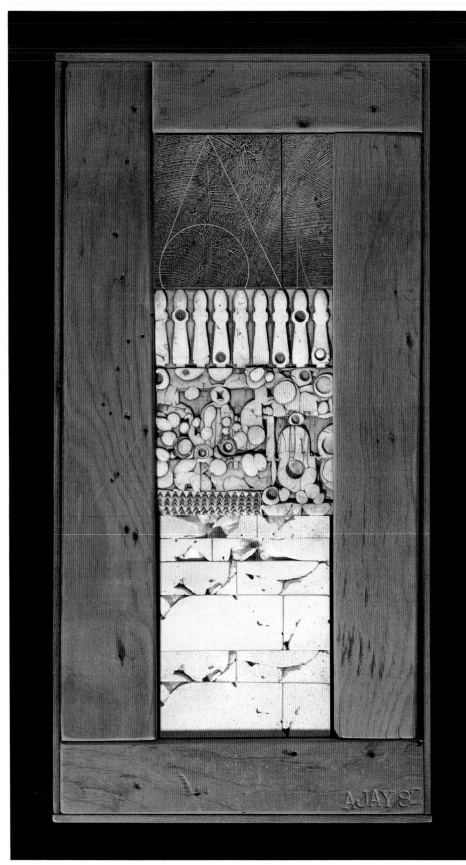

67. Façade and Reliquary Series 1, 1982
Wood and polyester resin, $16'' \times 8'' \times 1\frac{1}{2}''$;
collection of the artist.

68. Façade and Reliquary Series 5, 1982
Wood and polyester resin, $17'' \times 8'' \times 1\frac{1}{2}''$;
private collection.

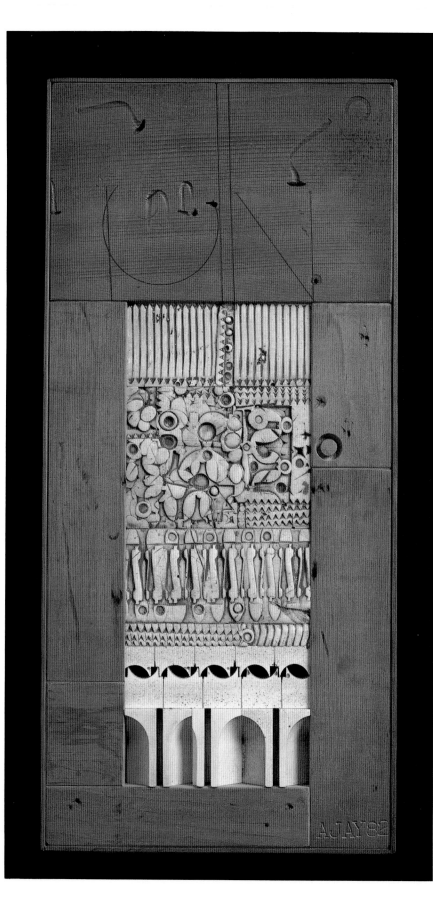

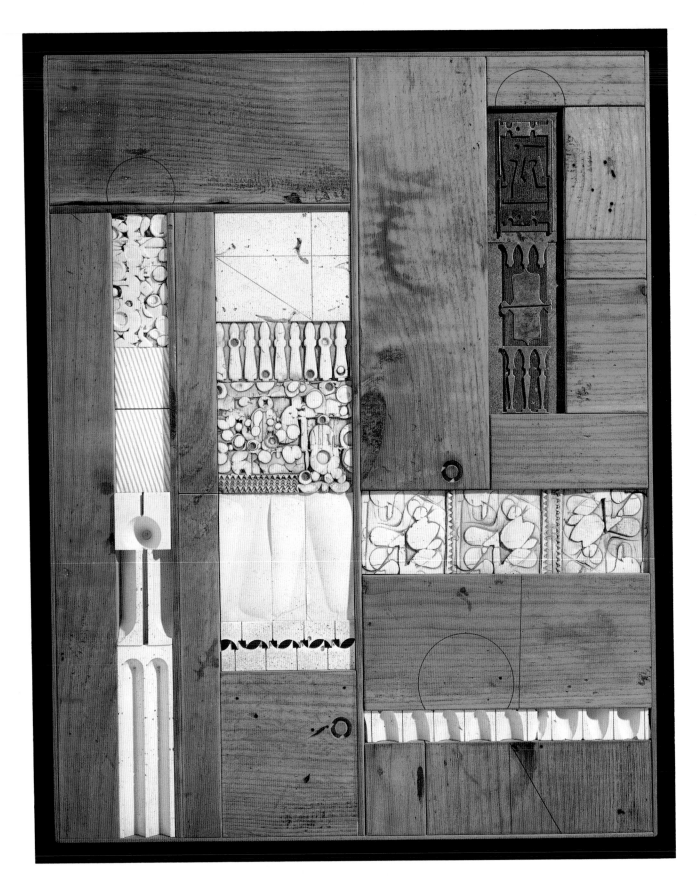

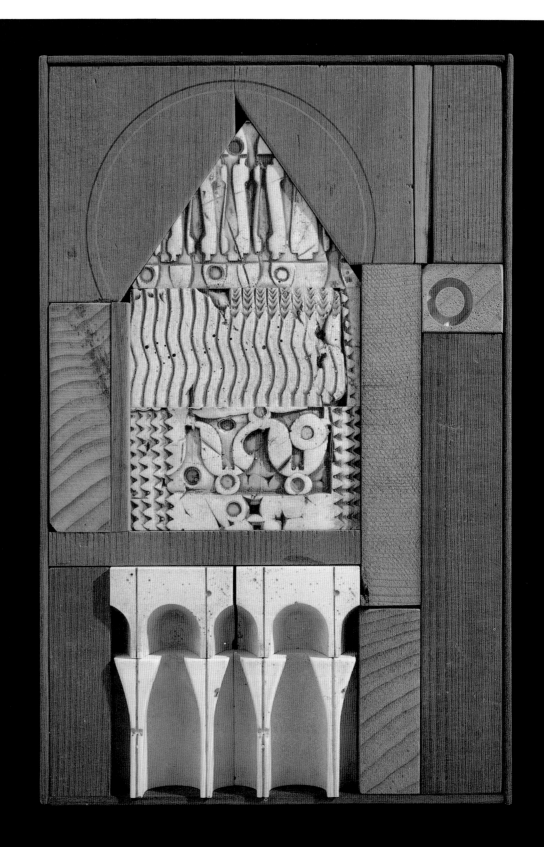

69. Façade and Reliquary Series 9, 1982
Wood, metal, polyester resin, 21″ × 17″
× 1½″; private collection.

70. Façade and Reliquary Series 15, 1983
Wood and polyester resin, 9½″ × 6″;
collection of the artist.

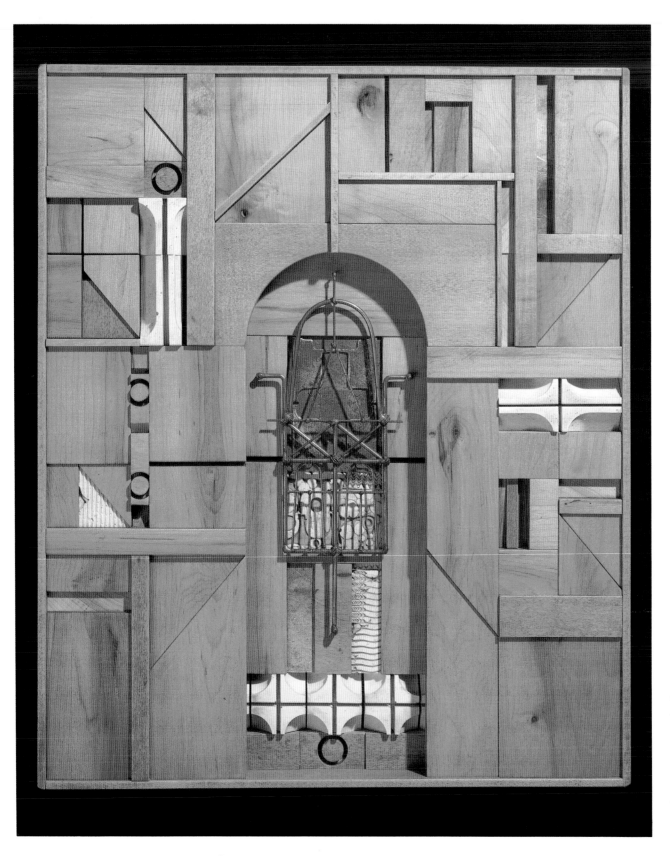

71. Construction 184, 1984
Wood, metal, polyester resin, 19¼″
× 16¼″ × 3″; private collection.

72. Construction 384, 1984
Wood, metal, polyester resin, 19¼″
× 16½″ × 3″; private collection.

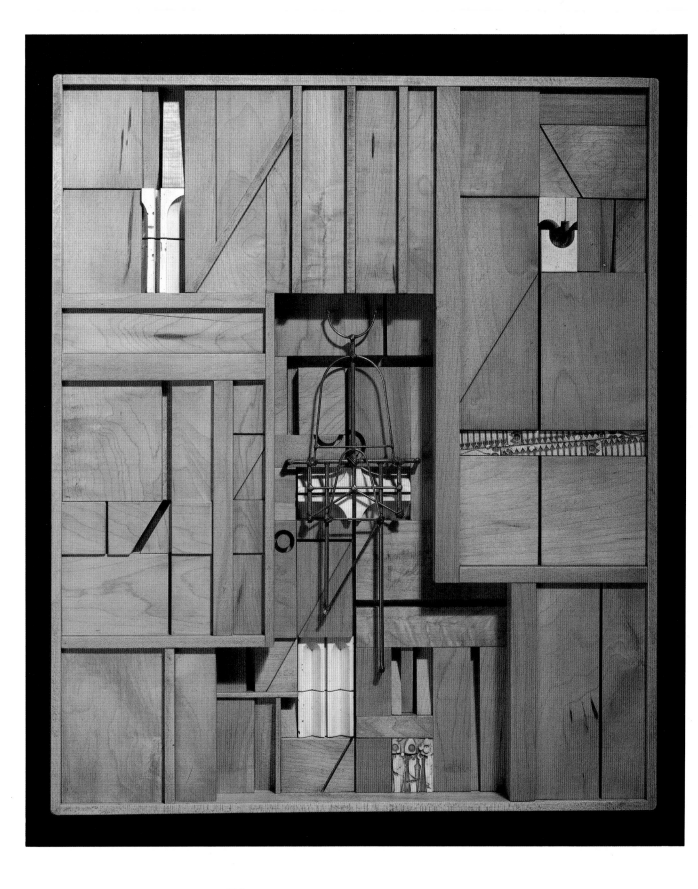

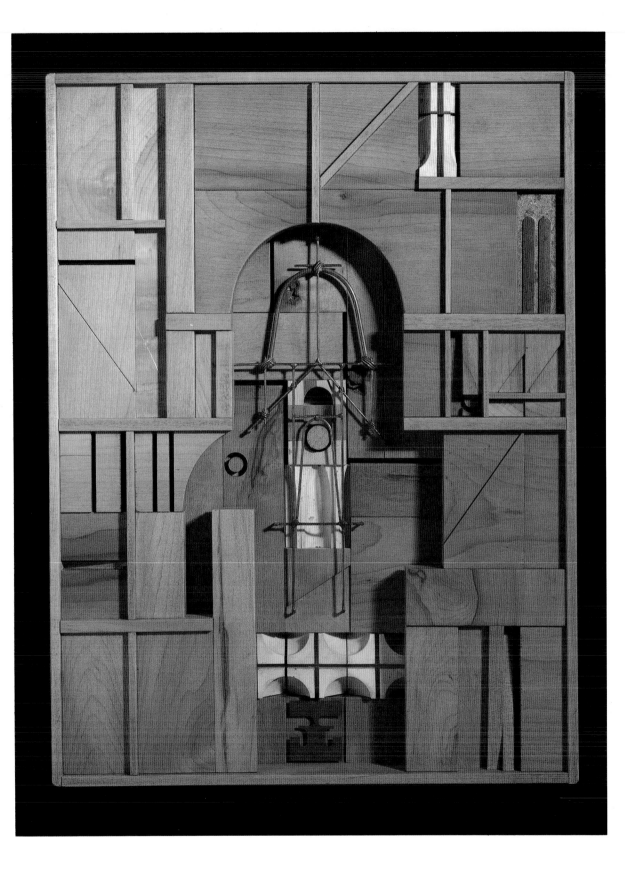

73. Construction 484, 1984
Wood, metal, polyester resin, 17″
× 13″ × 3″; collection of the artist.

74. Construction 684, 1984
Wood, metal, polyester resin, 19″
× 18¼″ × 3″; collection of the artist.

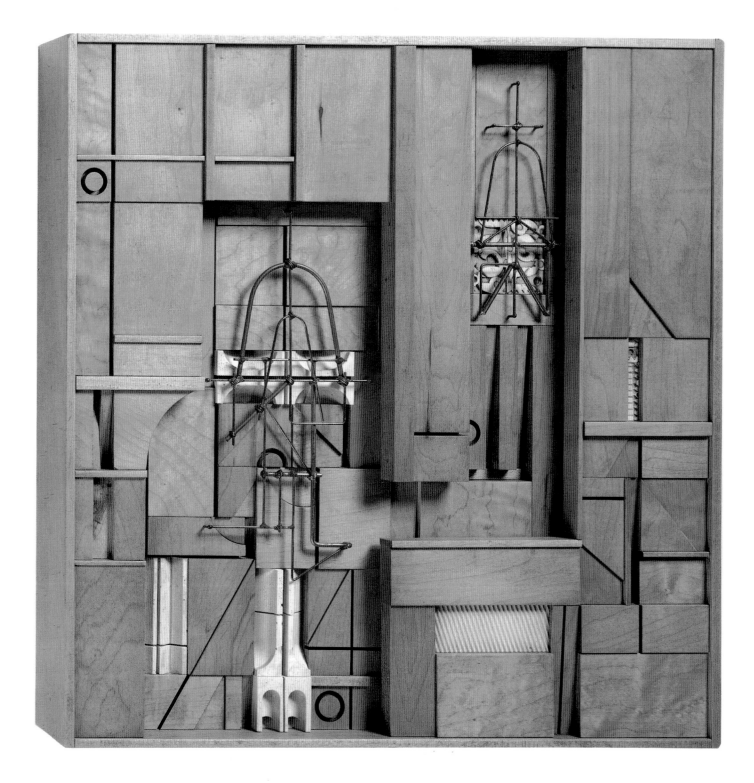

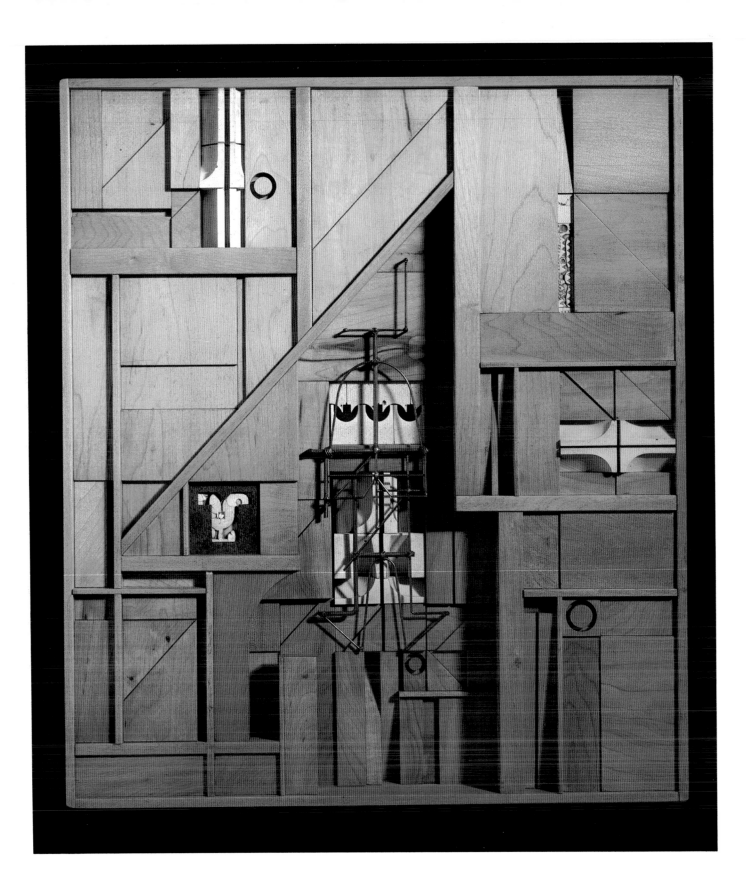

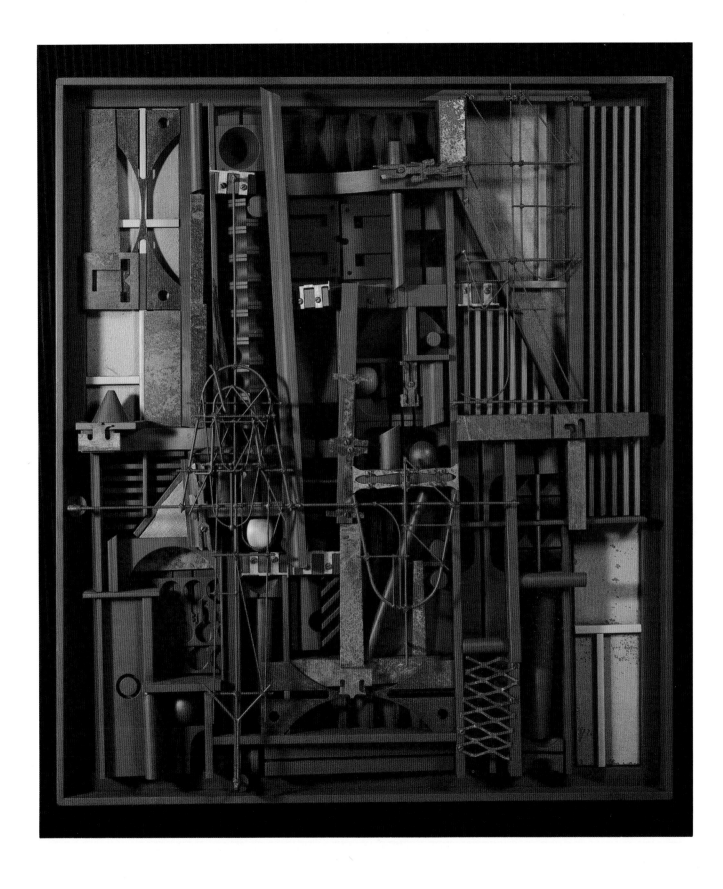

81. Construction 486, 1986
Mixed media, $23\frac{1}{2}'' \times 15'' \times 4''$;
collection of the artist.

82. Construction 887, 1987
Mixed media, $14'' \times 19'' \times 3''$;
collection of the artist.

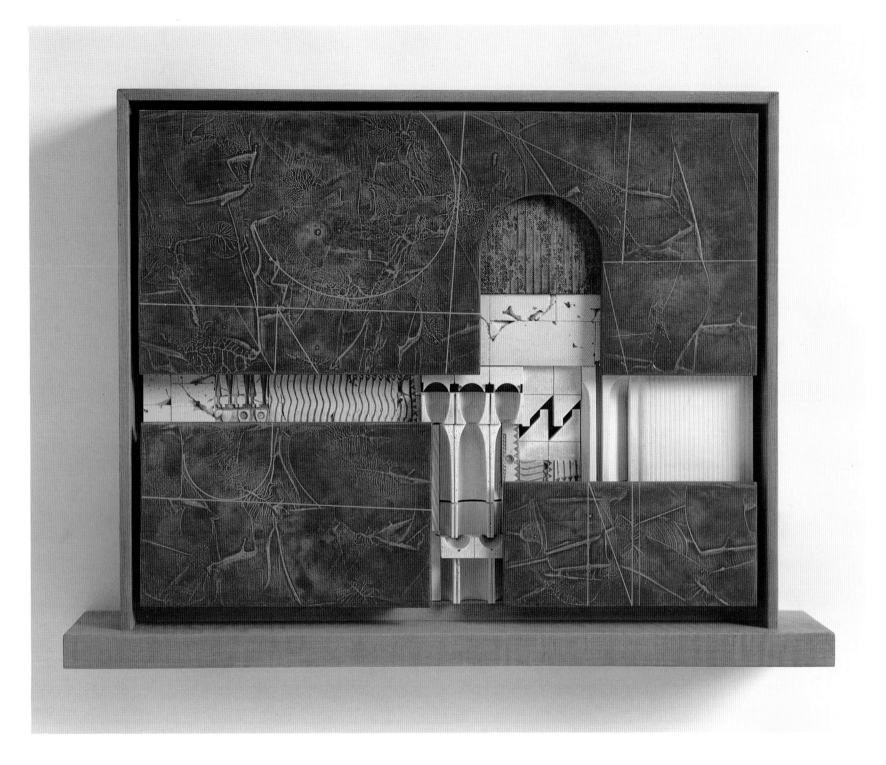

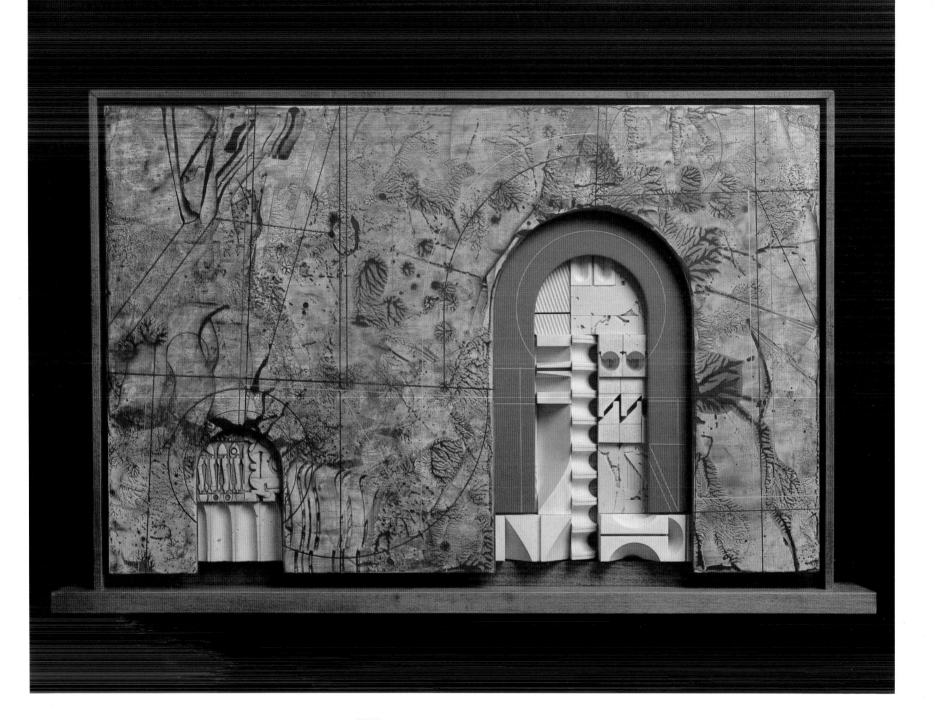

75. Construction 584, 1984
Wood, metal, polyester resin, $19\frac{1}{2}''$
$\times 17\frac{1}{2}'' \times 3''$; collection of the artist.

76. Construction 985, 1985
Wood, metal, polyester resin, $55''$
$\times 34'' \times 4''$; collection of the artist.

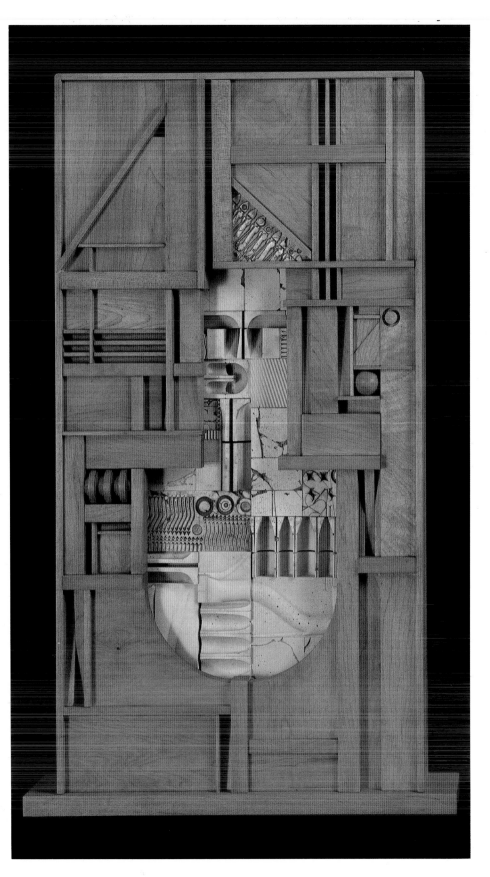

77. Construction 1085, 1985
Wood, polyester resin, 29″ × 17½″ × 3″;
collection of the artist.

78. Construction 1185, 1985
Wood, metal, polyester resin, 42½″
× 25″ × 4″; collection of the artist.

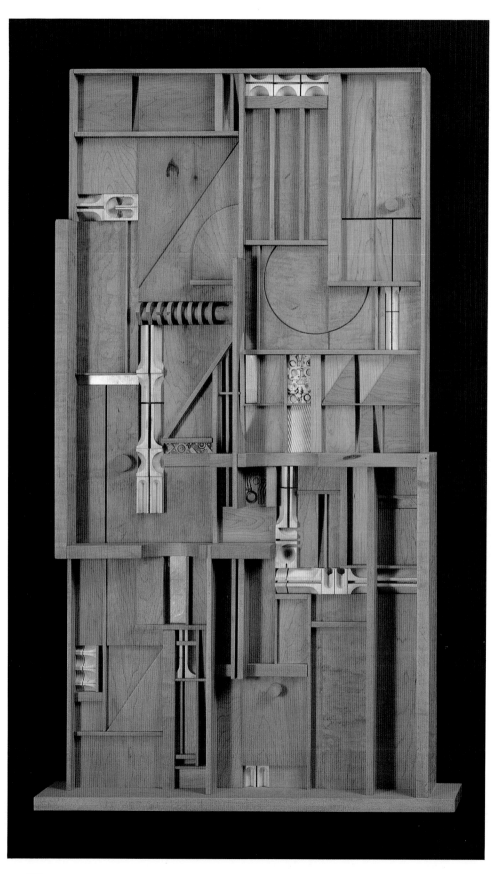

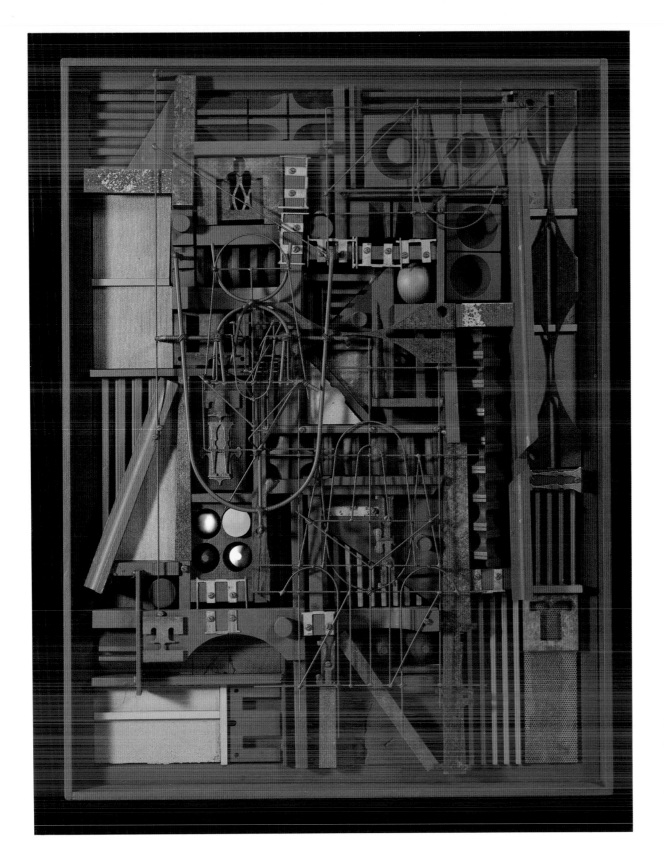

79. Construction 286, 1986
Mixed media, 25″ × 19″ × 4″;
collection of the artist.

80. Construction 386, 1986
Mixed media, 25″ × 22″ × 4″;
collection of the artist.

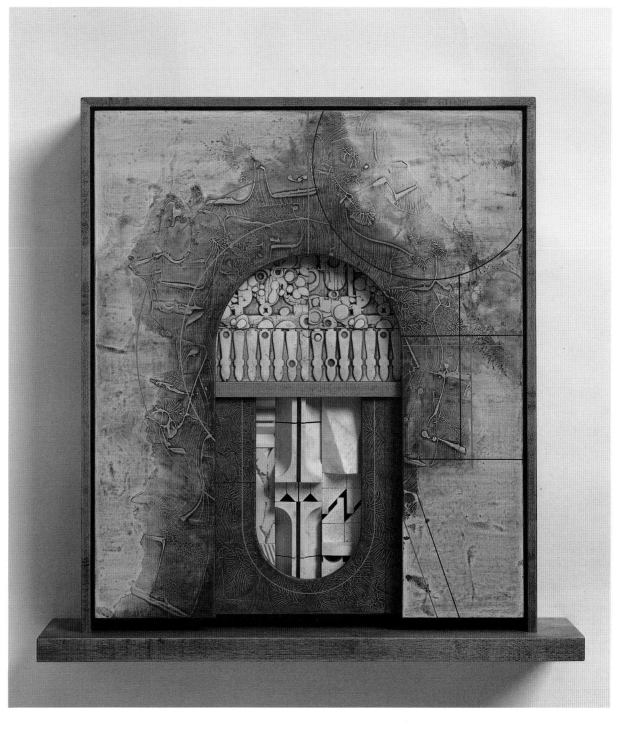

83. Construction 987, 1987
Mixed media, 18″ × 29″ × 3″;
collection of the artist.

84. Construction 1087, 1987
Mixed media, 17½″ × 17½″ × 3″;
collection of the artist.

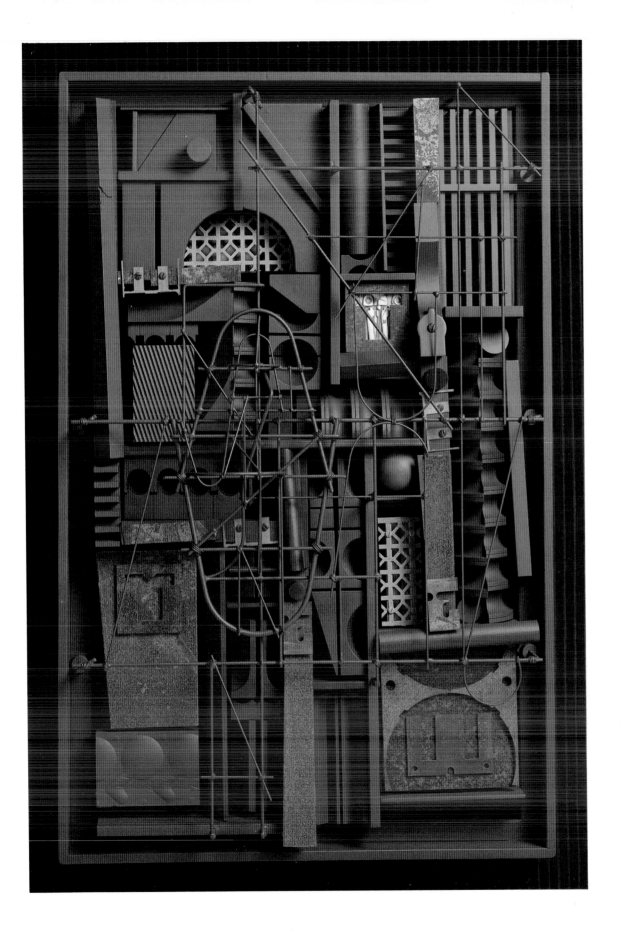

85. Construction 188, 1988
Mixed media, 23″ × 15″ × 5″;
collection of the artist.

86. Construction 288, 1988
Mixed media, 30″ × 37″ × 3″;
collection of the artist.

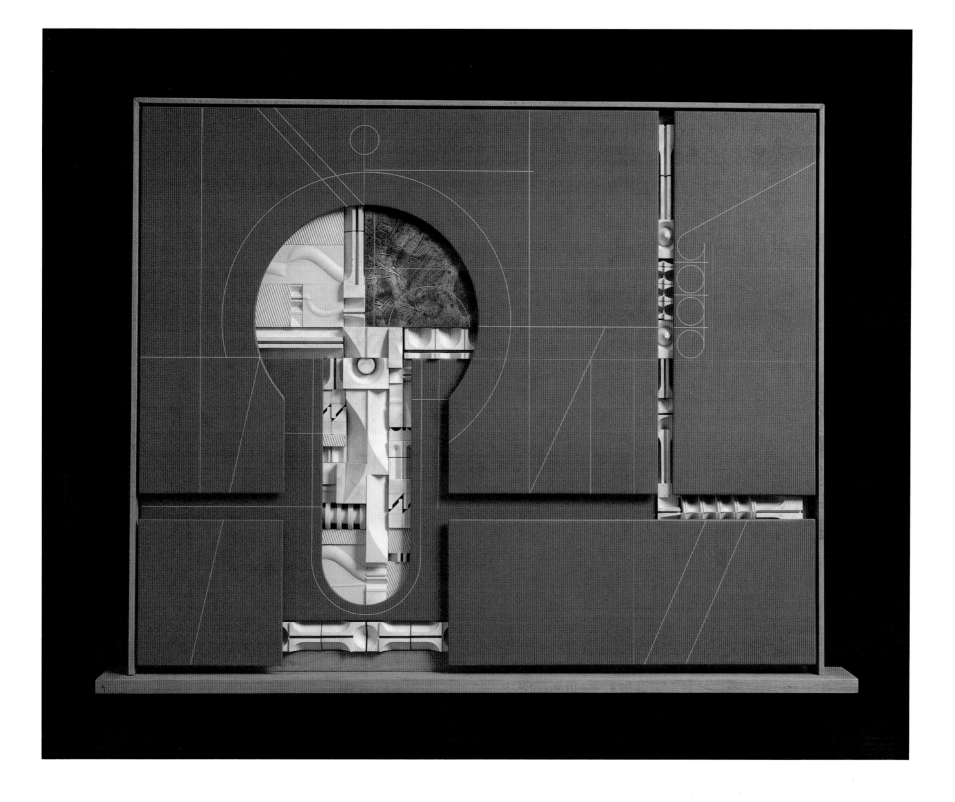

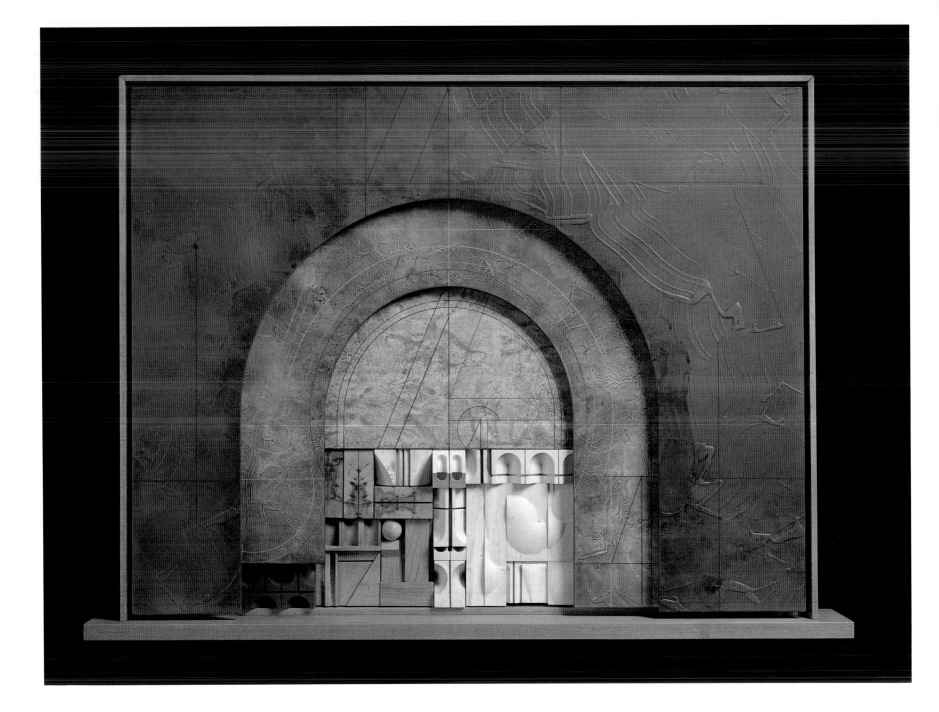

87. Construction 388, 1988
Mixed media, 26″ × 36″ × 4″;
collection of the artist.

88. Construction 488, 1988
Mixed media, 13″ × 30″ × 3½″;
collection of the artist.

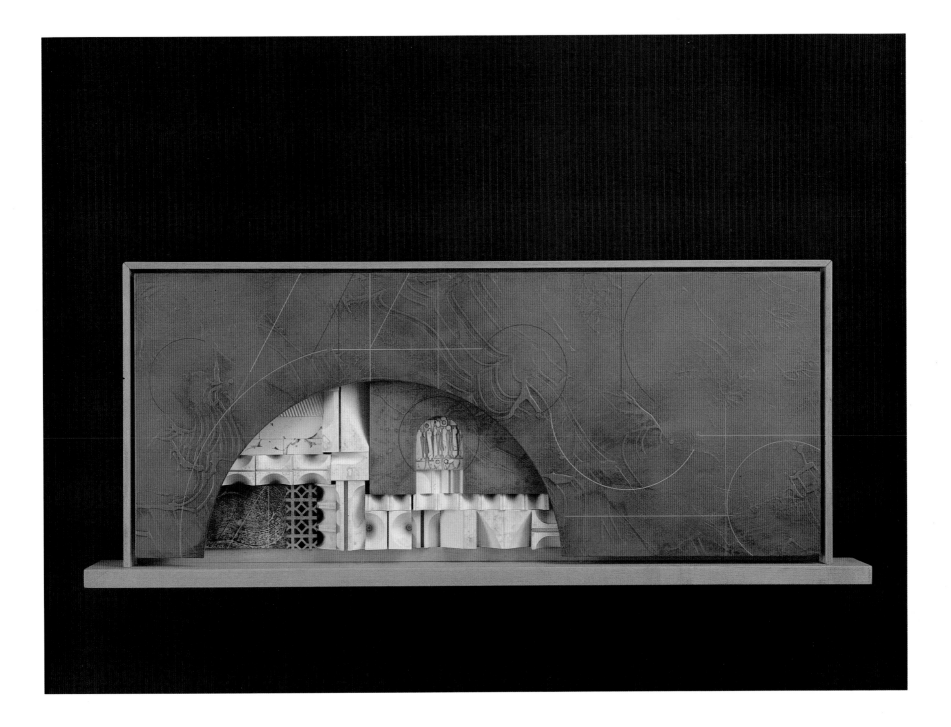

89. Construction 588, 1988
Mixed media, $31\frac{1}{2}'' \times 19\frac{1}{2}'' \times 3\frac{1}{2}''$.

90. Construction 688, 1988
Mixed media, $31'' \times 36'' \times 4''$;
collection of the artist.

91. Construction 889, 1989
Mixed media, 21″ × 24″ × 5″;
collection of the artist.

92. Construction 189, 1989
Mixed media, 26″ × 18″ × 4″;
collection of the artist.

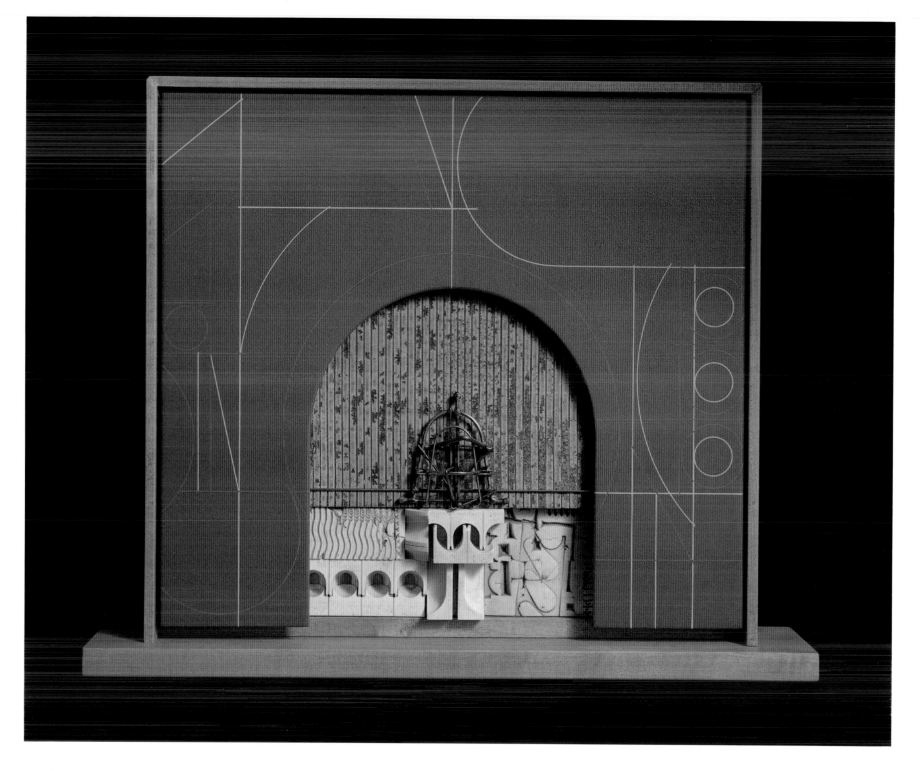

93. Construction 289, 1989
Mixed media, 15½" × 19½" × 3½";
collection of the artist.

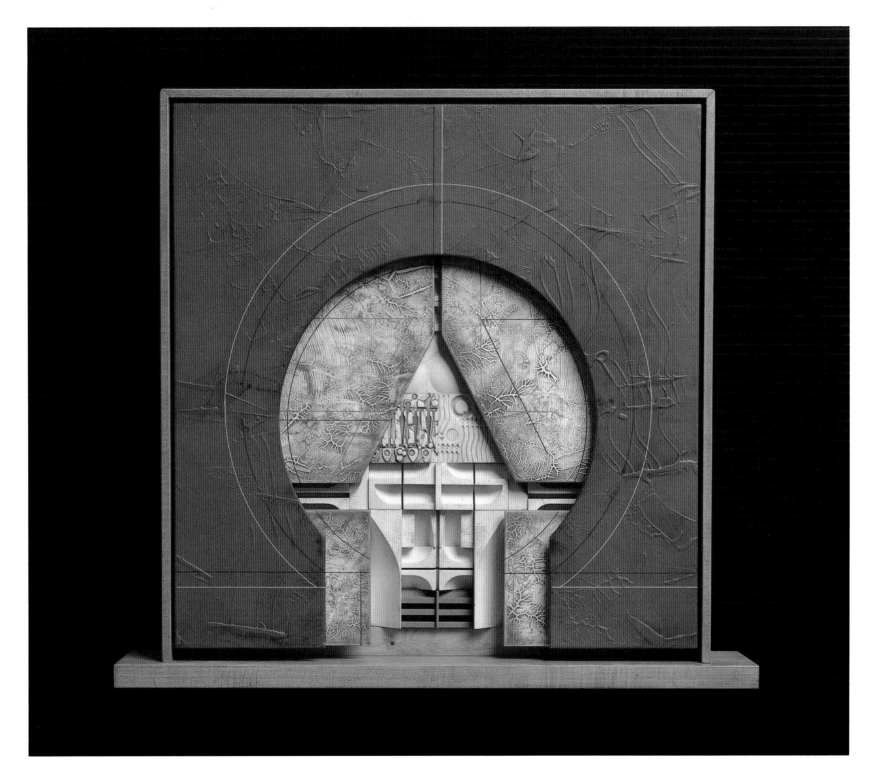

94. Construction 389, 1989
Mixed media, 19″ × 21″ × 3½″;
collection of the artist.

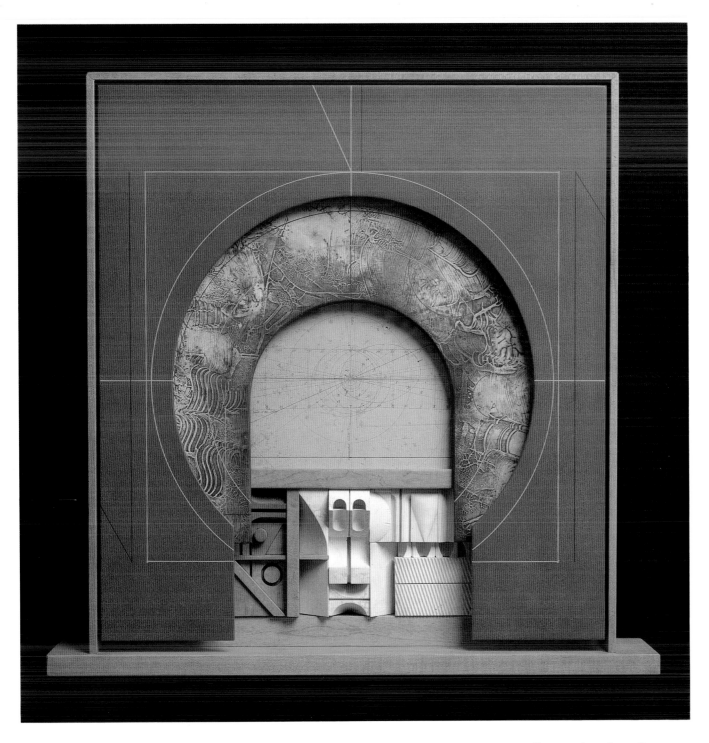

95. Construction 489, 1989
Mixed media, $21\frac{1}{2}'' \times 23'' \times 4''$;
collection of the artist.

96. Construction 589, 1989
Mixed media, $26'' \times 34'' \times 5''$;
collection of the artist.

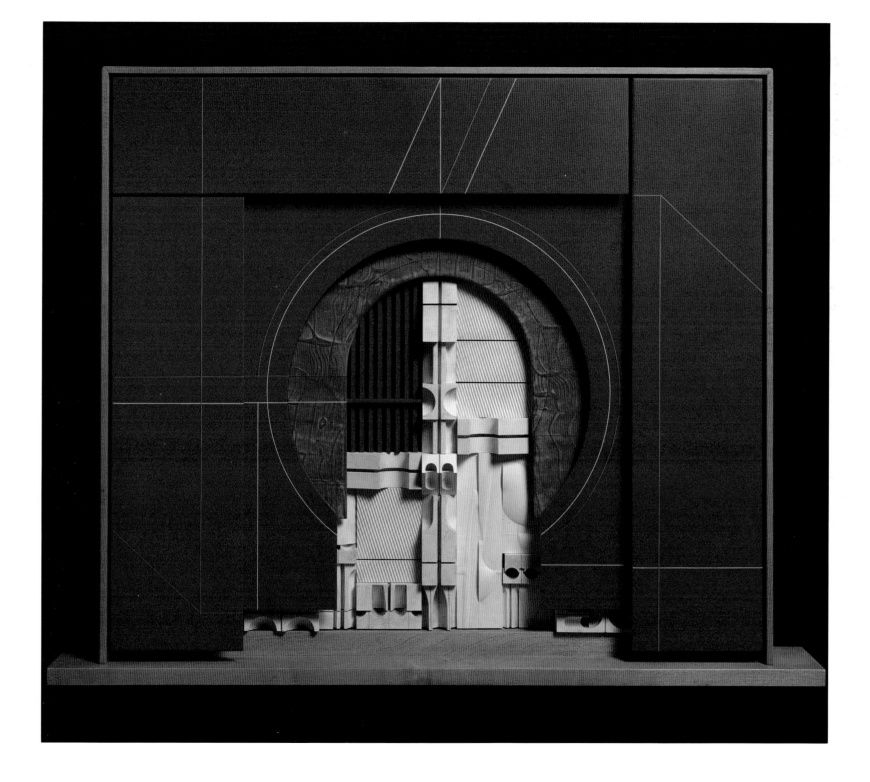

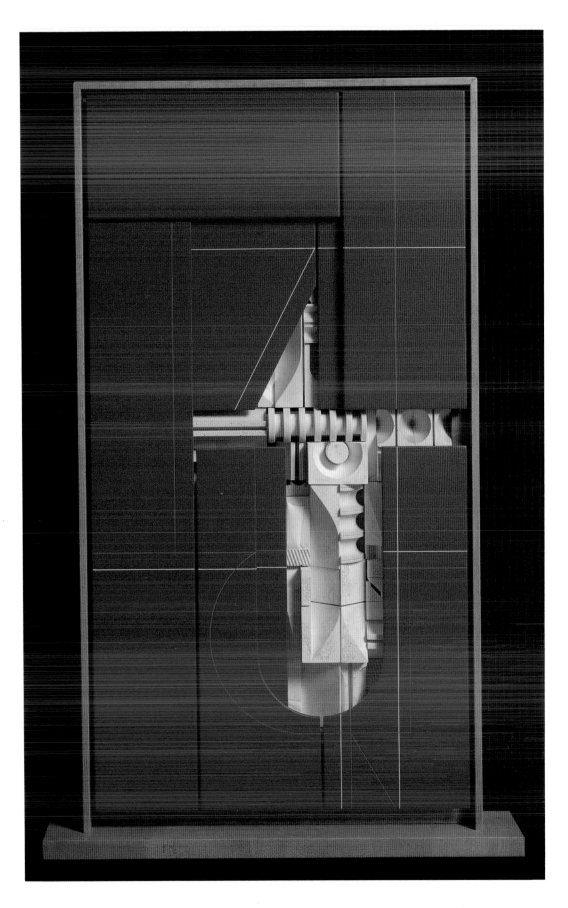

97. Construction 789, 1989
Mixed media, 30″ × 19″ × 4″;
collection of the artist.

# Epilogue

P ERHAPS WE ARE LEFT WITH MORE QUESTIONS than answers; perhaps this is ordained in all matters pertaining to art. The man makes art; art makes the man. Abe Ajay focuses on the world, clears the lens of his mind, and selects the truths that, appropriated for and incorporated into his work, approximate his vision. The work takes form, compelled and enforced by barely perceived powers; in turn, the work claims the artist and transforms him in the image of art. A toss up, an even bet as to whether Abe controls his work or, in the end, his work controls him. It does not seem to matter—even to this fretful, amused, passionate artist.

*Work* is the issue: work in the candy store, work in the saloon, work within the requirements of the WPA, work to earn a living and support a family; the fortunate person finds his work-of-works, a ritual and daily obligation to step outside himself, invoke and obey forces emanating from the deeply mysterious magnetic field of the human mind in search of itself and its god. Inevitability snared Abe's soul, shaped it in the holiness of work-to-make-art. He knows that such work has no end, that in his remaining years he will live in the knowledge that he has work yet to do: the artist claimed, the artist in grace, the artist at work.

# Collections and Exhibits

## Collections

Aldrich Museum of Contemporary Art, Ridgefield, Connecticut

Allentown Art Museum, Allentown, Pennsylvania

Bank of America, Los Angeles, California

Birla Academy of Art and Culture, Calcutta, India

Grey Art Gallery and Study Center, New York University Art Collection,
    New York, New York

Heublein, Inc., Farmington, Connecticut

Hirshhorn Museum and Sculpture Garden, Smithsonian Institution,
    Washington, D.C.

Housatonic Museum of Art, Bridgeport, Connecticut

J. Walter Thompson Company, New York, New York

Johnson Art Museum, Cornell University, Ithaca, New York

McKnight Art Center/Ulrich Museum of Art, Wichita State University,
    Wichita, Kansas

Metropolitan Museum of Art, New York, New York

Mount Holyoke College Art Museum, South Hadley, Massachusetts

National Museum of American Art, Smithsonian Institution, Washington, D.C.

Neuberger Museum, State University of New York, College at Purchase, New York

Pennsylvania Academy of the Fine Arts, Philadelphia, Pennsylvania

Solomon R. Guggenheim Museum, New York, New York

Tweed Museum of Art, University of Minnesota, Duluth, Minnesota

USX Corporation, Pittsburgh, Pennsylvania

## Solo Exhibitions

| | |
|---|---|
| 1964 | Rose Fried Gallery, New York |
| 1966 | Rose Fried Gallery, New York |
| 1968 | Rose Fried Gallery, New York |
| 1969 | Tweed Museum of Art, University of Minnesota, Duluth (catalog essay by John M. Johansen) |
| 1970 | Gimpel and Wietzenhoffer, New York |
| 1971 | Comsky Gallery, Los Angeles |

| 1972 | Oliver Wolcott Library, Litchfield, Connecticut |
| 1973 | Gimpel and Weitzenhoffer, New York |
| 1975 | Gimpel and Weitzenhoffer, New York |
| 1976 | County Federal Savings and Loan, Westport, Connecticut |
| 1977 | Gimpel and Weitzenhoffer, New York City |
| 1978 | Elaine Benson Gallery, Bridgehampton, New York |
| 1979 | Neuberger Museum, Purchase, New York, *Abe Ajay/Selections 1964–78* (catalog essay by Burt Chernow) |
| 1982 | Aaron Berman Gallery, New York (catalog essay by Irving Sandler) |
| 1984 | Sid Deutsch Gallery, New York |
| 1985 | Hewlett Gallery, Carnegie-Mellon University, Pittsburgh (catalog essay by Akram Midani; foreword by Elaine A. King) |
| 1985 | Washington Art Association, Washington Depot, Connecticut |
| 1987 | Sid Deutsch Gallery, New York |

# Selected Group Exhibitions

| 1965 | *White on White,* De Cordova Museum, Lincoln, Massachusetts |
| 1966 | Addison Gallery of American Art, Andover, Massachusetts |
| 1966 | *Highlights of the 1965–66 Art Season,* Aldrich Museum of Contemporary Art, Ridgefield, Connecticut |
| 1968 | Pennsylvania Academy of the Fine Arts Annual, Philadelphia |
| 1968 | Albright-Knox Art Gallery, Buffalo, New York |
| 1968 | *Made of Plastic,* Flint Institute of Art |
| 1969 | Flint Instiute of Art Invitational |
| 1969 | *A Plastic Presence,* Jewish Museum, New York; Milwaukee Art Center; San Francisco Museum of Art (catalogue essay by Tracy Atkinson) |
| 1970 | Gimpel Fils, London |
| 1972 | Storm King Art Center, Mountainville, New York |
| 1974 | Neuberger Museum, SUNY Purchase, New York |
| 1975 | *A Change of View,* Aldrich Museum of Contemporary Art |
| 1975 | *Contemporary American Painting,* Lehigh University |
| 1975–76 | *Constructivism is Alive,* Gruenebaum Gallery, New York City; University of New Hampshire; SUNY College at Purchase (catalog essay by Stephen Bann) |
| 1977 | The Alternative Center for International Arts, New York |
| 1977 | *Perspective 1977,* Freedman Art Gallery, Albright College |
| 1977 | *New York WPA Art,* Parsons School of Design, New York (catalog essay by Emily Genauer) |
| 1978 | *Connecticut Painting, Drawing, and Sculpture,* Carlson Art Gallery, University of Bridgeport; The New Britain Museum of American Art; Cummings Art Center, Connecticut College, New London (catalog essay by Virginia Mann Haggin) |

| | |
|---|---|
| 1980 | *Sculptural Forms,* Aldrich Museum of Contemporary Art |
| 1983 | *Working America: Industrial Imagery in American Prints, 1900–1940.* Metropolitan Museum of Art, New York |
| 1983 | American Academy and Institute of Arts and Letters, New York |
| 1984 | *New York WPA Artists: Fiftieth Anniversary,* Passaic County College, Paterson, New Jersey |
| 1986 | *Sculpture* 1986, Wooster Art Center, Danbury, Connecticut |
| 1987 | *State of the Artists,* A Connecticut Artists Invitational, Aldrich Museum of Contemporary Art |
| 1987 | *The Friends of Louise Tolliver Deutschman,* Paris/New York/Kent Gallery, Kent, Connecticut |
| 1989 | Connecticut/Collage, Art at 100 Pearl, Hartford, Connecticut |
| 1989 | Bruce Museum Connecticut Biennial, Bruce Museum, Greenwich, Connecticut |

# *Appendix I*

Reprinted with permission from
*Art in America* (Nov./Dec. 1972).

## Working for the WPA, *by Abe Ajay*

TIMES ARE TOUGH ALL OVER AGAIN. The great American art souffle of the sixties has collapsed and a lean generation of artful dodgers digs deep into SoHo, pooling its pot and food stamps in the biggest non-floating crap game in Fun City. While they earn their stripes or explore a drowsy Left-at-the-Post Minimalism it may be useful to look back on an even meaner year, when making ends meet was somewhat trickier than a waterbed calisthenic.

If all goes well, there could be a major revival of interest in American art and artists of the thirties, rivalling in scope, perhaps, the current appeal of the Tiffany lampshade, the Indianhead penny and the Thonet Bentwood chair. The most significant milestone of that Great Depression decade was the WPA Federal Art Project, a venture in government patronage of the arts which kept many of us alive and working in a hungry time when thirty-nine cents bought a banquet platter of franks and beans at any Stewart's Cafeteria.

I was privileged to be a part of the scene rather late in its cycle and still hold those years in especially fond memory as one of the most exciting and plausible adventures of my life. We sang some hard-time blues toward the end and I shall try to recall some of the lyrics as we go on, but the rewards were unique and irreplaceable during that one time in American art history when nearly five thousand artists over the country were united in the fickle custom of a single wide-eyed patron, the United States Government.

The Federal Art Project has been dead for thirty years now and every non-payday (of which this studio sees many) finds me out at the gravesite with a nosegay of *Cannabis sativa*. Time has leveled or scattered many of the old bunch, and most of the work, good and bad, has been lost, destroyed or recycled. A faded mural by Ben Cunningham is roped off from vandals at Coit Tower in San Francisco and a single print of mine lies flyblown and dog-eared in a basement dustbin of the Metropolitan Museum. In a moment of unbridled passion the old Met paid the government five dollars for one of my early woodcuts, an ancient flattery which has, thus far, gotten me nowhere.

For those who tuned in late, government patronage of the fine arts spanned a decade of the Great Depression, beginning in 1933 as the Public Works of Art Project under Edward Bruce and Forbes Watson. The PWAP was abandoned in 1934 and the Federal Art Project was born a year later within the province of the Works Progress Administration.

Under the direction of Holger Cahill, the Project was set up expressly to employ painters, sculptors and graphic artists, et al., at a living wage in exchange for a stipulated slice of their creative work. During its brief but stormy life the Project consisted of three main working sections: Mural, Easel and Graphic, along with other units ranging from a Models Service to the Index of American Design. The latter remains to this day a most remarkable and beautifully rendered chronicle of the historical decorative arts in America from the seventeenth century through the nineteenth.

By far the greatest contact between the people and the Project in New York City was made in the area of art education, the art teaching division being the largest of all the working units. Over two million art students were registered over the years for classes, many of which were the first ever held for the disadvantaged in the city's schools and settlement houses. Community art centers were established all over the city and staffed by dedicated teachers and historians from the WPA/FAP rolls.

The WPA Federal Art Gallery was opened at 7 east 38th Street in New York and had its first show of city artists in 1935. The first major national exhibit of Project work was held at the Museum of Modern Art in 1936 under the supervision of Dorothy Miller, then assistant curator of painting and sculpture. The three thousand catalogues of the show printed for MOMA by Spiral Press at the time contained a foreword by Alfred H. Barr, Jr., and listed among the eminent trustees of that date were Nelson Rockefeller, Marshall Field, Edsel B. Ford and Lord Duveen of Millbank.  Among the works shown were sketches by Arshile Gorky for his 1,530 square feet of mural for the Newark Airport administration building and three panels by Philip Evergood for his reference-room mural at the Richmond Hill Branch Library. A list of the other artists taking part in this show reads like a collector's dream: Stuart Davis, Marsden Hartley, Joseph Stella, Willem de Kooning, Raphael Soyer and Rufino Tamayo are only a handful of the accomplished rustics who showed proudly what $23.50 a week could buy for the only client showing the green in that pauperized year.

The gallery scene was bleak or nonexistent for young artists in the thirties, although Edith Halpert's Downtown Gallery on 13th Street did stock a few staples like Stuart Davis, Alexander Brook, Kunyoshi, and Ben Shahn while the Rehn gallery on Fifth Avenue handled some old-guard standbys of the Eugene Speicher genre. Certainly few collectors had as yet made it upstream from their Wall Street spawning grounds, and foundation grants were about as rare as a mink stole in a cold-water loft.

I was eighteen when I moved to New York in September 1937, nearly ten thousand years to the day after some previous innocent sketched a silly bison in a cave at Lascaux, saw that it was good and set about grabbing himself a gallery. Certain minor credentials had preceded me from my bituminous digs in western Pennsylvania, published drawings with which most of the New York artists were familiar, and they served as easy entree to a seasoned gaggle of pros who might otherwise have looked askance at a raw recruit in rimless glasses, snappy mustache and porkpie hat. Snuggling up to the action right off, I went to the opening of a splendid watercolor show at the Old Whitney Musuem on 8th Street, swallowed my first martini, patted Juliana Force on the ass, and

settled down for a long winter's night during which my three-hundred-dollar nest egg was swiftly dispatched.

It was then that I began to think seriously of the WPA/FAP, which was the single source of income for the artists I knew. The Project paid about eleven hundred dollars per year, a willowy fortune to me, and a prudent couple could survive handily if they ate with caution and watered down the gin.

The first cruel hurdle to employment on the Art Project was a rule that an artist had to be certified as totally indigent before he became "eligible for welfare," that final purgatory on the way to a job assignment. The regulation stopped just this side of a stripdown at relief headquarters to let them hear your stomach rumble before a caseworker granted an interview.

Many artists in the thirties were, of necessity, part gypsy and journeyman and faced another sticky problem in the stringent residence requirements. Ironically, eviction notices were often accepted as sufficient proof, and I knew of one avant-garde talent who successfully doctored a postmark to prove receipt of mail at a New York address since 1895. He went on to better things, winding up with a black-tie opening at the Jewish Museum twenty years later.

Happily, I made the rolls first time out and was assigned to the Graphics Division of the Project before I had a chance to pick up my poke of margarine, sweet potatoes and red cabbage at the local relief depot. Lynd Ward was graphics supervisor at the time and suggested I work at home instead of at a Project workshop, an amiable indulgence since I had chosen lithography as my medium and the heavy stones had to be trucked to my studio in Yorkville and then back to 110 King Street for printing. The terms of employment were eminently fair by standards of the day. Four weeks were allowed for the production of a print and, on the easel division, six weeks for a 24″ × 30″ painting. The going wage was $23.50 per week, paid in semi-monthly installments, which established a rough price of about $140 per canvas and $95 per print. The mural breakdown was more complicated, with time allowed for idea sketches and color studies, but in general approached the neighborhood of $2 per square foot. The materials provided gratis by all divisions were of first quality, if not always in adequate supply. I can recall many a hassle toward the end of a line when six hands reached for the same last tube of an especially choice vermilion. Actually a very respectable laboratory for the grading and testing of materials before distribution was maintained. It was called the Restoration, Installation and Technical Service Division and was headed by Raphael Doktor. When this able unit wasn't producing pamphlets on the efficacy of rabbitskin glue as a canvas size, it was scrubbing up rather dubious examples of Art Deco in armories and federal courthouses.

The payroll in New York embraced at various times just about everybody who ever stretched a canvas, rigged an armature or pulled a proof. Davis, Hartley, Gorky, de Kooning, Reinhardt, Rothko, Pollock, Guston, Gropper, Refregier, Evergood, Will Barnet and the three Soyer brothers are only a few in the grab bag of memory who put in a hitch on the Project before it was dismantled in 1943.

Nostalgia is a specious editor and most human experience tends to tidy up in retrospect, but I can recall no time since the thirties when artists of such mixed persuasion were as gentle and generous with each other on so many levels. Perhaps it was because everyone received the same paycheck twice each month. I don't know. But a buoyant sense of pride and kinship hung like a halo over even the most minimal of encounters among the artists I knew during most of the Project years. An open-door policy was de rigueur in a good number of studios and jammed rent parties were sponsored with regularity to bail out the profligate few who had run through their government stipend before the landlord took his bite. Abstractionist and Social Realist alike nipped at the same bottle and danced, for that time, to the same Dixieland jazz tune.

The young were afforded the benefit of both doubt and experience and encouraged, along with the wise and the wary, to sit up of a Friday night and take a little broth at McSorley's wonderful saloon. Here, one might endure Henry Glintenkamp's latest discourse on Orozco and the merits of Mexican broads or attend little Abraham Walkowitz as he doodled his 407th final remembrance of Isadora Duncan. The veneration gap of the sixties was a full thirty years away. It was a good and brotherly time.

At least everybody was working and there was never, to my knowledge, any pressure by the Project administration to influence the direction or style of an artist's production. The Social-Surrealist Philip Evergood was supervisor of the easel division for a while, and Burgoyne Diller headed the mural section, promoting the work of abstractionists Arshile Gorky, Ilya Bolotowsky, Stuart Davis, and Byron Browne.

Alas, other difficulties more than made up for the freedom enjoyed in the creative effort itself. The WPA timekeeping regulations were a joke and a persistent source of friction between artist and administration. Easel and graphic artists in particular might indulge a built-in habit of years, that of working into the night or at odd hours of the day, and a spot check by a Project investigator during his own working hours could easily find the artist out for a stroll, basting a turkey or negotiating a sweet romance on the studio divan.

Another nightmare bogey was the growing lack of job security inherent within the very nature of the congressionally funded WPA/FAP. Fear of the "pink slip" was universal, as I recall, and one would bed down at night in a cold sweat anticipating the morning mail, approaching the box next day with all the trepidation of a latter-day bomb disposal squad called to work at the Bank of America (Berkeley Branch).

If we would properly sample this gloomy pudding of anxiety, we must flip back for a moment and ponder the ill-tempered events which set it to cooking a full year before my time.

Franklin Roosevelt was elected for a second term in 1936 and the congressional ax began swinging with a vengeance thereafter to "balance the budget." For every Philistine in the House there was the jawbone of an ass in the Senate who deplored and attacked the Project as one vast boondoggle. Rumors of massive firings began to leak from Washington and were followed by an order from Col. Brehon Somervell, then local

WPA administrator, requesting supervisors to draw up a list of artists "least useful" to their operation.

The first dreaded batch of pink slips appeared in the mail and a series of angry demonstrations began, organized by the Artists Union. The fat, if such were to be had in that year of famine, was in the fire.

On December 1, 1936, a bone-cold Tuesday, 219 Project employees invaded the eighth floor of FAP headquarters at 6 East 39 Street in what was later to be tagged the "219 Sit-In Strike."

Seventy-five policemen and five emergency squad trucks pulled up to the scene at 4 P.M. and moved in with riot gear to clear the building, severely beating many of the artists including Philip Evergood, Helen West Heller, Philip Reisman, and Paul Block, who was later to be killed in Spain, fighting with the Abraham Lincoln Brigade.

Four hours later the eviction was completed and the bloodied 219 were packed into eleven patrol wagons, taken to the East 35th Street Police Station and booked for disorderly conduct. Evergood recalls that they were "tossed into stinking jail cells with toilets overflowing and the floor running with two or three inches of filthy water." At 1 A.M. they were assembled in night court and released in custody of Congressman Vito Marcantonio. The charges against all were dismissed two days later.

This contrasts remarkably with the tale of a Stuart Davis brush with the law during the long-playing Ohrbach strike in the late thirties. Arrested on the picket line, taken to jail and released, he was approached on the same line next day by the policeman who had booked him the day before. Tapping Davis timidly on the shoulder, the officer asked for his autograph, explaining that his wife had recognized his name in the public prints as a "famous artist" whose work she had once seen in a museum catalogue.

Thus bloomed the subtle vagaries of law and order as the WPA/FPA dribbled its gore on a congressional chopping block. Stays of execution were granted from time to time as minor concessions were forced by the Artists Union, but all the signs of a terminal malaise were on the chart and hung like a Con Ed belch of melancholy doom over the art community. After 1938, the trajectory of the Project pointed clearly downhill and the fortunes of the artists it employed were to decline accordingly. From a peak employment figure in New York of 2,323 in October 1936, the job roll dwindled to a paltry 630 in March 1942. I can recall no grand suicide excursions out of top-floor studio windows, but that might simply suggest we owned a less inventive strain of mind than the average Wall Street broker.

As the Project lost its life, works too bulky to be stored were apparently destroyed out of hand along with vital records, making it difficult if not impossible to trace the art which had been normally allocated. When the phase-out was nearly complete, most of the work in the stacks was put up for sale in a frail attempt by the government to get back at least a dime on its dollar. The bidding was a mite less brisk than for a Velázquez at Sotheby's, but some of the merchandise did indeed move off the shelf, most often for the simple cost of materials involved.

Art which was not sold or allocated was stored in government warehouses and, after the dust had settled, many of the WPA paintings were auctioned off as "used canvas," finding a tawdry home as inventory with secondhand art dealers who made a minor killing on salable work for which they had paid little or nothing at all. The buzzards were on the wing, and the sweet old Project, still warm to the touch, was being buried like a wasted beggar on Boot Hill.

The WPA Federal Art Project was finally liquidated in January 1943. In New York City alone 200 murals, 12,000 oil paintings, 2,100 pieces of sculpture and more than 75,000 prints from 3,000 original plates had been produced and allocated to schools, hospitals, libraries, colleges and public institutions. But the party was over. The final solution of the artist question in America had been duly arrived at, and thus ended the noblest experiment of them all, not counting that one effort by Lorenzo de Medici to get his house artist a job as busboy in a four-star Florentine pizza parlor.

But all was not lost for the artist, as we shall see. At least not entirely. A fairly competent watercolorist named Hitler had swallowed up half of Europe and was reaching for the desert menu. Prosperity, in the guise of World War II, was flexing its sexy muscles just around the bend. A few stragglers at the end of the Project chow line were mustered into service as camouflage experts for the Air Force. Others designed VD posters and army field manuals on the care and feeding of the M1 rifle. That Neanderthal notion (never a great one) of "art as weapon" had come full circle, and the remnants of the Project became the Graphic Section of the War Services Program, a different drummer indeed, which collapsed of its own feather weight at the end of January 1943.

A couple of years ago I received a questionnaire from Francois V. O'Connor soliciting a recollection of my tenure on the WPA/FAP, that short-lived government plunge in the art market. I fear my response at the time was too feeble and frigid to serve Mr. O'Connor well and I regret this because his effort was eminently honest and well directed. His report is titled *Federal Support for the Visual Arts: The New Deal and Now* and is the only attempt I am aware of which measures the dignity and purpose of the Project above and beyond the hard-edged data cataloguing the affliction, last words, and final disposition of the corpse. This fascinating document is now in its second printing (New York Graphic Society, Ltd., Greenwich, Connecticut).

In addition, the Archives of American Art, its ear to hallowed ground, set up a special program in the mid-sixties to tape the fertile memories of some ex-Project artists still active and articulate. I don't know which artists were chosen for this oral research or how ambitious a package was planned since the material is slugged "closed to scholars" for some tight-lipped reason. One can only surmise that the Ford Foundation funding died laughing on its way to the bank or was switched to some more sprightly branch of the performing arts at the Kennedy emporium.

Obviously a more extravagant effort is needed if the history of American art in the thirties is to be recorded, and Nancy Hanks might well persuade Mr. Nixon to make this Great Leap Forward at the next meeting of the National Endowment for the Arts. The cost of a single rivet on his proposed space shuttlecraft would more than pay for an audio-visual compendium of the Project experience from cradle to easel to grave. After all, the Library of Congress must be brimming with the total recall of princes, pederasts, and poets, literary nuggets ranging in style and taste from, let us say, a Fatty Arbuckle recipe for bathtub gin to a Vladimir Nabokov disc on making it for the first time with a gypsy moth. Why not an eight track stereo tape of Philip Evergood booming out his story of the "219 Sit-In Strike" at WPA headquarters in 1936?

Like sex, art is best learned about in the gutter or behind the barn from those who make it. Leaving the place of the WPA/FAP in art history entirely to the art historian is not the peachiest idea in the world. Indeed, it may be like leaving a barnyard roll call to the fox, a state of the affairs in which the heavy art talk can be finger-lickin' good but the roster of those present-and-accounted-for shrinks in direct ratio to the art historian's appetite. The carcass is picked clean enough for the books, but heart and wishbone are invariably missing.

If a true picture of the art scene in this country during the lean and hungry Depression is to be painted, it will be the artists themselves who must at least stretch the canvas. And if it were to be done, I would recommend that it be done quickly, because it is a matter of some small time before the final roll is called up yonder. Unlike old cavalrymen, artists are more inclined to drop dead than fade away, going no longer to heaven or hell but, through some divine propulsion, directly to the Marlborough Gallery from Frank E. Campbell's Funeral Chapel.

# Selected Bibliography

## About the Artist

*Acorn Press Arts Weekly* (Ridgefield, CT). "A Dialogue with Abe Ajay," p. 1, November 4–5, 1987.

*The Advocate* (Stamford, CT). "Abe Ajay, Selections 1964–1978," December 28, 1978. Exhibition at Neuberger Museum, State University of New York at Purchase.

Aldrich, Larry. "New Talent USA," *Art in America,* p. 53, July/August 1966.

Barnitz, Jacqueline. "Abe Ajay," *Arts Magazine,* p. 67, February 1968.

Braff, Phyllis. "From the Studio," *East Hampton Star,* pt. 2, p. 7, July 6, 1978.

Campbell, Lawrence. "Ajay," *Art News,* p. 50, December, 1964.

Canady, John. "Abe Ajay," *New York Times,* p. 26, October 17, 1964.

Canaday, John. "Abe Ajay," *New York Times,* p. 24, January 27, 1968.

Chernow, Burt. "Abe Ajay," *Arts Magazine,* p. 9, December 1978.

Chernow, Burt. "Abe Ajay Searches for the Perfect Universe," *Westport* (Connecticut) *Fairpress,* p. C9, December 18, 1978.

*Danbury News Times.* "Abe Ajay Exhibits," p. 63, November 22, 1978.

*Danbury News Times.* "Ajay's Art . . . Another Dimension," p. 33, March 6, 1975.

*Danbury News Times.* "Highlights of the 1965–66 Art Season," p. 6, July 9, 1966. Exhibition at the Aldrich Museum, Ridgefield, CT.

Edgar, Natalie. "Abe Ajay," *Art News,* p. 11, March 1968.

Feller, Colta. "Abe Ajay," *Arts Magazine,* p. 48, June 1966.

Glueck, Grace. "Abe Ajay," *Art in America,* p. 166–67, November/December 1970.

Gollin, Jane. "Abe Ajay," *Art News,* p. 10, Summer, 1966.

*Greenwich* (Conn.) *Time.* "Neuberger Museum, SUNY, Opens Four Different Shows," December 11, 1978.

Gruen, John. "Ajay," *New York Herald Tribune,* p. 9, October 17, 1964.

*Hazelton* (Pa.) *Standard-Speaker.* "Nationally Known Artist Among Art League Jurors," p. 23, March 29, 1979.

Hoffeld, Jeffrey. "Constructivism Is Alive at Grunebaum," *Arts Magazine,* p. 22, May 1975.

Kramer, Hilton. "Abe Ajay," *New York Times,* p. 26, May 14, 1966.

Levick, L. E. "Ajay," *New York Journal American,* p. 7, October 17,1964.

Mellow, James R. "Abe Ajay," *New York Times,* p. 17, February 10, 1973.

Merkling, Frank. "Ajay's Art: 'my own chemistry,' " *Danbury News Times,* pp. 1–5, April 25, 1982.

Miller, Donald. *Pittsburgh Post Gazette,* p. 19, March 5, 1985.

Raynor, Vivien. "Ajay," *Arts Magazine,* p. 71, December 1964.

Raynor, Vivien. "Notes on Some Native Sons." (Connecticut Painting, Drawing and Sculpture '78), *New York Times,* p. 14 WC, February 5, 1978.

Raynor, Vivien. "The [Aldrich Museum] '60's Collection Revisited," *New York Times,* pp. 4–5 CN, December 10, 1978.

Raynor, Vivien. "Perfection and Decadence" (Ajay exhibition at Neuberger Museum), *New York Times,* p. 6 WC, December 31, 1978.

Raynor, Vivien. "Abe Ajay," *New York Times,* p. 21, May 7, 1982.

Raynor, Vivien. Review of exhibition at Washington Art Association, *New York Times,* p. 24 CN, June 23, 1985.

Raynor, Vivien. "Abe Ajay," *New York Times,* p. 28, April 17, 1987.

Raynor, Vivien. "Twenty-four Artists and Friends in Kent Show" (Friends of Louise Tolliver Deutschman), *New York Times,* p. 28 CN, August 16, 1987.

Sandler, Irving. "The Poetic Constructivism of Abe Ajay," *Arts Magazine,* pp. 94–95, February 1977.

Scott, Martha. "Each Item a Jewell . . . ," *Bridgeport Sunday Post,* p. C28, January 28, 1968.

Scott, Martha. "No Art Show Quite as Beautiful . . . ," *Bridgeport Post,* p. C22, November 29, 1970.

Scott, Martha. "Ajay in Bethel and Ajay at the Neuberger," *Bridgeport Sunday Post,* p. D15, January 14, 1979.

Scott, Martha. "Abe Ajay," *Arts Magazine* p. 12, December 1982.

Silver, Cathy. "Abe Ajay," *Arts Magazine,* p. 5, May 1982.

*Time Magazine.* "Abe Ajay," p. NYR1, February 2, 1968.

*Times Herald Record.* (Middleton, N.Y.) "Art Shows on Display at Purchase," December 16, 1978. Exhibition at Neuberger Museum, State University of New York at Purchase.

Wilson, William. "Art Walk." *Los Angeles Times,* p. 4, April 23, 1971.

## By the Artist

"The Prize: An Exchange of Letters with Ad Reinhardt," *Art in America,* pp. 106–9, November/December 1971.

"Working for the WPA: A Memoir of the Artist's Experience on the Federal Art Project," *Art In America,* pp. 70–75, September/October 1972.

Review of Francis V. O'Connor's *The New Deal Art Projects* and *Art for the Millions, Art in America,* p. 38, November/December 1972.

"Ben Cunningham, 1904–1975," catalogue essay-tribute for a memorial exhibition at the Neuberger Museum.

# Index of Names